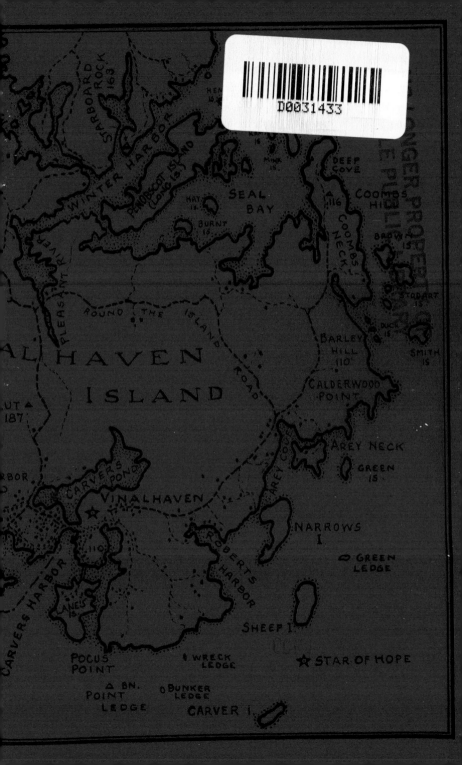

THE ISOLATION ARTIST

SCANDAL, DECEPTION, AND THE LAST DAYS OF ROBERT INDIANA

BOB KEYES

Godine ☆ Boston ☆ 2021

Published in 2021 by Godine
Boston, Massachusetts

LIBRARY OF CONGRESS CATALOGING-IN-PUBLICATION DATA
Names: Keyes, Bob, 1962- author.
Title: The isolation artist : scandal, deception, and the last days of
 Robert Indiana / Bob Keyes.
Description: Boston : Godine, 2021.
Identifiers: LCCN 2021015114 (print) | LCCN 2021015115 (ebook) |
 ISBN 9781567926897 (hardback) | ISBN 9781567926903 (ebook)
Subjects: LCSH: Indiana, Robert, 1928-2018—Last years. | Artists—
 United States—Biography. | Art and society—United States—
 History—21st century.
Classification: LCC N6537.I53 K49 2021 (print) | LCC N6537.I53
 (ebook) | DDC 700.92 [B]—dc23
LC record available at https://lccn.loc.gov/2021015114
LC ebook record available at https://lccn.loc.gov/2021015115

Endpaper map courtesy of the Vinalhaven Historical Society.

First Printing, 2021
Printed in the United States of America

THE ISOLATION ARTIST

This book is dedicated to Edna Keyes,
my mother, for inspiring me and holding me
to account growing up; and to Chuck Reece,
my first editor and longtime friend, for setting
high standards in journalism and in life and
holding me to account in both.

AUTHOR'S NOTE

I first interviewed Robert Indiana in 2002, shortly after joining the staff of the *Portland Press Herald/Maine Sunday Telegram*. Between 2002 and Indiana's disappearance from public life in 2016, I interviewed the artist—either in person or on the telephone—at least a half-dozen times. On some occasions, I was given unique access to otherwise private events and conversations. All sources used in the writing of this book—including interviews, court documents, medical reports, and newspaper articles—are cited at the end of the book. While I have honored the request for anonymity from a few sources, no pseudonyms and no composite characters have been used.

CONTENTS

Editor's Note: For Robert Indiana, the number o symbolized death—in his artwork, he often represented o in black-and-white or shades of gray. In this book, readers will not find a chapter 10, but instead a chapter o, as an homage to the artist.

"A sum of money is a leading character
in this tale about people,
just as a sum of honey
might properly be a leading character
in a tale about bees."

Kurt Vonnegut, *God Bless You, Mr. Rosewater*

1

I f you wanted Robert Indiana to open the heavy wooden front door to the Star of Hope, you removed a palm-sized hunk of granite hidden on a narrow ledge overhead, pounded three times on the middle of three stars, and waited. Then he knew it was safe to open. He was usually on the other side.

If Indiana felt like it, he would let you in. If he didn't, you could try again another day.

The artist had the reputation for being reclusive. But he wasn't a recluse. Another word people liked to use to describe him was *hermit*. He wasn't that either. Robert Indiana was an ass.

Indiana had become purposefully elusive and hard to reach because he relished the reputation and reality of being difficult—and it was often convenient. He was a man who avoided conflict, yet constantly created it by making things difficult. He did it out of carelessness or he did it intentionally, but either way he did it because he could. He had the power.

If you really needed to reach Indiana, he was always available. He lived in the grandest house on a small island a dozen miles off the coast of Maine. He had nowhere to hide.

If you were trying to reach Indiana by phone, you let it ring into his answering machine, then told him who you were and why you wanted to talk. Indiana usually hovered nearby, listening. If he wanted to talk, he'd pick up. Before a frustrated museum director presented him with the answering machine—and neglected to update the message, so Indiana's greeting was voiced by a charming female curator—you let the phone ring once, hung up, called again and let it ring twice, hung up, and then called a third time. That little code signaled to Indiana that you were an insider, and it was safe for him to pick up.

With Robert Indiana, it was all about ritual. He lived in a former Odd Fellows Hall with peepholes and hidden doors, and a century's worth of accumulated spirits, mysteries, and oddities. He was an odd and tortured soul even before he arrived on Vinalhaven island, in the 1970s, and took up residency as the sole occupant of the Star of Hope, a dilapidated Victorian structure built for gatherings of men. There, he descended into deeper, dangerous, and more complicated eccentricities with each passing year.

With Indiana, it was also about vanity. He resented that his art was always better known than he was. He wanted people to come to him, to pay their respects to him—yet, even when they did, he might turn them away. For slights real or perceived, he declined meetings with presidents and partnerships with rock stars. One unbroken thread woven through the story of his life is that of missed opportunities and the personal hurt and professional cost that accompany both.

By the time he died, at the age of eighty-nine, in the spring of 2018, Robert Indiana hadn't spoken to the press in more than two years. He'd stopped communicating with his art dealer the year before. The last time people on Vinalhaven

saw him puttering about was long before the first snow of the season had settled over and quieted the island. As fall turned to winter, no one could reach him—not by phone, email, or any combination of knocking on doors, rapping on windows, or spying with binoculars from a dooryard away on a frozen, starlit night, hoping for even a glance of the old man shuffling past a kitchen window.

He just disappeared, vanished, as if lost in one of those thick island fogs that blow in suddenly off the North Atlantic and settle over the timber and granite town, shrouding it like a heavy blanket that muffles voices and snuffs out light.

After Robert Indiana died, the island he'd called home for four decades was awash in rumors that quickly surged and flooded the mainland. Some said he had lived his final months in squalor amid cat piss, dog shit, and rainwater seeping in from a leaky roof. There were allegations of elder abuse, of signature machines, and the suggestion that he'd been held against his will while artwork was created under his name without his knowledge. And most damning were the murmurs that Indiana's death had been hastened—indeed, that he might not have died on Saturday, May 19, as was widely reported and believed, but had actually died the day before, on Friday, May 18, the exact day his longtime art dealer filed a lawsuit against him that alleged copyright infringement by way of willful ignorance.

Years after Indiana's death, there remain unanswered questions about the cause and manner of his passing. Although foul play was ruled out, the Maine medical examiner concluded that both the cause and the manner of Indiana's death were "undetermined," an extremely uncommon result for an autopsy: nationally, only 1 to 3 percent of autopsies result in a finding of "undetermined." The autopsy did conclude that

Indiana suffered from severe coronary artery disease, complications from which had a serious impact on his health and likely led to his death. Two independent forensic pathologists who reviewed the autopsy report agree with the conclusion. But a close reading of the report also reveals many anomalies. For instance, the report noted elevated levels of both morphine and isopropanol, a leading ingredient in rubbing alcohol. Both morphine and rubbing alcohol are consistent with end-of-life care, but both are inconsistent with Indiana's beliefs as a Christian Scientist, one of the tenets of which is to shun Western medicine. The autopsy also included a screening for the presence of heavy metals in Indiana's system, suggesting that investigators had suspicious that the artist had been poisoned.

Inquiries by local and state authorities, as well as by the FBI, yielded nothing related to crimes before Indiana's death or a cover-up afterward. No one has been charged with anything. When the notion of foul play comes up today, many who live on Vinalhaven island dismiss it at as conspiracy theory. Others aren't so sure. As in any other small town, opinions and facts begin to blur.

It is a fact that the Star of Hope had become a dump. Whatever ailments befell Indiana at the end of his life, it had been a long time since anyone in his employ had paid much attention to the integrity of the home he'd spent nearly half of his life curating as his one true and lasting statement of self-expression. Indiana drew his final breath laid out on a bed that was scarcely better than a cot, on a ratty, stained mattress more befitting a drafty shack than the once-stately Star of Hope, with the chandeliers, tapestries, and Victorian-era furnishings Indiana had collected and cared for. In the end, it almost came crumbling down around him. The plas-

ter peeled from the walls, his vast collection of newspapers and magazines—each edition of the *New York Times*, saved since god knows when, bundled with green balling twine and stacked in the attic—was ruined. Some works on paper were water damaged, shoved aside, and allowed to deteriorate. A builder hired to inspect and restore the Star of Hope after Indiana died said its internal structural support system was so compromised from rot that if left unrepaired, the walls were as few as five years away from blowing out and bringing down the building in a cloud of dust.

None of this was for lack of funds. Robert Indiana died with at least $5 million in his bank account, and there was plenty more.

It was for lack of love.

☆

BY THE TIME he reached eighty, in September 2008, Robert Indiana's broken heart showed itself in the hollow edges of his eyes. They'd been intimidatingly sharp up until then, but the artist's eyes looked tired as he stood passively in the kitchen of a longtime friend, shifting from foot to foot and looking away as the two men who most controlled the fate of his legacy—the art consultant and one-time London gallerist Simon Salama-Caro and the New York art publisher and sometimes-artist Michael McKenzie—chatted about his past and future as a great American image maker.

They talked about him as if he weren't even there, as if he were already dead.

If his eyes told the truth, he was well on his way.

Outside, it was a glorious fall day on Vinalhaven, a sprawling, wooded Maine island that entices with its mystery, elusiveness, and seclusion. Many artists disappear along the

Maine coast, and the most hardy and adventurous choose islands as their hideaway. Vinalhaven isn't a hobby-artist's island—it is beautiful and rugged with its tall red spruce, balsam firs, and paper birch trees and deep granite quarries, but it is not quaint. Those who come from away have their work cut out to earn the respect of the island's hardworking year-round residents. This is true of all Maine towns, but islands ask even more of newcomers. In addition, Indiana was openly gay in a community not known for its tolerance, particularly in the 1970s, when he arrived.

Robert Indiana fled New York because he'd grown to feel betrayed and maligned in the city. On Vinalhaven, he might have hidden out, or maybe even faded away. But instead, he chose as his home the grandest structure on the island, the elegant twelve-room Star of Hope Lodge, a former Odd Fellows Hall that towered over the harbor, visible to visitors as they arrived by public ferry. Wedged between the three-story Memorial Hall and a row of wooden storefronts on Main Street, you couldn't miss it. The hall was built in the waning days of the nineteenth century, the heyday for Vinalhaven and its granite quarries, which provided construction material for the bridges and buildings of North America and helped inspire the architects and designers who dreamed about what they would build with it—and, a century later, the artist Robert Indiana. A few years before islanders nailed the last wooden shingles to the mansard roof that would become the Star of Hope's distinctive architectural feature, laborers hoisted blocks of Vinalhaven granite into place as anchors for the Brooklyn Bridge.

When Indiana established his studios in the Coenties Slip section of Lower Manhattan as a young artist in the 1950s, the bridge was part of his daily view and a significant influence

on his life and art. During that time, he also worked briefly at the Cathedral of St. John the Divine, whose massive columns were quarried and turned on Vinalhaven. It's unclear if Indiana realized the Vinalhaven connections so early in his artistic life, but there they were in plain sight. The aura of Vinalhaven surrounded him and tugged at him from his earliest days in Manhattan, whether or not he knew it. For Indiana, who tried to build his life as a series of interlocking puzzle pieces, Vinalhaven fit like a preordained destination. As much as he chose Vinalhaven, he was just completing the puzzle, with Vinalhaven and the Star of Hope as the final pieces.

So here he was, on the occasion of his eightieth birthday, in the kitchen of an island friend, Salama-Caro and McKenzie discussing him as though he were more a commodity than a man, feeling betrayed by those he had trusted most to look out for him, both in art and in life. Outside the kitchen door, a few dozen of Indiana's friends from the island and art worlds of Maine, New York, and France had descended to celebrate the icon's birthday. The host, Indiana's loyal friend Pat Nick—founder of Vinalhaven Press, where Indiana expended considerable creative energy—had assembled all the right people. There was sculpture in the garden, a huge cake on the patio table, and an oversized *LOVE* birthday card that everyone signed.

And indeed, despite the unease in the kitchen, there was much to celebrate.

☆

IT WAS THE autumn of 2008 and the country was on the cusp of electing Barack Obama as its first Black president. And thanks in no small part to Obama, for the first time since the Vietnam War, Indiana's art was in front the public

in a significant way. Back in the 1960s, in the generation of discontent when Indiana came of age, it was his *LOVE*, a simple word loaded with complexity, that made him famous. Indiana, who always described himself as a sign painter first and foremost, had made the word *LOVE* his own in 1965 by reimagining its form: he stacked the letters two over two and tilted the *O*, transforming a word into a lasting message of a generation. The brilliant, imperfect simplicity of *LOVE* was embraced immediately. It was art everyone could coalesce around, both the square, baby boomer parents and their free-love, hippy children, and other people around the world. *LOVE* would later be reimagined in many dimensions and languages, as well as a postage stamp, and become an international image of acceptance and harmony.

LOVE not only became his best-known and most-recognized piece of art—indeed, his biggest hit—but it also affirmed and distinguished his artistic style: sharply painted lines, distinct shapes and colors, and a precise message, even if a deeper, more personal meaning was sometimes hidden in the easily consumable, bite-sized pieces of art he dropped on the world, like the pop songs of his day. *LOVE* worked in many languages and media, and was reproduced across the country and across the globe as large-scale public art.

That Indiana waited too long to try to copyright the image—he'd created *LOVE* in response to a commission from the Museum of Modern Art (MoMA) to design a Christmas card—and barely benefited from it financially at the time dogged him to his dying day, and became the lasting irony in his life and career.

More than forty years after *LOVE*, with glassy eyes and a lack of interest creeping into his soul, here was Indiana thinking about *hope*, another geometric, graphically friend-

ly word that offered all kinds of generational connotation. Just as *LOVE* had become an emblem and rallying point for peace-seekers, *HOPE* was offered as a symbol of a new America with the promise of equality and justice for all.

And by god, it was working. McKenzie, who had collaborated occasionally with Indiana since the 1990s, was back in the artist's life and pushing *HOPE* as Indiana's next great work—perhaps his final, lasting statement.

McKenzie convinced Indiana to put his energy into *HOPE*. They signed a contract to work together, with McKenzie promising Indiana $1 million a year in return for the licensing rights to it. With McKenzie prodding him, Indiana riffed on what he created with *LOVE*, essentially copying himself—the creative license of any artist, and something Indiana had used to both his advantage and his detriment over his long career. Displaying his flair for showmanship, McKenzie scrambled to fabricate a six-foot, stainless-steel version of *HOPE* and placed it outside the Pepsi Center in Denver, site of the Democratic National Convention that August, where it caught the attention of the political elite and everyday Democrats hoping for change.

☆

ROBERT INDIANA WAS back.

That was the topic of discussion in the kitchen on Vinalhaven that sunny September afternoon. It was all about love and hope, the themes of his life, and Indiana found himself in the middle of his past, present, and future. He looked disgusted and disengaged.

Indiana addressed the small group. "Michael has reached the conclusion, and I do not entirely agree with him, that *HOPE* one day will be on the same level as *LOVE*. That

would be nice, but I think he is being optimistic," he said slowly, in a scholarly voice. "We shall see."

The artist spoke with a cadence that sometimes sounded like poetry. Indiana's voice was sharp and hard, like the edges of his painted lines. Just as he chose his colors with precision in his art, so, too, did he choose his words in conversation: not one wasted or out of place—except in anger.

Yes, he was pleased that the sculpture caught the attention of Obama, whom Indiana liked—liked very much indeed. An old liberal who infused politics into his art from the Kennedy years, Indiana was thrilled at being associated with the man on his way to becoming the nation's first Black president, though two years later the artist brusquely declined an invitation to meet with Obama in the Oval Office because of a perceived slight. And yes, he certainly liked the prospect of making another splash. What artist at eighty years old wouldn't like the chance to make another statement of impact?

But he also didn't want all the work he made between *LOVE* and *HOPE* to be overlooked—he loathed the idea of being defined by those words and by the limited scope of those pieces. He also hated being called a Pop artist, lumped together with Warhol and Lichtenstein. He and Warhol were friends who became rivals, and Indiana saw himself on a different plane, as a serious, sustaining artist whose work would outlast and rise above trends.

McKenzie plowed past his partner's sentiments and laid it on thick. Just as *LOVE* helped define the 1960s, he said, *HOPE* would do the same for the young people of the United States rallying behind Obama. His voice rose to the pitch and rhythm of a car salesman with a touch of P.T. Barnum thrown in, offering something impossible and a reason to believe it might be real.

"Every generation is getting a tag, and not all those tags are entirely complimentary. You have the Me Generation, the Slacker Generation, Generation X. But when you call a generation the Hope Generation, it's a completely different story," McKenzie said. "Bob is in a perfect position to show the way." He gestured toward Indiana with outstretched arms and open palms, as if presenting him on a pedestal.

Salama-Caro, who'd flown in from France for the party, had been mostly quiet, and looked askance as McKenzie rambled. Until that morning, Salama-Caro knew little of *HOPE* beyond its existence as a one-time sculpture in Denver. But just before the party, he learned that it was bigger than a single sculpture, and he was horrified. Indiana invited him for a private visit, and when Salama-Caro walked into Indiana's studio, he noticed between ten and fifteen silkscreened *HOPE* prints on canvas in different sizes and colors.

Indiana told Salama-Caro they were McKenzie's work, and asked him to meet with McKenzie to figure out what to do with them. Salama-Caro was angry. These weren't a few new *HOPE* paintings created by Indiana in his studio, but what Salama-Caro perceived as mass-produced oil-on-canvas prints, made by McKenzie in his studio, being passed off as original Indiana paintings. He'd tangled with McKenzie back in 1999, when McKenzie tried to reproduce and sell *LOVE* artworks. Salama-Caro was caught off guard at the production-quality of this new work but told Indiana he would meet with McKenzie out of respect for Indiana's wishes.

When he finally spoke up in the kitchen that afternoon, Salama-Caro politely wished *HOPE* well but discounted the idea this new motif would rival *LOVE*, or many of the other works of art that Indiana had created over the years. He didn't want to insult the artist by denigrating this new

work. Whereas McKenzie presented himself as brash, loud, and boastful in an entitled, ugly-American kind of way, Salama-Caro was smooth and refined with a European flair for deferential politeness.

"His legacy is enormous. He is truly a giant American artist," Salama-Caro said, bowing to Indiana.

He had made it something of a personal mission to resurrect Indiana's career when the pair began working together in the 1980s. He eventually arranged for Indiana to sign two contracts with an entity known as the Morgan Art Foundation, a for-profit company that would go on to finance Indiana's most ambitious projects. The contracts Indiana signed gave Morgan Art intellectual property rights to *LOVE*, as well as the ability to fabricate and sell other images Indiana wanted to see in sculptural form. Another contract allegedly dealt with rights for additional work, though Salama-Caro and Morgan Art failed to produce that contract in court.

On Salama-Caro's advice, Morgan Art had invested millions of dollars resurrecting Indiana's career long after he had disappeared off the coast of Maine to wallow in the misery of his forsaken nineteenth-century lodge. As Indiana's agent, Salama-Caro wasn't about to let McKenzie step in and steal the artist from him—not after everything Salama-Caro had done to bring life back to Indiana's career and light back into his life, and certainly not with a piece as derivative as *HOPE*.

Salama-Caro had arrived in Indiana's life at a time when the artist was vulnerable. He had begun self-isolating, removing himself from the art world, and severing ties with many curators and dealers. His personal life was equally in disarray. Indiana often attributed the frequency with which the Star of Hope's front windows were broken to the rituals of local vandals, but his problems with the island commu-

nity—and indeed the larger community of Maine—were likely much deeper than teenage pranks, and certainly more burdensome and consequential.

Indiana was arrested and charged with three counts for solicitation of prostitution in 1990, accused of paying minors for oral sex. The salacious charges included allegations that Indiana had sought sex from an islander when the boy was twelve years old, and that their relationship continued six years. A second male accuser changed his story when it went to trial, in 1992, denying at the last minute he was paid for sex with Indiana. A third male accuser refused to cooperate and police dropped the counts involving him.

After a tense few hours and an overnight deliberation, a jury acquitted Indiana, finding him not guilty. "We were lucky," Indiana told his attorney when the verdict was read. But luck comes in many shapes and forms. An acquittal signifies that a prosecutor failed to prove his case beyond a reasonable doubt, not that a defendant is innocent. So Indiana was acquitted in the mainland courtroom but treated as guilty and seen as a child molester and pedophile by many back home on the island. Those allegations resurfaced three years after his death, when a longtime employee named Wayne Flaherty, as part of a plea deal with federal authorities over charges of social security benefits fraud, accused Indiana of molesting him when he was a teen in the 1980s. Beginning soon after the acquittal, and continuing until Flaherty's firing shortly before the artist's death, Indiana paid Flaherty what amounted to hundreds of thousands of dollars, often in cash. Flaherty, who was fifty-three when he was sentenced, described it as "hush money" in his court pleadings. He blamed Indiana for a lifetime of addiction and depression.

Prosecutors working with the Social Security Administration wrote in court documents that they had no reason to disbelieve Flaherty's accusations of abuse and believed he had credible evidence against Indiana, but didn't disclose the substance of that evidence. In support of Flaherty's accusation that Indiana provided him with drugs and money in return for sexual favors for many years, his attorney asserted: "This is born [sic] out by Defense Exhibit 2." In a follow-up interview, Special Assistant U.S. Attorney Jeanne D. Semivan said prosecutors had "no reason to be skeptical" of Flaherty's allegations, but said she couldn't provide details.

As resentment toward Indiana grew in the early 1990s, he worried someone would torch the Star of Hope. When he lay in bed at night, alone in a twelve-room lodge, he slept with one eye and one ear open, watching for an angry mob that might escalate from throwing rocks through his windows to hurling Molotov cocktails, and listening to the creaking and moaning of the rotting wooden building as it shook against the relentless Atlantic wind.

His relationship with the island and the state had become rife with conflict. Indiana accepted the broken windows because he thought he understood the motive of initiation behind them, though he eventually boarded up those windows to save from having to keep repairing the broken glass, and later painted them as American flags. But other incidents left him feeling distrustful and insecure. He felt shunned and underappreciated by the state as a whole—never giving him the welcome, acceptance, and embrace he craved—and that made him angry. He had tax troubles with the IRS in the 1980s, soon after arriving in Maine, but settled those quickly and seemed to be in a good place until 1990, when the sex charges surfaced. From 1991 to 1993, and then again from

1995 to 1997, he either didn't pay or underpaid his state income taxes, and the revenue office in Augusta, the state's capital, came after him hard, slapping a series of liens on his island home that totaled more than $300,000.

The liens, four in all, were preceded by a mountain of letters and numerous calls, all of which Indiana ignored. He was, he confided to friends years later, deeply depressed and desperate for much of the 1990s, and at times suicidal. Whatever demons in New York he tried to escape had followed him to the Star of Hope.

Salama-Caro and the Morgan Art Foundation offered a lifeline. In return for the full and exclusive rights to *LOVE* and the promise of producing new sculptures, Morgan Art assured Indiana an income to pay off his debts, as well as the opportunity to rebuild and support his career in perpetuity.

In spite of all his professional and personal turmoil, Indiana was reluctant. He turned aside Salama-Caro's advances time and again. Eventually, after persistent lobbying, Indiana agreed to form a partnership. It would be a decision he'd come to regret. No artist the stature of Indiana had ever given up full rights to a piece as popular and recognizable as *LOVE*; that he did it twice—first in the 1960s and then again thirty years later—spoke to his desperation and depression.

By 2002, all the liens against Indiana were released, and he became a very rich man, thanks in large part to his relationship with the Morgan Art Foundation. Salama-Caro delivered on his promise to secure key museum and gallery exhibitions. But over time, Indiana soured on the relationship. Perhaps with McKenzie sowing seeds of discontent, Indiana wondered if Salama-Caro had taken advantage of him at a time when he was most vulnerable, and he grew to resent his

agent. With McKenzie paying him $1 million a year to work on *HOPE,* Indiana became increasingly distrustful of Salama-Caro and Morgan Art, though he was still contractually obligated. McKenzie goaded him. As early as 2014, he told Indiana he should sue to reclaim his rights from Morgan Art and began looking for lawyers to help him do so, and he tried to convince Indiana that Morgan Art was an illegitimate off-shore company and that the artist's work was being used to enrich anonymous and shady investors. Soon, Indiana began openly deriding Morgan Art in conversation, convinced the organization was ripping him off—it paid him, but far less than what he was sure he was owed, and the group's accounting made no sense to him.

Perhaps responding to the emotions of McKenzie's urging, Indiana became increasingly angry at Salama-Caro and Morgan Art.

Many years later, Salama-Caro observed Indiana's push-pull behavior with those closest to him. "It's part of his psyche," he said in an interview; "it's part of his behavior in his life. It's sort of—if I can use the following words—almost trying to create a problem for himself. And that has been reflected in many situations."

McKenzie agrees. "You know what Bob's problem was? He tried to please everyone. He would say what you wanted to hear, then he would say something else behind your back."

Those back-stabbing tendencies were catching up with the artist in real time in the kitchen on that otherwise pleasant fall afternoon on beautiful, verdant Vinalhaven, on the occasion of his eightieth birthday. All the pieces in the chess game of Robert Indiana's life were assembled on the board: Salama-Caro, McKenzie, and the artist himself. Indiana was the king, but who would be a pawn and who would play the

knight was still uncertain. Through his failing, watery eyes, Indiana could see he had to move to avoid checkmate, but he feared he had nowhere to go. It scared him and kept him awake at night, alone in the Star of Hope.

IN THE YEARS after his eightieth birthday, Robert Indiana tried to do what he cared most about: make art and promote his work. *HOPE* gave him the late-career bounce McKenzie promised, and Morgan Art delivered too. Indiana had museum and gallery exhibitions across the country, and in 2013 he finally landed a long-desired solo exhibition at the Whitney Museum of American Art—though he complained it covered only one floor and not the whole museum.

But the characters he'd either allowed or invited into his orbit were beginning to chafe against one another. It would take a decade of carelessness, mixed messages, and shady business deals, but the friction between Indiana and the two art dealers would eventually ignite.

Convinced that McKenzie and an islander named Jamie Thomas had been manipulating Indiana in old age, in May 2018 Salama-Caro and his financial backers at Morgan Art lost patience and filed an extraordinary federal civil lawsuit in the Southern District of New York against their longtime client, charging copyright violations and breach of contract. It alleged that McKenzie and Thomas, with or without Indiana's knowledge, pushed an illicit scheme to create and sell

unauthorized Indiana artworks that infringed on Morgan Art's exclusive rights.

The lawsuit was a turf battle, and Indiana, who had lived mostly alone with no serious partner during his entire forty years on Vinalhaven, was the prize. His estate was worth between $25 million and $100 million, depending on which estimate you believed. The initial lawsuit spawned several related legal cases and employed dozens of lawyers for years, as in federal, state, and county courts in Maine and New York—as well as in the court of public opinion—the primary players in Indiana's life began settling the conflicts he himself refused to resolve.

After Morgan Art's initial lawsuit, in May 2018, it filed a second suit in the Southern District of New York, in September. This one, following Indiana's death, alleged elder abuse and mismanagement of the Indiana estate by its Maine attorney. The estate filed counterclaims, arguing that Morgan Art underpaid Indiana and accusing Simon Salama-Caro of being a double agent of sorts: Salama-Caro had described himself as both Indiana's exclusive agent and an adviser to Morgan Art as they made deals with the artist. In spring 2021, after three years of trading damaging personal and professional accusations, Morgan Art, the Indiana estate, and the Star of Hope Foundation—the entity Indiana created to manage his art legacy, archives, and home-turned-museum after his death—signed a settlement agreement resolving their differences and agreeing to work together. They all insisted the settlement would remain a secret.

That settlement did not involve McKenzie, who remained at legal odds with both Morgan Art and the estate, a pariah to both. As one person close to Indiana observed of McKenzie, "[P]eople would recoil from him."

Thomas and the estate—once allies—also fell into deep acrimony, and Thomas sued in Maine to indemnify his legal costs and other losses. The estate also claimed abuse by Thomas and further alleged he stole art and money from Indiana by taking advantage of his failing eyesight and health. The two parties ended up with a settlement under seal.

Meanwhile, Indiana's will—whose validity several people questioned but did not formally contest—remained in limbo in probate court while the lawyers battled it out and argued over fees and the ownership of artwork.

At the time of the signed settlement of the primary litigation—three years after the legal battles began and Indiana's death—the estate was on the hook for close to $10 million in legal fees, or anywhere from 10 to 40 percent of its total value—a distasteful irony for a man who generally disliked and distrusted lawyers but seemed to attract them the way the bright yellow forsythia of a Vinalhaven spring attracted the season's first buzzing bees.

So much for love and hope.

☆

THE STORY OF Robert Indiana's final days is more than a legal drama. It's also the story of what happened in the dark recesses of the Star of Hope among men who fought for control of Indiana's legacy and money. It's a tragedy of Shakespearean machinations involving a failing king, full of rage, who rarely emerged from his castle; the plotting, manipulative knights who fought over his crown and jewels; and the loyal and innocent pawns on either side of a widening moat filled with chaos and acrimony.

Tensions had been simmering since Indiana's eightieth birthday, when Salama-Caro felt blindsided by McKenzie

pushing *HOPE* into the world and exerting more influence on Indiana's creative life. Salama-Caro's concerns grew acute in 2013, when McKenzie purchased a house on Vinalhaven and began spending more time away from his office and studio in Katonah, New York, and more time with the artist in Maine. Salama-Caro and Morgan Art had invested millions of dollars in Indiana over several decades, helped him realize his dreams of creating a massive collection of sculptures, and landed him the Whitney retrospective, a late-career highlight. Salama-Caro intended to protect his investment.

Early in 2014, Salama-Caro's grown son, Marc, showed up at the Star of Hope to huddle with the artist about McKenzie's growing influence on Indiana's artwork. Like his father, Marc Salama-Caro is suave, quiet, and polite—and always impeccably dressed. He runs an art consulting business, MMC Art, that is associated with Morgan Art. The men met in the living room on the second floor with its built-in cabinets where the Odd Fellows stored their regalia. Indiana wore a heavy white sweater, appropriate for the season, black trousers, and loafers. He sat in a metal chair with a cup of his favorite freeze-dried coffee on a table beside him.

Marc told Indiana he had been to the Miami Art Fair in December 2013 and saw an eighteen-inch sculpture attributed to Indiana titled *CHAI*, the Hebrew word for life. Indiana said he had no knowledge of the work and told him McKenzie must have made it.

"And you say you've never seen one?" Marc asked, his English accent rising with the question.

"No, no," Indiana replied, in his quavering, faltering voice.

"And you never authorized that, no?"

"No. I don't like it," Indiana said, and clasped his bony hands. "How do we restrain Michael?" he asked. "Help me.

How does one restrain Michael? He's beyond me."

Then Indiana laughed quietly to himself and called McKenzie "mischievous" under his breath. But he also confessed to Marc that he was afraid of McKenzie, and described him as a "loose cannon" and "out of control."

Marc captured the exchange on video, without Indiana's knowledge. It was later circulated by Morgan Art to marshal sentiment against McKenzie as the legal case unfolded. Those who were close to Indiana and who have seen the video think Indiana might have been playing Marc Salama-Caro a bit, or simply telling him what he wanted to hear, as was in Indiana's character. It might have been another example of him playing both sides of the fence—claiming in conversation that he distrusted McKenzie while endorsing McKenzie's work, directly or otherwise. That had been the pattern since 2008.

Soon after that meeting, Indiana signed a document disavowing a rendering of *LOVE* that McKenzie had reproduced through his company, American Image Art, in various color combinations on aluminum panels and exhibited and sold in the United States, Great Britain, and Italy. Indiana signed the letter, and Marc left him with a copy for his records. Whether the work was fraudulent didn't matter. Its authenticity was beside the point. From the perspective of the legal team representing Morgan Art, the *LOVE* that McKenzie was peddling, and which Indiana had agreed to disavow, infringed on Morgan's exclusive lifetime rights to it, as conferred by Indiana in their 1999 agreements.

Morgan Art's counsel, Luke Nikas, a litigator with the New York office of Quinn Emanuel Urquhart & Sullivan, didn't have to prove it was a forgery, which is never easy to do. He just had to prove that McKenzie—and by extension

the artist himself—had infringed on Morgan Art's contract by exhibiting and selling it.

The game was afoot, with a quickening pace.

Two days after meeting with Indiana at the Star of Hope to sign the disavowal letter, Morgan Art said Marc Salama-Caro received an email from Indiana's email address that read, succinctly and emphatically:

FUCK YOU DO NOT COME BACK YOU ARE NOT WELCOME. YOU FUCKING PRICK.

He didn't reply, but five minutes later, another arrived:

DO you speak English. I told you to leave. Fuck someone else. You are a crook.

Marc was stunned.

Four days later came an email with the subject line: "New Way of Doing Things." This one read:

Message, going out to all concerned. Mr. Robert Indiana is not feeling up to snuff these days. [S]o from now on, if persons want to see Bob in person for ANY reason, one must have prior permission. In other words if you call or email that you are on your way to see Mr. Indiana, [i]t will be a wasted trip if you have not been told personally that it is fine to come. To [sic] many people have just come without prior permission. Thank you for respecting his privacy.

The message was signed: "Staff, Robert Indiana Estate."

If Robert Indiana had long been difficult to reach before, he was about to become even more elusive. But Morgan Art was prepared to fight. Salama-Caro believed that through his efforts, Morgan Art delivered everything it promised to Indiana, and even if the artist felt the organization was not paying him every cent he was owed, he had millions in the bank and his art—sculptures, paintings, and prints—was in prestigious public and private collections around the world.

The Salama-Caros and Morgan Art were certain Indiana did not send the inflammatory emails, or even the conciliatory one that begged off visitors. Indiana never wrote his own emails, instead turning over that task to, among others, one of his longtime studio hands, Webster Robinson, a Navy veteran who swears like a sailor in conversation but says he tried to respect Indiana's dignity when representing him in writing. As far as the Salama-Caros were concerned, these emails were the hallmark of Jamie Thomas, the relative newcomer to Indiana's inner working circle.

"Marc knew Bob wasn't behind that email," says Nikas, who began representing Morgan Art in 2017. "They had a good relationship. Marc cared about Indiana. He looked up to him. When he saw that email, he believed right away that Jamie Thomas was behind it 100 percent."

The Salama-Caros and Morgan Art concluded that Thomas had sent the recent missives based on both their tone and their timing. The tone was rude and dismissive and in contrast to the tenor of Indiana's meeting with Marc Salama-Caro just two days before the "FUCK YOU" email. There was tension in that meeting, but it was respectful and cordial. And they assumed the timing had everything to do with the letter Indiana had signed disavowing McKenzie's unauthorized *LOVE*, a copy of which Marc left with Indiana and, they presumed, Thomas had seen and conveyed to McKenzie. Salama-Caro and Morgan Art believed McKenzie and Thomas to be fearful that their evolving scheme regarding Indiana's art would be discovered, and they needed to limit Indiana's contact with the outside world.

Despite the emails, Marc wouldn't play along. He called Thomas's bluff, and continued to visit with the artist throughout 2014 and into 2015, with good and bad results. Their re-

lationship took a calamitous turn when Morgan Art threw a wrench into plans for a Maine-issued license plate honoring Indiana with an image of *LOVE*. The project had begun in 2013, and plates were being sold in advance of their manufacture, when Morgan Art informed the Maine Crafts Association, which had organized the effort, it expected $25,000 and a percentage of each plate sold in exchange for the use of the image.

Morgan Art's demand for compensation doomed the project, according to Kathleen Rogers, Indiana's former publicist. During an emergency meeting at McKenzie's house on the island in spring 2014 to discuss what to do next—a meeting attended by Indiana, McKenzie, Thomas, and Rogers, who was working pro bono—McKenzie suggested they go around Morgan Art and use *HOPE* instead. Rogers dismissed the idea. "It's too late for that," she said. "That's not going to happen."

Unannounced and unexpected, into the boiling cauldron walked Marc Salama-Caro. He'd been told of the meeting at McKenzie's, and showed up uninvited. Rogers describes what happened next.

"Bob was so furious about Morgan's interference with the project—he so badly wanted it and would have been so tickled to see people driving around Maine with his license plate—that he started thundering at Marc as soon as he walked in. '*LOVE* is mine, how dare you! Stay out of it and let Kathleen do her job!' Marc just stood there and took it. He didn't say a word. Jamie and Michael enjoyed it all very much, but I just wanted to get out of there."

The license-plate project died, and the lines were clearly drawn: McKenzie and Thomas on one side, the Salama-Caros and Morgan Art on the other, with Indiana forever in the middle.

Marc Salama-Caro eventually mended things with the artist and in July 2015 Indiana gifted him with one of his valuable *Decade: Autoportrait* paintings, a million-dollar work. But the damage was done, and the heat from Indiana's fractured relationship with the Salama-Caros went from years-long simmering frustration into boiled-over anger. Perhaps emboldened by Indiana's outburst at Marc Salama-Caro over the license-plate fiasco, McKenzie and Thomas began exploring their options.

In April 2014, McKenzie sought legal counsel for Indiana to challenge Morgan Art's authority over his artwork. "I have been working with Robert Indiana for several years, and many of us around him have become increasingly concerned about his estate, art and copyright, particularly as they pertain to Simon Salama-Caro, who has aggressively presented himself as the owner of the previously mentioned," he wrote to a Portland attorney. "Can I possibly meet with you for a consultation regarding this matter? I have a house in Vinalhaven so am back and forth through Portland. Certainly, Bob needs representation."

At the time, Indiana already had representation from Ronald D. Spencer, a leading art-world attorney from New York, who also happened to represent Morgan Art—a complicated twist that would soon grow more complex. Within a few years, Spencer would represent neither Indiana nor Morgan Art, fired under unusual circumstances by Indiana in 2016 and replaced at Morgan Art by Nikas, another art-world legal specialist, when it became apparent that Morgan Art would have to sue Indiana. When Nikas began representing Morgan Art, in 2017, he was representing the infamous New York gallerist Ann Freedman, who was mired in multiple lawsuits and accused of selling $80 million in fraudulent art.

Three years earlier, on May 13, 2014, McKenzie emailed Indiana: "There are innumerable people who now feel you MUST have the rights, and this includes friends, attorneys, other publishers, journalists and a wide circle of art people," he wrote, pressuring Indiana to disassociate from Morgan Art and to pursue legal claims. "For whatever differences there are in your immediate circle, I believe Jamie, Web, Wayne, Val, Pat Nick, Kathleen and myself all agree that you MUST have the rights to the work that is purely a creation of your own imagination and genius and that we would all help to make that happen."

Five days later, McKenzie emailed Thomas: "We need to see all Bob's contracts. Then we know where the violations are. But he has to act on it. No one knows if Simon is ripping him off except him. . . . [W]ithout Bob at least allowing a lawyer to act on his behalf, I don't believe there is anything you can do."

That winter, they had their lawyer.

"Brannan is working for Bob," McKenzie emailed Rogers, naming mainland attorney James W. Brannan, who had wandered in and out of Indiana's life until then and would become the key player in years to come. Rogers, who was not part of the Star of Hope boys club, believes McKenzie sent the email to her in error.

She had never heard of Brannan.

"Working on what?" she asked.

McKenzie never replied.

☆

IN OCTOBER 2015, Indiana's personal assistant, an island resident named Valerie Morton, died. Morton, the local librarian, had looked after Indiana's personal affairs and finances for

years. She was an unofficial gatekeeper and trusted adviser who served as coexecutor of Indiana's estate.

Morton was a strong female presence in an environment of mostly men. She was loyal and protective, and a fair referee. But most important, she was someone Indiana relied on to always hold his best interests at the top of her mind. She respected and cared for Indiana as a human being. He'd become "Bob" to so many; she called him Robert.

Quiet, unassuming, and apolitical in the studio, she was organized and efficient, characteristics she carried over from her work as a librarian. She kept the peace and she kept order. She was no-nonsense. Morton lived and dressed simply, and had little awareness of or interest in the roles that outsiders like Salama-Caro and others played in Robert's career and life. She wasn't easily impressed, and she looked at Simon Salama-Caro with suspicion—then again, she was suspicious of almost everyone who called on Indiana from London, New York, or even Portland, Maine's largest city. Morton didn't suffer fools.

Indiana benefited from her instincts. He was fond of her, and she seemed genuinely fond of him.

Her death signaled the start of a difficult new chapter in Indiana's life. Without Morton to protect him, he became more vulnerable than ever. "After Valerie died, Jamie pretty much took right over," says the former-Navy-man-turned assistant Webster Robinson, who was in the Star of Hope during much of Morton's tenure, though he would be elbowed aside after her passing. First, Thomas switched Indiana's phone calls so they rang to his cellphone or at his house. Then he took over Indiana's email account, which Robinson had informally managed for many years. "I answered all of Bob's emails until Jamie changed the password on me," he says.

In May 2016—just a few months after Valerie Morton's death and only a few years after hiring Thomas to help out around the Star of Hope—Indiana appointed Thomas as his legal power of attorney and healthcare power of attorney, a move that surprised some people close to the artist. To this day, Robinson is convinced beyond a doubt—based on what Indiana told him—that his boss didn't understand the paperwork he had signed.

On Vinalhaven, Indiana's hiring of Thomas was treated as good news. Indiana's reputation had run hot and cold since he was charged with solicitation of minors, and it seemed to be getting cooler with time. For residents, the spectacle and curiosity associated with sharing a small island with one of the world's most famous artists wore off quickly, as did the patience of many who never understood the homage paid to Indiana by art-world elites, who showed up each summer and beat a path to the towering old lodge and showered Indiana with the attention he craved.

Word on the island was that some of Indiana's assistants had taken advantage of him financially and otherwise, neglecting the Star of Hope while drawing huge salaries for doing little more than humoring him by listening to his repeated stories, putting up with his rants, and feeding him buckets of Kentucky Fried Chicken—and high hearts so he could shoot the moon in card games of Hearts. Many locals viewed him as a pervert and tax cheat, or worse. He was accused of harboring what one local cop described as "criminals and druggies," and all the work he had done in his early years to beautify the Star of Hope was falling away with neglect as he aged.

Indiana himself appeared to be falling apart, with years of bad habits—fast food from the mainland, doughnuts from

down the street, and too much time in the dark—beginning to catch up with him. His physical decline became apparent to friends in 2013, when he began looking gaunt, weak, and, at times, disoriented.

Thomas, dark haired, square jawed, and paunchy, was a respected member of the community. He made his living as a jack-of-all trades, as many self-reliant islanders do, including fishing and caretaking. He was also an actor, a musician, and an artist.

Among the tasks that Thomas claimed credit for in the few public statements he has made was untangling $4.6 million in recent Indiana tax troubles, including unpaid back taxes and issues with payroll taxes. Thomas also tried to feed him healthy food, even if Indiana rejected it and let it sit in the refrigerator to mold. And he arranged for flowers to be sent regularly from the mainland, to please Indiana's finer tastes. Instead of taking advantage of Indiana, Thomas was seen as someone who would try to prevent exactly that from happening any longer.

Thomas was a well-liked native of the close-knit island community, but those on the outside—Indiana's friends in the art world—point to the spring of 2016 when Thomas assumed authority in Indiana's life as the moment the notoriously difficult-to-reach artist disappeared for good. Indiana stopped replying to his messages altogether, whether they were by letter, email, or phone.

No matter what combination of door knocks people tried, Robert Indiana stopped answering.

☆

ON JUNE 17, 2016, Marc Salama-Caro did receive an email from Indiana's account: "We seem to be having a problem

with communication. BOB IS NOT UP FOR ANY VISITS. I will let you know when he wants visitors. Please respect this."

This email Thomas signed himself, and in his signature indicated that he was now acting as Robert Indiana's power of attorney.

From then on, Indiana was off limits to almost everybody. In July, Thomas turned away John Wilmerding, a preeminent American art scholar and historian from Princeton University who spent summers in Maine and was Indiana's personal friend. "Bob is not up for many visits right now," Thomas told him. That was a first. Indiana always met with Wilmerding, and gladly. Wilmerding forwarded Thomas's note to Marc, writing, "Big surprise. I wonder whether he even showed Bob my message."

Indiana's longtime attorney, Ron Spencer, was also turned aside. Before Morton's passing, whenever Spencer called, Indiana either picked up or called back. "But after Valerie died, if I called Bob it would click into Jamie Thomas's cell phone and Jamie would get on the phone and say, 'Bob is not up for the call,'" Spencer says. "If you sent him an email, you would not get a response. If you sent him a letter, same thing—no response."

That fall, Salama-Caro implored the artist to meet with the deputy director of the Albright-Knox Art Gallery, in Buffalo, which was preparing a major Indiana exhibition for the summer of 2018. Thomas was unmoved. "Bob is not up for any visits," he wrote Salama-Caro. "If he changes his mind you will be informed."

McKenzie, meanwhile, was sending newly made Indiana prints and paintings out on exhibition and telling any reporter who asked for an interview that Indiana was either "under the weather" or "just not feeling well right now," but otherwise in fine health for an old man.

By then, Attorney Brannan had become fully entrenched in Indiana's life. In May 2016, at the same the time that Thomas became Indiana's power of attorney and exactly one year after McKenzie announced that Brannan had joined Indiana's legal team, the lawyer was named Indiana's personal representative in a new will he himself wrote. Soon after, he was plotting how to handle the news of Indiana's death and how the estate could wrest the rights to *LOVE* from Morgan Art.

Brannan, who accused others of being double agents, appeared to be working both sides of the fence himself. While Brannan was helping plot Indiana's separation from Morgan Art, the Salama-Caros had reason to believe Brannan was on their side—because he told them as much. In a June 2017 meeting with Simon and Marc Salama-Caro, Brannan "only had positive things to say" about the Salama-Caros and "fully recognized" that Simon Salama-Caro had helped Bob "tremendously," according to notes of the meeting taken by Marc Salama-Caro and submitted in court documents. Brannan also asked why Indiana had received "practically no payments" in more than a year, but expressed a desire to work together to build Indiana's legacy. His attitude had changed by year's end.

In December, Brannan, Thomas, and Thomas's attorney, John Frumer, convened a meeting of the board of the Star of Hope Foundation, which was tasked with forwarding Indiana's legacy. The artist was not present. Thomas's wife, Yvonne, took notes, according to minutes of the meeting.

During the meeting, the group discussed a likely lawsuit with Morgan Art and their plan to acquire and sell the rights to *LOVE*. "[I]f there is litigation . . . we may want to be the defendant because we will be selling the *LOVE* rights,"

read the minutes. And, "John [Frumer] has the Morgan letter ready to go and has given a copy to Jim."

In addition to planning for a lawsuit, they were discussing how to handle Indiana's death and will, noting the 120-hour waiting period following a death required by Maine law to file a will with the probate court. According to the minutes:

"When Bob dies, Jim will file the will within 120 hours. On hour 121, Jim becomes the appointed executor, and he is interested in continuing to work with both Jamie and John."

Also: "Jim has an obit prepared to share with the media. Jim is the spokesperson and any inquiries from the media should be directed to him. 'No comment—talk to Jim.'"

And this: "Jim has made arrangements with Walker Hutchins [funeral director]—they will use a van not a hearse, and will send a different person to keep a low profile."

There was one other note of interest: It said that island nurse Jennifer Desmond had seen Indiana two weeks before and reported him in decline. According to the meeting minutes, "His check-writing capacity is failing due to his poor eyesight."

Thomas arranged for Frumer to send a cease-and-desist letter to Morgan Art in February 2018. The letter accused Morgan of breaching its agreements with Indiana and demanded that Morgan stop "stating, acting, representing or otherwise facilitating or permitting the appearance that [it had] authority to speak for, authenticate work of, collect money for, authorize sales and/or exhibits for, authorize use and/or fabrication of Mr. Indiana's works or likeness thereof."

Other letters went to galleries that sold Indiana's artwork, warning them about doing business with Morgan Art.

Provoked, Morgan Art responded forcefully. Ten weeks after it received a cease-and-desist letter from Frumer, Thom-

as's attorney, it filed its lawsuit—which had been in the works for a year—against not only McKenzie and Thomas but also Indiana himself. From then on, what were once skirmishes and minor battles would become an all-out war, and Robert Indiana was the first casualty.

ROBERT INDIANA'S DEATH became public on Monday, May 21, 2018. He was reported to have died, peacefully, on the afternoon of Saturday, May 19. He had been ill for some time and took a serious turn in the days before he died, according to his personal representative, James Brannan.

"He died on Saturday afternoon, around 5:45, at the Star of Hope," Brannan told the *Portland Press Herald* when he shared the news late in the day on Monday. "He had been in a period of declining heath. He died of respiratory failure with his caregivers by his side."

But former studio assistant Webster Robinson is certain the artist died on Friday, not Saturday. He received an email from Melissa Hamilton, another former studio assistant, who was then living in Connecticut, on Monday afternoon. It read, "Cheryl called me today [Monday]. Bob passed on Friday, May 18. They flew his body to the mainland. I'm so incredibly upset. Melissa."

The "Cheryl" referred to in the email, Vinalhaven resident and Indiana friend Cheryl Warren, later denied any knowledge of Indiana dying on Friday instead of Saturday, and says, "I have not heard that, and I don't think there was any foul play or anything like that." She declined to answer

more questions and hung up the phone. Melissa Hamilton, a witness in the New York lawsuit initiated by Morgan Art, did not respond to multiple interview requests to clarify her email or other aspects of her time working with Indiana.

Michael McKenzie is also certain Indiana died on Friday and not Saturday. "Sure, he died on Friday. No question. I'm 99.9 percent sure he died on Friday," he says.

McKenzie is vague about his source of information, but at 3:21 p.m. Monday, May 21, he texted Thomas, "I was just told Bob died on Friday." He later said he couldn't recall who told him Indiana died on Friday, but he hasn't waffled about his understanding of when Indiana died, or why he believes Thomas waited twenty-four hours to report the death.

"If Bob died at four o'clock on a Friday and you called the coroner's, where is the coroner going to be? Sure as hell not on Vinalhaven. So, what's the difference if you wait twenty-four hours?"

Among many things, the difference is, of course, the suggestion of a cover-up.

When Knox County Deputy Sheriff Rob Potter learned that Penobscot Island Air, the local air service, had been called to the island and that Indiana's body was "quickly whisked off" without his knowledge, he was, as he put it, "pissed."

"If you have a death, law enforcement has to be called, especially when it's Bob," Potter says. "With this guy, nobody called, except whoever loaded him in the back of Rescue and took him to the airport."

Just as Brannan and Thomas had planned, the death was low profile and quiet. Nobody noticed a thing—except, perhaps, Cheryl Warren.

Potter, who has been friends with Brannan since their high school days, says he learned of Indiana's death only after the

body had been removed from the Star of Hope. It was driven four miles to the island's airstrip. From there, a plane transported it on the short flight to the mainland, and it was then taken to a funeral home in Rockland, the small city where the ferry that serves Vinalhaven departs and arrives.

"There are just too many questions," says Potter. "I would have wanted to walk into the scene, look at the home and take pictures, and just be able to look around. With any death, you want to be able to see what medications he was taking, if he was being treated by a doctor, and I would have called the medical examiner's office. The medical examiner has to know that Bob died."

But nobody outside of Indiana's final inner circle knew—his caregivers, his recently appointed power of attorney Thomas, and his recently appointed executor Brannan—and they were uniform in their story: Indiana died on Saturday, May 19, after a slow and steady decline that accelerated in the final forty-eight hours or so of his life.

☆

JENNIFER DESMOND, CLINICAL director and family nurse practitioner at Vinalhaven's Island Community Medical Services, administered Indiana's end-of-life care and was with him when he died. She says it's common island practice to forgo calling police with an attended death. She signed the death certificate and stands by her decision not to notify the deputy sheriff. "If I have a patient who dies and I sign the death certificate, the police don't need to be notified, especially if it's an attended death, as Bob's was," she says.

The current director of the ambulance service on Vinalhaven, who was not in the director's position at the time of Indiana's death, said Desmond was correct. If the attending

physician is familiar with the patient and has no concerns about the circumstances of the death, he or she can sign the death certificate, and police don't need to be notified.

Desmond also says she honored Indiana's wishes with his end-of-life care, respecting his Christian Scientist beliefs, relieving his symptoms, and respecting how he wanted to die. She administered drugs consistent with hospice care and his desires, but only at the very end and only to relieve specific symptoms, she says.

She understood that he "did not love Western medicine," and unlike most patients on the island, whom she might see four or five times a year, she would see Indiana far less frequently—and only when he wanted to see someone and almost always at his home. His dislike of doctors was as acute as his distrust of lawyers. In 2011, Indiana suffered a kidney infection severe enough that studio assistants Sean Hillgrove and Webster Robinson feared he would die if they did not seek help. But they made another employee call the ambulance because they knew Indiana would be angry and they didn't want him angry at them.

He was angry, all right, but as his temperature spiked and blood showed up in his urine, Indiana acknowledged the seriousness of his illness and agreed to go to the hospital. He was taken by ambulance via the ferry to a mainland hospital, where he recovered for a few days before talking his way into a discharge. Some say he left on his own, without the blessing or knowledge of his doctor.

"Anecdotally, he escaped on his own volition after a few days," says Kathleen Rogers, his former publicist. "As the story goes, he hid out at the Farnsworth until he could catch a ferry back to the island." He recovered at home, where Hillgrove, Robinson, and the others provided round-the-clock

care for a few weeks, until he convinced everybody he was fine. They hid his medicines in his food and drink in order to trick him into taking them.

In addition to eschewing Western medicine and medical intervention because of his Christian Science faith, Indiana was superstitious, which may have intensified his unwillingness to interact with medical practitioners.

Desmond says she and Thomas assembled a care team about eight months before Indiana died, and the care became around the clock for "probably the last two months." He did not want his death to be a fuss, and he approved the plan that called for the quiet removal of his body, the flight to the mainland, and a quick cremation. The last step of that plan fell apart when the FBI got involved, at the urging of Morgan Art attorney Luke Nikas. Instead of a cremation, they ordered an autopsy.

Desmond was furious.

"I was surprised and saddened to hear afterward that the police were involved and the decision [was made] for an autopsy, because I certainly did not expect that," she says. "Maybe I should have, but I certainly didn't order it. When I signed the death certificate, I thought that was that."

In the days and weeks afterward, Desmond, a registered nurse and certified nurse practitioner who is trained in hospice care, faced many sit-down interviews with local and state police, as well as one with Special Agent Thomas P. MacDonald out of FBI's Boston office; he questioned Desmond for two hours.

When a toxicology exam reported the presence of morphine and isopropanol, there were more questions. The morphine was consistent with palliative-care measures, and the isopropanol, a common household chemical associated with

rubbing alcohol, was "most likely" related to Indiana's care at the funeral home. Also in Indiana's system were lorazepam, a sedative used to treat seizure disorders such as epilepsy and sometimes prescribed to relieve anxiety, as well as atropine, a prescription medicine used to treat the symptoms of low heart rate and wet respirations when the lungs begin filling with fluids. All of those drugs are consistent and common in hospice care, and Desmond acknowledges using all of them with Indiana. She drew the cocktail of drugs from a common "comfort kit" for caregivers, a pre-bundled package of medications used to relieve distressing symptoms. "Any hospice patient has drugs in their system," she says. "It wasn't any sort of secret."

The autopsy was inconclusive about what part, if any, those chemicals, particularly isopropanol, played in Indiana's death. "The extent to which the toxicology findings contributed to his death is not possible to determine," wrote Deputy Chief Medical Examiner Dr. Lisa Funte.

In a follow-up interview, a spokesperson for Maine's Office of the Chief Medical Examiner said it was unclear if isopropanol contributed to Indiana's death, but that the presence of *any* amount was cause for concern because it should not be in anyone's system. The Indiana autopsy was complicated by the fact that noninvasive preparation of his body for burial or cremation had already been begun. "In most instances," the chief medical examiner's spokesperson wrote, bodies being autopsied "come to our office prior to being prepared by the funeral home. So what a typical amount of isopropanol is present in a case prepared by a funeral home has not been characterized."

In addition, when it came to how the autopsy results may have differed based on whether or not Indiana died on Saturday or Friday, the spokesperson said it was impossible to say how different, if at all, results would have

been had Indiana's body had been examined sooner than Tuesday, May 22, either seventy-two or ninety-six hours after his reported death.

"The metabolism and distribution of substances are individualistic, especially with drugs, since you have no way of determining when the drug was consumed, or the amount of the drug consumed," the spokesperson wrote. "Obviously, you have continued absorption and metabolism in a living individual, with a time course of blood levels related to the pharmacokinetics of the drug. In individuals who are deceased, metabolism stops, and a component of postmortem redistribution occurs. The extent to which that occurs is time-dependent, but is unique to each individual. Of course, the longer the time interval from death, the more postmortem redistribution will affect the drug levels."

For those who wonder if Indiana's death may have been hastened, this cloudy area of the toxicology report fuels their suspicion: the longer the delay in reporting a death, the more time for drugs in the system to be absorbed. Had the tests been conducted sooner—had Potter or another authority been notified and the medical examiner called right away—the answers might be clearer.

The autopsy report resulted in a finding of "undetermined" for both the cause and manner of death and the medical examiner's office said it would reopen the case with new information. But there was little doubt of a key factor in his death: one way or another, Indiana died with a badly broken heart. "It was known that Mr. Clark has significant cardiac disease and was in end-of-life care," the autopsy reads, using Indiana's birth and legal name. "Evidence of severe coronary artery disease was identified at autopsy, and the complications of which are the most likely cause of his death."

The coroner's report contained other pieces of revealing information about the end. Indiana was extremely frail: at five foot, seven inches tall, he weighed just 107 pounds. Although he had become rail thin in his final years, 107 pounds at death represented a substantial weight loss from when he was last seen regularly, in 2015. For his final journey he'd been dressed in a pair of blue fleece pajama bottoms and a blue plaid button-up dress shirt with a navy blue cardigan over it. His hair was trim, cut to a length of three inches, and his fingernails were, the report notes "well-groomed."

Two forensic pathologists who independently examined the autopsy report agreed there was almost certainly no foul play involved in Indiana's death, but both said the report suggests his death appeared suspicious or unusual enough to raise questions. For example, the autopsy included a heavy-metals screening, which turned up levels of cadmium that might be explained by Indiana's exposure to paint and his love of Garcia y Vega cigars. A pathologist who reviewed the autopsy report says a metals screening confirms that Indiana's death was treated as suspicious, because such screenings are rarely done anymore. Dr. Gregory J. Davis, a forensics specialist at the University of Kentucky and consultant for the Office of the Chief Medical Examiner in that state, says he agrees with the medical examiner's conclusion that Indiana probably died of cardiac disease and doubts that Indiana was poisoned, but the metal report indicates that someone thought he might have been, unlikely though that would be.

"The era of poisoning someone to get rid of them went out with the turn of the last century," says Davis. "We're not that subtle anymore. We tend to bludgeon, hack, and shoot." But the presence of the metals screening indicates that somebody "was suspicious about something," he says, adding that

an "undetermined" finding "is a festering wound, essentially. The reason we do autopsies is to give answers. The intimation here is, either she [the medical examiner] had information that folks were concerned that this was a suspicious death or she was concerned about the toxicology results."

According to a spokesperson for the Maine Medical Examiner's Office, the examiner ordered the screening to make sure she had all the information necessary to make an informed decision. "While a heavy-metals screening is not common, when there is a high-profile death it may be ordered to cover all bases."

Desmond says she turned over her medical records to Thomas's lawyer, John Frumer. In addition to Indiana's medical records, she turned over all her written correspondence with Maine's Department of Health and Human Services (DHHS) regarding its inquiry into complaints by a former employee who believed Indiana suffered from elder abuse. Citing privacy issues, Desmond declined to share Indiana's medical records for this book.

Ultimately, no charges were filed in Indiana's death, despite inquiries from state and local police as well as the FBI, and the Maine DHHS never issued public findings about its investigation into the accusations of elder abuse.

Desmond was insulted and angry when stories in the media implied that Indiana was mistreated. Those stories were false, she says, and the lawsuits they were based on—filed by Brannan against Thomas and by Morgan Art against the estate, and both resolved with a confidential settlement—created sensational impressions of Indiana's circumstances. Indiana did not die in squalor, Desmond insists. His bedroom was spartan, set up in an awkward space on the second floor between the kitchen and pantry and close to the bathroom.

One of the unusual characteristics of the Star of Hope was its lack of a bedroom. It was, after all, designed as an assembly hall and place for ceremony. Indiana set up a grand bedroom on the third floor, which he offered to guests.

He slept in a bed that was barely more than a cot in a small space with a window that overlooked a pond behind his house, from which he liked to watch his pet geese. He had a bookshelf and a couple of dressers for clothing. In addition to being close to both the bathroom and the kitchen, it gave him access to his work if he felt so moved in the middle of the night.

When he died, he was surrounded by his art, by *LOVE* maquettes, small paintings, and various catalogues, all within reach. Yes, the Star of Hope had issues, Desmond admits—the pigeons were a problem, for example—but otherwise "the house was fine, like any other old house on the island. There was nothing at all that I would have considered unsafe or unclean or worth calling adult-protective services for."

Other people with firsthand information of the conditions at the time of Indiana's death vigorously challenge Desmond's assessment of the physical space. He was a multimillionaire, but Indiana's mattress was thin and lumpy and "it was just a physically nasty environment," says someone who saw the space soon after Indiana died. "It was all very shocking and just really sad to see. It was dry where he was, but it was dirty. I was struck by the sadness of the space." There were animal feces on the floor in Indiana's living area.

Regardless of the conditions inside the house, Indiana wouldn't leave. A nursing home or mainland hospital care was out of the question. "From the moment I first met Bob," says Desmond, "the one thing he said to me consistently was 'I want to die at home. I want to stay here. I don't want to

be in a hospital, and I certainly don't want to be in a nursing home.' It was important for Jamie [Thomas] to make that happen, and in order to make that happen, he needed to find people to give this care. He had to pull together a team."

The only hindrance to assembling a team was Indiana. He didn't want people around. "Bob was very private, and like many people he did not love the idea of people being there twenty-four/seven. In the beginning, it was just mealtimes. As his needs progressed, it began to be twenty-four/seven," Desmond says.

The day Indiana died, Desmond says she traveled with her daughter to the mainland for an afternoon dance recital, and they went by plane instead of boat because "[I] knew it was getting close" and she wanted to be with Indiana when he died. When she got back to the island, she went to her apartment to shower and change, and returned to Indiana's side. Desmond says he died moments after she arrived.

If nothing else, Desmond's timing was opportune. By being at his side when Indiana died, she had the authority to sign the death certificate as an attending physician, negating the need for the deputy sheriff to be called, and ensuring Brannan's hope for a quiet removal of the body.

As a solitary old man who'd made a lifetime habit of pushing people away yet had become dependent on a community that was often indifferent to him, Indiana died surrounded by employees rather than loved ones.

☆

ON THE MORNING of Sunday, May 20, Morgan Art legal counsel Luke Nikas received an email from *New York Times* reporter Graham Bowley, who was seeking information about Indiana. Bowley was reporting a story for Monday's newspaper

about Indiana vanishing from public view, based on the shocking lawsuit Morgan Art had filed two days earlier.

As far as Nikas knew, Indiana was still alive.

On Monday, after the *Times* story about the lawsuit appeared in print, Spencer informed Bowley he had just learned from an island source that Indiana had died, and Bowley scrambled to confirm the news so he could update the story. He eventually reached Jim Brannan, who, apparently surprised by the question, responded, "How did you find out?"

The news of Indiana's death shocked Nikas because of the timing. When he filed the suit on Friday, he knew Indiana was frail, "but we had no expectation that he was going to die that weekend," he says. "Our filing had absolutely nothing to do with our understanding of his condition, or whether he was alive or dead, on his death bed or nearing it."

Nikas says Morgan Art sued Indiana "to protect him," because those who were supposed to protect him weren't doing their job. He immediately wondered if Indiana had been murdered. "The fact that he was reported to have died the day after we sued him was highly, highly coincidental, or foul play," he says, "and I tend not to believe in coincidences."

Nikas felt the need to act with urgency. He contacted the FBI and requested an autopsy and investigation into Indiana's death. According to Nikas's sources on the island, art at the Star of Hope was already going out the door.

"You need to investigate what is happening," Nikas told his contact at the FBI. "This is highly suspicious, and we want an autopsy, and we want to preserve the art in the house."

Desmond understands why people who are not from Vinalhaven might be suspicious, especially Indiana's art-world friends who remember him as engaged and full of vim and vigor. But he hadn't been like that in years, she

says, and his desire to be left alone because of his failings was real.

His physical decline started to become apparent by 2013, when he looked tired and frail at the Whitney opening. An island visitor in 2013, who had never met Indiana before, said she was shocked at his appearance and described him as "definitely failing." Two years later, another visitor found him to be "typically old man-ish. He needed to change his clothes, and he probably hadn't showered in some time. He hadn't been out in the sun much."

Three years later, at the end of his life, Indiana was almost blind and had to give up reading books and newspapers, which depressed him. Thin and frail, it was difficult for him to navigate the Star of Hope. Famously cantankerous and combative, he'd become simply old-man grumpy. He complained a lot, and shouted orders to all in his employment. In 2017, he reluctantly acceded to Thomas's suggestion that a chairlift be installed to help him up and down the massive central staircase, though he had few occasions to use it because he barely left the house anymore, and he didn't want people to know about the lift. It embarrassed him; Robert Indiana was nothing if not vain. But it's impossible to know if those around him refused all visitors to Star of Hope to hide the reality of Indiana's declining health or simply because the artist didn't want people to see him so frail and pitiful.

"I think he was always a little bit of a hermit-type person, and toward the end of his life he became more so like that," Desmond says. "I'm very comfortable saying that was his choice. There were many times I was with him and someone would be knocking on the door, and he always said—always—'I don't want to see anybody. I have no interest in seeing anybody.'"

Whatever might have happened to Indiana at the time of his death, Nikas thinks too much time has passed to do much about it. "There is no way to indict someone for murder two years later without more evidence," he says. "The more times passes, the less evidence becomes compelling, or becomes stale."

That's why Deputy Sheriff Potter says he was angry he wasn't called to the Star of Hope when Robert Indiana died. Once the body was removed, he had no chance to mount a meaningful investigation. Before long, Potter was fired from the police force for "misconduct"; he now works as a caretaker on the island.

DURING HIS CAREER, Robert Indiana had three primary homes and studios, two in New York and one in Maine. Each was an emphatic and precisely tailored expression of his place in the world, and the one place where he was in total control. Warhol had his factory. Indiana preferred castles.

His first studio-loft was at 25 Coenties Slip in Lower Manhattan. He settled there in 1957 after arriving in New York three years earlier and moving at least three times. Once he found Coenties Slip—an industrial dockland area that attracted young artists, among them Ellsworth Kelly, looking for cheap space, located in the heart of what is today the city's Financial District—he stayed eight years, until 1965, when the neighborhood was razed and redeveloped. From there, he moved into a former luggage factory with thirty thousand square feet across five floors at Spring Street and the Bowery. He could afford the larger space because he was making a little more money. The Museum of Modern Art purchased its first Indiana painting, *The American Dream #1*, in 1961 after Museum Director Alfred Barr saw it in a gallery and fell in love. He described the painting as "spellbinding." It's a painting of four circles, each with its own central

star, with words and numbers enclosed within the stars and around the circles.

The Indiana biographer Susan Ryan called *The American Dream #1* Indiana's "most important work" of the period because of what it signaled in his development as an artist and the attention it brought him. With this painting, he found his signature style, concerned equally about form and content—paintings with colors, shapes, symbols, and language. And with this painting and others that followed, he became the "sign painter" that he saw himself as for the rest of his career, with each sign leading the viewer down another biographical path of Indiana's life. One story layered on top of the one before, and all of them lead down a watery path that ends at a prominent house endowed with color, shape, symbol, and language on the edge of a sprawling spruce-and-granite island in Maine.

But before that, in his sprawling new space in New York, Indiana had a studio for drawing, a studio for painting, and a studio for sculpture, and he had living quarters, a gallery, and office and library space. He didn't inhabit the space as much as he created it, showing his first inclination toward making his home a lasting statement of his artistic self. Studio, home, and identity became one as he grounded himself in his environment by using every inch of his surroundings for expression. In that respect, Indiana's Bowery studio served as a template for what would become his grandest life work in Maine more than a decade later: refurbishing the Star of Hope Lodge and filling it with his art and personality and making it his legacy.

Indiana was always a keeper. Some would say he was a hoarder. His penchant for saving and conserving things might have stemmed from his Depression-era ethic of wasting nothing, or from his industry as an artist—or perhaps simply his patholog-

ical ego, which compelled him to save everything for the sake of his personal history and mythology. He kept much of the art he created and needed a place to display and store it. He kept materials and found objects, which he used in his work. He bought back some of his earliest drawings when they came up for auction and displayed them in the Star of Hope. He kept every edition of the *New York Times*, neatly stacking and bundling them in the attic, a testament, perhaps, to his enduring commitment to stability—and proof that he was here. He even kept his clothes from the 1960s.

And Robert Indiana kept virtually everything ever written about him, every newspaper article, every magazine spread, every exhibition catalogue, every book or passing reference; he also kept grudges, never forgetting those who wrote bad things about him or betrayed him.

At the Star of Hope, when a museum director bought him an iMac, set up an internet connection, and established an email account, Indiana pooh-poohed the idea. "Oh, Dan," he said to former Portland Museum of Art director Daniel E. O'Leary, who hauled the bulky machine over on the ferry, "I don't know why you're doing this. You're wasting your time."

After O'Leary plugged in all the cables and hooked everything up, he called Indiana over to see what he had done. O'Leary googled Indiana's name and up popped fifty-two hundred hits. Indiana nudged O'Leary aside. All of sudden, the computer wasn't such a bad idea. "He wanted to look at every single one of them. We were up for most of the night. For Bob, this was absolutely like a gift falling from the heavens," O'Leary says.

He found one interview from 1972 that was several hundred pages, and asked for a printer. "So, I bought him a printer," O'Leary said. "He wanted to print the whole thing."

A Google search of Indiana's name today returns roughly 173 million hits.

Indiana didn't settle in Maine and make it his home for almost half his life by chance. After serving in the Air Force, in 1949 he'd enrolled in School of the Art Institute of Chicago on the G.I. Bill. At the college, he won a scholarship to attend the Skowhegan School of Painting & Sculpture, in rural central Maine, for the summer of 1953. Skowhegan, which still operates a summer residency program, offered a small community and deep immersion for an extended period to painters and sculptors and convened many of the leading contemporary visual thinkers. Indiana attended the same summer as did David Driskell, who also later based his life and art around a studio in southern Maine.

Indiana returned to Maine in 1969, visiting Vinalhaven at the invitation of his New York friend and Maine summer resident Eliot Elisofon, a photojournalist who worked for *Life* magazine. Elisofon's work often reflected the larger world from the perspective of an artist who never forgot or turned his back on his humble beginnings, a theme that Indiana related to as someone who rose from a difficult childhood to make his life in the arts. Like Elisofon, Indiana made work that reflected his own humble beginnings. When Indiana expressed an interest in the Star of Hope, Elisofon bought the building, then rented him the upper floors as a summer and fall studio.

In fall 1970, Indiana began working on Vinalhaven for the first time. It was a pivotal moment, for the obvious reason that it placed him squarely on the island as an artist. In doing so, Indiana followed a long tradition of New York artists who come to Maine in the summer and fall. By the end of the decade, he established himself as a year-round resident, further distancing himself from his peers.

Coming to Maine represented a leap of faith, the likes of which he hadn't made since moving to New York and changing his name. Other than Elisofon, he knew no one on the island. But he was ready for a new chapter, and Vinalhaven offered it, says Ryan, his biographer. "Those were tough days for him in New York, tough times," she says. "I think Robert lost touch with people, he lost his studio, and then he just had the opportunity to have the house in Maine, and he took it. It was a complete leap."

Elisofon died in 1973, and three years later, in November 1976, Indiana purchased the Star of Hope from the photographer's estate for $10,000. He moved to Vinalhaven permanently in 1978. From that moment, Indiana's creative output involved not only the work he produced at the Star of Hope, but also the Star of Hope itself.

The Victorian structure with its imposing mansard roof, topped with a small tower and decorative iron cresting, would come to embody both Indiana's life and his art. It evolved from being part of his oeuvre to his greatest lasting installation and his most meaningful artistic statement.

Indiana always envisioned the Star of Hope as a museum celebrating himself and began treating it that way as soon as he settled there. It took two vans twelve trips between New York and Maine to transport all of his stuff, art stuff and otherwise. The Star of Hope is a sprawling three-story Victorian, plus an attic, with steep, wide stairs and large, open rooms, as well as small awkward spaces. Indiana filled every bit of it, and then some. More than anything else, he filled it with art—mostly his own.

Vinalhaven and the Star of Hope captivated Indiana. Soon after he settled, he unearthed the connections to the island that lurked in his past. He discovered that from the quarries of Vinalhaven came the Brooklyn Bridge, deepening the link be-

tween the island and his Coenties Slip studio. And soon he also realized that modernist and Maine native Marsden Hartley—a personal hero—spent the summer of 1938 in a studio not far from the Star of Hope. These discoveries affirmed his decision to settle on Vinalhaven, and both were additional pieces in his personal puzzle and mythology falling into place.

At each step on his life's path, he narrowed the scope: from rural Indiana and the car factories of the Midwest to the skyscrapers of Manhattan and the industry of Coenties Slip, and then across the mythical bridge to the land of Hartley and the enchanted wooden lodge of the men who called themselves Odd Fellows.

It was perfect.

The symmetry of the Brooklyn Bridge and the story of Marsden Hartley consumed Indiana's creative vision in his first decade as a full-time island artist, as he revealed his own story and the connections to his past and present through his art.

In 1983, he made a screenprint called *The Bridge*, following up on a motif he had begun in New York in 1964 with *The Brooklyn Bridge*, a series of four oil-on-canvas square panels that he assembled as a single diamond. Each offered the same view of a bridge tower, in different gradients from black to white. He ringed the tower and its cables in a circle, and within each circle he quoted a different line from Hart Crane's epic poem *The Bridge*:

"Thy cables breathe the North Atlantic still"
"And we have seen night lifted into thy arms"

Some twenty years later, when he updated the idea from his home on Vinalhaven, the bridge was central in his mind, connecting his past to his present and future. An artist who lived his life guided by signposts and attuned to circumstance, fate, and the preordained nature of coincidence, In-

diana had begun making sense of the island and how it fit into his life. By moving to Vinalhaven, he crossed the bridge to its point of origin and foundation. *The Bridge* was a sign-post of his new home in Maine and his former home in Coenties Slip. "From the vowels of Vinalhaven to the consonants of Brooklyn and Manhattan," he wrote in a circle, colored in red.

A few years later, in 1989, he began a monumental series of eighteen paintings called the *Hartley Elegies*, an exploration of identity and loss and a tribute to Hartley, a gay artist who had preceded Indiana to Vinalhaven and for whom Indiana felt sympathy, empathy, and connection. The paintings, which he worked on for six years, weave references to himself, Hartley, their lovers, and specific places, events, and times. They are colorful, vibrant, and loaded with meaning.

As he settled in, Indiana's colors expanded with his new home, and how could they not? He had traded the mono-tones of the New York landscape for the seasonally explosive colors of a New England island, with deeper blues, more verdant greens, and the lavender, pink, and yellow of lilacs, lupines, and forsythia. He even flashed a bit of dark humor when he made a painting called *Fog,* a solid canvas of gray.

☆

INDIANA SURELY UNDERSTOOD the cultural weight of the Star of Hope the moment he saw it as the ferry moved past the rocks that frame Carver's Harbor and maneuvered toward the town landing. Though dilapidated with fading siding and in poor condition when he purchased it, the looming beast struck in him a sentimental chord.

Indiana had become disillusioned with New York and unhappy with his treatment by the city's museums and curators.

Other artists in his circle were getting solo museum shows and early-career retrospectives, but not Indiana. The Pasadena Art Museum organized an extensive Warhol retrospective in 1970 that toured the United States and Europe, and a year later Warhol designed the *Sticky Fingers* album cover for the Rolling Stones, a testament to Warhol's popularity, hipness, and cultural relevance. MoMA opened an Ellsworth Kelly solo exhibition in September 1973. It would be forty years before Indiana received similar treatment.

Indiana had his own successes during this period, but they were double-edged. *LOVE* became a wildly popular postage stamp in February 1973—for Valentine's Day—bringing him a level of fame that fed his ego and vanity but brought little in the way of financial rewards.

Wounded and jealous, Indiana suffered.

As an artist who required an inordinate amount of validation and who was quick to feel stung by even the perception of rejection, he no longer felt welcome in New York. When Elisofon first expressed enthusiasm about buying the Star of Hope and renting part of it to Indiana, it seemed an agreeable solution to a growing concern. He could maintain his presence in New York and still escape to Maine, following in a long tradition of artists who found refuge and solitude along Maine's sprawling, anonymous coast.

Indiana felt called to the Star of Hope, as if following a north star. The Order of Odd Fellows constructed the lodge from existing Main Street buildings in 1884–85, combining two of them and connecting them by adding a huge mansard roof structure that created an imposing, top-heavy edifice.

After he bought the lodge, Indiana took pride in repairing the Star of Hope and worked closely with state historians to lobby for its inclusion in the National Register of Historic

Places, which occurred in February 1982, just four years after he moved in year-round. He spent the next four years fixing and filling the building but failed to address the more serious structural issues—even as he was tidying it up, he didn't realize the Star of Hope was falling down around him.

But to his delight, the Odd Fellows had left behind many items, small things like brass door knockers and ceremonial hats, and larger items, such as chandeliers, a cast-iron stove, and dark, ornate wooden thronelike chairs. He incorporated these elements in the display of his art and began creating his museum and shrine the moment he moved in permanently.

☆

THE PUZZLE PIECES were clicking into place. Everything fit. In the Star of Hope, Indiana found the purpose of his life's work, if not the purpose of his life itself. In the Star of Hope, he had his long-sought permanent home that would become a museum, create context for all of his work, and elevate its meaning.

"This mixture, combination, and integration of his life and his art in a building that was designed and still retained the character of a fraternal organization meant to serve the people of Vinalhaven is simply astonishing," says Michael Komanecky, the curator from the Farnsworth Art Museum, in Rockland, who worked closely with Indiana on exhibitions in the artist's later years and considered him a friend. "It was to me then and remains now one of the most remarkable artist environments in the United States."

Indiana knew what he had in the Star of Hope and understood the obligations of owning such a structure. Even though he intended to turn it into a shrine to himself, the Star of Hope also represented a project that was much larger than him or his art, and he recognized that from the outset, says the

Maine historian Earle G. Shettleworth Jr., who worked with Indiana to get the building listed as a historic structure.

When it was well kept, the Star of Hope was a showpiece. Indiana furnished it like a museum, rotating his own art so people who showed up one year would see something different when they returned the next.

He loved showing it off. Indiana was endowed with a sense of performance and drama. He was well rehearsed and spoke slowly, with deeply considered words. He looked you in the eye and paused between sentences so people heard what he was saying, even though he told the same stories over and over. His paintings were loaded with personal references and imagery—clues to his past and links to other artists and important people in his life—and he enjoyed revealing his own story scene by scene, painting by painting.

When he was younger, he'd be apt to greet visitors in his work clothes, jeans or overalls, with his hair pulled into a ponytail and a bandana around his head. Sometimes he wore a hat.

As an old man, he was fond of sweaters and long, heavy shirts, which draped over him like a flag. His hair might be cropped short one year, long the next. When he met you at the ferry terminal, he picked you up in his old Subaru, a cigar smoldering in his mouth. Then it was a short drive down Main Street. The tour sometimes began across the street from the Star of Hope, in his Sail Loft, which he began renting in 1981 and purchased in 2016. It served as his primary sculpture and painting studio, as well as a storage area for the old VW bus he brought up from New York and his famous *EAT* sculpture from the World's Fair in Queens in 1964. *EAT* was a massive, clumsy piece, a twenty-four-foot-square electric sign that spelled out the word *eat*. Commissioned by the architect Philip Johnson for the curved façade a fair pavilion, *EAT*

hung among other large-scale works by Warhol, Lichtenstein, and Kelly. Pre-*LOVE*, it represented an important milestone in Indiana's public life and an early foray into public art, an arena he would fully embrace when *LOVE* was installed as a large sculpture in Central Park in 1971 and at Kennedy Plaza in Philadelphia as part of the city's Bicentennial celebration.

EAT was a veiled tribute to his mother, who spoke the word to him on her deathbed, as he rushed to her side. "Did you have something to eat," she asked, according to Indiana legend. And then she died.

Indiana never saw *EAT* illuminated at the World's Fair. The illuminated art caused confusion among fairgoers, who assumed it advertised a pavilion for food, so the lights were quickly shut off. It wasn't until June 2009, when Maine's Farnsworth Art Museum convinced Indiana to dig it out of storage at the Sail Loft, that he actually got to see it with the lights on. The museum reconditioned the sculpture and its four-hundred-plus lightbulbs and placed it on the roof of its downtown building—a move that delighted Indiana. He told the *Portland Press Herald* that seeing the sign illuminated was "an exciting situation. I have not seen it erected in close to fifty years. It's been in storage since the fair closed."

At the Star of Hope, he converted the original street-level storefronts into storage spaces for his flat files brimming with prints, drawings, and other works on paper. On the second level were his primary living spaces: a kitchen, living room, bathroom, ballroom, and dedicated card room. He had an office and workspace off to one side, with filing cabinets and a table for meetings. Up on the third floor were both a reception room and the ceremonial chamber, all decked out with period furniture and accoutrements—plush, velvet, ornate— left behind by the very odd fellows.

Throughout, Indiana had wall space for some of his *Hartley Elegies*, his *Mother and Father* diptych, and tables, pedestals, and floor space for sculpture. There were dozens, if not hundreds, of artworks. He stuffed the ceremonial chamber with sofas, chairs, and lamps and filled the house with his eccentric collection of children's stuffed animals—giraffes, lions, zebras.

With everything he did to adapt the Star of Hope to his own use, he was also careful to keep much intact, including the fraternal order's items that came with the house, such as the banners, coffee mugs, and colorful fuzzy hats.

"He gloried in the original features," Shettleworth says. "He loved all the paraphernalia. It would appeal to him for what we know about his art—very colorful, direct, and demonstrative. He understood what this was about, and he wanted to preserve it."

Indiana also believed that his effort to restore a key community building would create goodwill with the town. By 1981, when he first summoned Shettleworth for a meeting, he was beginning to sense that his presence on the island was causing friction. If townsfolk saw that he cared enough about the building to invest in its preservation and keep it rooted in the sense of the community that birthed it, maybe they would accept him.

Then again, maybe not.

☆

INDIANA'S ARRIVAL IN Maine was a spectacle. On an island, no event or stranger goes unnoticed, and he drew attention immediately. As with most other entrenched coastal communities, Vinalhaven—which had a population of about twelve hundred year-round residents when Indiana settled there

permanently in 1978—is curious about strangers and new-comers, and not always welcoming. People earn their keep, and island justice comes swiftly to those who cross whatever line is drawn.

To some, Indiana was an outsider and a nuisance, the cause of unwanted attention whose presence was both odi-ous and offensive from the moment he arrived. To others, he was one of the greatest artistic voices of a generation, and the most famous artist to live on Vinalhaven since Marsden Hartley.

Indiana wanted to fit in, and he enjoyed feeling welcome. He worked hard in his early years in Maine to cultivate friendships and to be a good neighbor. In addition to invest-ing heavily in the Star of Hope while working with histori-ans and preservationists, he reached out to educators, writers, curators, and others.

Marius Peladeau, the Farnsworth Museum director at the time of Indiana's arrival, was among his earliest Maine friends. He recalls Indiana as cooperative and friendly but guarded. He could be coy, playful, and teasing. Those eyes that had grown dull by his eightieth birthday twinkled when Peladeau first met him.

"He was a very warm, accommodating, and low-key per-son as long as you didn't pry into his private life," Peladeau says. "As long as you stuck to his art and career and what you saw in his paintings, once he was your friend, he was always your friend."

The art critic and writer Edgar Allen Beem met Indiana soon after the artist arrived in Maine, and first interviewed him in 1982, when the Farnsworth mounted *Indiana's Indiana*.

Indiana was direct with Beem about his life in Maine and his reputation: "I would like to establish the fact that I am

here in Maine. So far, I have been hiding out, but I am not a recluse," he told the writer.

He went on to say that he felt slighted in New York, that New York had paid insufficient attention to his work. He didn't appreciate being known as a Pop artist and called himself "the least pop of the Pop artists."

It was the beginning of a long friendship, one that was built on trust.

One time, Indiana stopped for an unannounced visit to Beem's home near Portland. He pulled his VW van into the driveway, stepped out, and rang the bell. Looking back, Beem is somewhat astonished that one of the most famous artists of the twentieth century dropped in for a visit, just because. But that was the least of it.

At the time, Beem led tours of locations in Maine important in the history of American art. On two occasions, Beem took tour groups to Vinalhaven to meet Indiana. "He couldn't have been more gracious. He opened the place up to a busload of strangers from out of state," Beem says. "The fact that he would let a dozen people get off the ferry and come traipsing downtown and parade through the Star of Hope, and that he would not only give them a tour but open up each of his studios, is really quite remarkable."

Indiana was in a good place at the time, and it showed in his willingness to engage with people and, indeed, to invest in lasting friendships, a benefit of setting down roots and investing in home, something he had resisted time and again.

When Beem, his wife, and their two young girls came to Vinalhaven for a Fourth of July celebration as a guest of Pat Nick—host of Indiana's eightieth-birthday party many years later—the artist took them to dinner at a village restaurant. When one of the kids complained about her dinner, Indiana

politely called the waitress over and said, "This young lady doesn't like what she ordered. Can we try something else?"

That evening, he hosted the Beems in the ceremonial chamber on the top floor of the Star of Hope. It was the largest open room in the house, and the one with most of the leftover arcana of the Odd Fellows.

In addition to his own dogs, cats, and geese, Indiana was fully involved in the eccentric hobby of collecting stuffed animals—his constant companions, ever loyal. He spread them throughout the house and especially in the ornate chamber with its tapestries, garish carpet, and princely ambience. There were chessboards with marble pieces, sculptures of *LOVE*, and model wooden boats.

Here, he allowed and encouraged Beem's girls to play.

"I was surprised that he was perfectly comfortable having little kids run around up there," Beem recalls. "On the one hand, we heard plenty of stories of him being reclusive and standoffish, and an oddball in the Odd Fellows Hall. But most of our experiences, he was a sweet guy. When I think of it now, I'm almost embarrassed at how well he treated us."

Beem still has a letter he received from Indiana after a visit to the island in 1982. Typewritten over two pages, single-spaced, and on ornate Star of Hope Lodge stationery, Indiana began his letter with a poem:

> *For E.A.B.*
> *Edgar All(a)n*
> *Was a Po(l)e,*
> *Not a Be(a)m,*
> *But(t) either make*
> *A good Her(m)*
> *Indiana does.*

Indiana purposely misspelled Beem's name for the sake of wordplay, and "Herm" refers to a series of pole-like sculptural works that he began in New York and fully realized with the found objects of Vinalhaven—beams for wharfs, often. No doubt, Indiana delighted in having silly fun with Beem's name, poles, and herms.

He was reaching a point of comfort in Maine, had begun making paintings, prints, and sculpture that referenced his new home, and was proud of what he had to show for his time on Vinalhaven. But soon, the bitterness and anger that crept into his life in New York began to surface in Maine. One curator recalls a mid-1980s visit to the Star of Hope that began civilly but turned awkward. The curator came to Vinalhaven to see a mutual friend, who suggested that Indiana would welcome a visit.

"We knocked on his door and were let in by a self-consciously disheveled Indiana, who proceeded to give us a full tour of the premises," the curator recalls. "We had tea in the ceremonial room with a canopied dais still against one wall. *LOVE* paintings in various color combos hung on the walls. So, talk began cordially and trivially, Bob asking about the ferry ride over. But soon he steered the conversation toward how no one in Maine appreciated the great artists in their midst. He named Hartley and, I think, [John] Marin, but then he became darker and—still ever polite—damned Maine's curators today for ignoring 'the greatest artist in the state.' He meant Louise Nevelson, but I knew he was referring to himself, and by 'curators' he meant me. His language became bitter and insulting, though he was careful never to assault me directly, only obliquely."

They let themselves out, with Indiana still steaming. That evening, they met up again for dinner. Indiana was jovial

and gregarious, an altogether different man from hours before. At dinner, he laughed a bit too loudly at the curator's jokes.

Afterward, the curator's friend said Indiana was contrite for his performance that afternoon and wanted to apologize. "But he never really apologized. He only guffawed at my stupid jokes," the curator says.

Alden Chandler, who was known as Alden Wilson when he directed the Maine Arts Commission, spent parts of four decades navigating Indiana's ever-changing moods. They attended parties together as early as the late 1970s, "when," Chandler says, "Bob was like the Star of Hope. He was the star of the party. He was doing what Bob did at the time, sort of puffing around."

They became friendly, and Indiana sometimes turned up at Chandler's house on the mainland unannounced and often bearing gifts. "I don't know how he got my address—I didn't give it to him," says Chandler, who welcomed the visits. "He couldn't have been nicer, warmer, and more pleasant. There was a genuine side of Bob, and it didn't seem to be a forced side of his personality."

Chandler felt empathy for Indiana, because he perceived the world-famous artist as someone uncomfortable in his own skin: "He experienced accomplishments and fame very early on. He had a very good ride from the get-go, and he had something to offer that was distinctive. He had to know that. But there was something about the guy that was not comfortable with his achievements, his accomplishments. With Bob, things were never good enough. The show was never big enough, the catalogues never nice enough."

As executive director of the Maine Arts Commission, Chandler was a public-art gatekeeper, and Indiana was

keen on having a Maine-centric painting or sculpture placed in the art collection of the State of Maine and displayed in the capitol, in Augusta. By 2002, discussions were finally under way. As Indiana saw it, it was a matter of respect. That same year, Indiana's governor had declared "Robert Indiana Day" in his home state, and the artist was hoping for a bigger, more lasting honor from his adopted state. If an orphaned son of Indiana warranted a day of recognition in his birth state, then the adopted son of Maine deserved something more.

He expected Maine to purchase or commission art outright through its public-art program, but his art was more valuable than Maine could afford. And besides, Chandler got immediate pushback from some legislators, who did not want Indiana's art selected at any price because of the allegations that he'd solicited sex from minors.

"It got very complicated, and Bob made everything worse by creating a couple of works that were wholly inappropriate for the State House," Chandler recalls, with the amusement of hindsight. One was a painting that referenced Vinalhaven and nearby islands, and the other was a sculpture of found objects washed up on shore. Neither represented Maine as a whole, and Chandler wasn't comfortable presenting either for consideration.

"He started using words like *enemy* and *victim*, as in he was being victimized," Chandler says. "He just felt he was so important that he should have free rein. Bob eventually came around to understand that the pieces he made didn't speak to the whole state. I think he got that. But given his ego and his feeling of importance, he felt everything should just work smoothly and he should be selected, and things should just move right along."

Indiana ended up making a painting called *First State*, a diamond-shaped, six-foot oil-on-canvas with a big numeral 1 in the center, a glow of light bursting from behind suggesting the sun's rays, and the phrase "Maine—First State to Hail the Sun." After much wrangling, negotiation, and drama—and the involvement of lawyers—the painting came as a reluctant gift from Indiana to his adopted state, a result that made him look good in public but left him angry, embittered, and feeling further disrespected.

In May 2007, at a reception in Indiana's honor at the governor's house, the governor thanked the artist for his generosity. "It is a beautiful painting about Maine, by a Maine artist, given to us because of the artist's genuine affection for and gratitude toward this state," said Governor John Baldacci.

Only part of that statement was true. It was a beautiful painting. But Indiana's feelings toward Maine were growing less genuinely affectionate by the year, and the drama surrounding *First State* had something to do with it: the painting Indiana hoped to sell but ultimately gave as a gift was appraised at more than $1 million.

It hung for a short time outside the governor's office until 2010, when a Republican named Paul LePage won election and demanded it be removed.

☆

WHEREAS INDIANA'S INTRODUCTION to Maine came by way of his summer at Skowhegan, his deeper tie to the state, and specifically to the midcoast, came through his friendship with the greatest female sculptor of the twentieth century, Louise Nevelson. A native of Russia, in what is present-day Ukraine, Nevelson emigrated to the United States with her family, and was among a small enclave of Jews who made

their home in Rockland, the nearest port to Vinalhaven, in the early 1900s. She had a difficult time as a young Jewish girl in a provincial fishing community but attributed her grounding in art to the education she received in Rockland schools. Indiana could see something of himself in Nevelson's story: a stranger in a new place, trying to fit in, and finding solace in art.

Rockland was a dirty, working-class city in Nevelson's day, but it gave her exactly what she needed: a way out. She would not have become the bold, edgy artist she became if not for coming of age in Rockland, a city she would not recognize today, with its contemporary art galleries, restaurants, and coastal-hip vibe.

Long before Rockland became chic, Nevelson returned to plan an exhibition at the Farnsworth, and asked to visit Indiana on Vinalhaven. Museum Director Marius Peladeau gladly arranged a day trip. Indiana, who had not been long in Maine, gave them a tour of the Star of Hope, and the conversation turned to Nevelson's upcoming exhibition. "Louise looked right at me and said, 'If you are going to do me at the Farnsworth, why not do Bob at the Farnsworth, too?'" Peladeau says. "I said, 'If Mr. Indiana will consent.' He said, 'Oh yes, I even have a title for it: Indiana's Indiana.'"

The exhibition took place in 1982, the first major show of Indiana's art in Maine, and it was triumphant for the both the artist and the museum. It introduced Indiana to a new audience in the state and it signaled to the larger world that the Farnsworth was serious about exhibiting contemporary art. It also signaled the beginning of what would become a hot-and-cold relationship between Indiana and the Farnsworth, and with museums and curators in Maine generally,

and it continued a pattern long established by the artist with museums directors and curators in New York and elsewhere.

Christopher Crosman, another former director of the Farnsworth and founding chief curator of Crystal Bridges Museum of American Art, in Arkansas, says he always felt like a freshman at the senior prom in the company of Indiana. "Indiana enjoyed the dance and dangling of favors that he knew as well as I did were beyond my grasp," says Crosman.

The Farnsworth Museum had limited resources, but Indiana wanted it to flex like a big-city museum. He also wanted the museum to focus less on the Wyeths and more on him. He invited Crosman for a studio visit and proceeded to badger, berate, and bully him. "I don't recall our conversation, but it pretty much centered on why the Farnsworth needed to pay more attention to him," Crosman says. "He was clearly annoyed that we were in the process of rebuilding a relationship with the Wyeth family."

In private, Indiana referred to the Farnsworth as "the Wyeth museum."

That is how the relationship went: Indiana never quite happy and the museum, in his mind, never doing quite enough. He always wanted more. "He was always really good at playing the bird with a broken wing," says Dan O'Leary, the former museum director from Portland who set up Indiana's first internet connection and whose relationship with the artist finally soured after twenty years of hectoring. "He always needed somebody to be sympathetic and helpful."

Before their friendship faded, O'Leary and Indiana got along pretty well. During one of his first visits with the artist, O'Leary mentioned that the Portland Museum owned several pieces of furniture from Portland-area Odd Fellows lodges, and he offered some to Indiana as a trade.

As O'Leary recalls, the museum rounded up a couple of heavy wooden benches, a bookshelf, and a few ceremonial thrones. The furniture was worth between $10,000 and $20,000.

O'Leary expected something of equal value in return. Instead, Indiana gave the museum *Electi*, a painting from 1960 that Indiana made in response to John F. Kennedy's election. It was originally called *Election*, and was one-quarter wider. The painting came back damaged after a gallery exhibition, with a hole on the far-right of the canvas. Indiana kept the painting in its damaged state, but interpreted Kennedy's assassination as a mystical message and cropped the painting, removing the section with the hole and making the piece one-quarter smaller. *Election* became *Electi*, and is now owned by the Portland Museum of Art.

"It's a million-dollar painting," says O'Leary. "It was very generous of Bob. He loved his furniture."

WHEN ROBERT INDIANA left New York for good, in 1978, he was a bitter man. *LOVE* made him an international art star, but he felt he had little to show for it relative to his peers.

Pre-*LOVE*, Indiana worked in orbs and herms, using painted circles and shapes that resembled ginkgo leaves. His herms were totemlike constructions, made with wooden beams, iron wheels, and other industrial elements that he found in his neighborhood. His personal geography began showing up in his art as early as 1959, when he started working on *The Slips*, an eight-foot-tall oil-on-board painting naming the various slips of his neighborhood—Coenties, Catharine, Market, and five others.

Politics crept into his work with the election of JFK, and he painted about racial injustice in 1962 with *The Rebecca*, a political and historical painting about a slave ship that sailed into New York Harbor. On the outer circle, he painted the words "THE AMERICAN SLAVE COMPANY" in stenciled lettering. On an inner circle, he painted "PORT OF NEW YORK," and in the middle the numeral 8, a reference to the month of August, the month the *Rebecca* stopped sailing and the month his mother was born and died.

Indiana began riffing on the idea of *LOVE* in 1961 as a two-dimensional painting entitled *4-Star Love*, which is now also part of the collection of the Portland Museum of Art thanks to O'Leary's friendship with Indiana. Painting on a canvas of blood-red paint roughly twelve inches square, Indiana placed the word *LOVE* in block letters along the bottom edge, with an upright letter O. Above the letters, he arranged four stars, two over two.

From that early idiom, the image evolved until it became its iconic self. Instead of four stars, two over two, Indiana place the four letters of *LOVE* two over two. Just as he honored his mother with *EAT*, he honored his father with *LOVE* by framing the letters in the colors of the logo for Phillips 66, where his father worked pumping gas. Finally, the touch of brilliance: he tilted the letter O to the right just so, "as if the foot of the L has given it a kick," the critic Grace Glueck wrote years later in the *New York Times*. Indiana also drew inspiration from the Christian Scientist church where he attended services and went to Sunday school as a boy. He never forgot how the otherwise austere church had a single inscription imprinted on the interior walls, which he stared hard at: GOD IS LOVE.

He told people *LOVE* was supposed to be *FUCK* with a priapic "U" tilting to the right, but Ellsworth Kelly talked him out of it. For Indiana, the actual word was less interesting than the shape and placement of the letters and the colors.

When the Museum of Modern Art commissioned a Christmas card from Indiana, in 1965, he sent them *LOVE*. Then the U.S. Postal Service turned *LOVE* into a postage stamp on Valentine's Day 1973, issuing 330 million 8-cent stamps and paying Indiana a flat fee of $1,000.

Years before he became the director of the Farnsworth Museum, Christopher Crosman was working in the education department at the Albright-Knox Art Gallery, in Buffalo, when the stamps were issued, and Indiana happened to be jurying an exhibition at the museum at the time. The use of his art as a postage stamp unquestionably bothered Indiana, Crosman recalls. "He didn't complain to me or anyone else, except to say he thought that the U.S. government's action to 'cancel Love' several hundred million times was about right." Indiana was upset about the Vietnam War and the country's continuing struggle with the civil and the feminist movements, and he was deeply suspicious of government infringement on individual liberties. And yet he approved the use of the image and accepted the fee.

Indiana's biographer, Susan Ryan, says his real trouble with *LOVE* stemmed from his ethical conviction that art could not and should not be copyrighted or trademarked. When the Stable Gallery, in New York, used Indiana's *LOVE* as the poster for an exhibition in 1966—the first time the motif was put on public view, following its use as the museum Christmas card—no one involved knew the law or bothered to investigate. They talked about it, but Indiana argued against affixing the copyright notice to the poster because it created a visual impairment and detracted from the image, Ryan says.

Without a copyright notice on to the poster, *LOVE* went into the public domain when the poster circulated. From that point and until the Morgan Art Foundation began claiming it back, *LOVE* was fair game. According to Ryan, Indiana later applied for a copyright, and was rejected on the grounds that a single word could not be protected. He did not appeal the decision. He was advised to seek a trademark, which he declined to do.

His logic was murky and flawed, but it was rooted in the idea that he did not want his art to become a brand or commercialized. "But that's exactly what he was doing by not obtaining a copyright," Ryan says. "All art today is commercial. We all understand that now, but back then, it seemed to make him less of an artist. It seems like the dark ages to think that way now, but that's the way it was and that's how he felt."

Other than the $1,000 Indiana received for the stamp and whatever he earned at the Stable Gallery, he received nothing else for *LOVE* until three decades later, when he began doing business with Morgan Art.

Indiana resigned himself, and decided the more the image proliferated, the more famous he would become. He did become famous, and also an easy target. As early as 1971, he complained that the image was "the century's most plagiarized work of art." That was just the beginning.

In hindsight, it seems tragically fitting that Indiana's career would eventually be mired in accusations of forgery and fraud. *LOVE*, which became one of the most recognized images of the twentieth century, was without an "original," in a fine-art sense: it was seen as a Christmas card, then a poster, then a series of paintings, then a sculpture. Almost from the moment it was introduced, it existed in multiple forms and lent itself to fraudulent *LOVE* pieces to be mass-produced by anyone who wanted to do it.

Even though he regularly participated in making otherwise fairly straightforward deals more complicated than they needed to be—or explicitly caused the complications—what Indiana imagined to be the dramas of the New York art world took their toll on him. He fled the city with a chip on his shoulder and ready for a new be-

ginning, but trouble with fraudulent artwork would follow him wherever he went.

☆

THROUGHOUT HIS CAREER, Indiana would pay studio assistants to perform all manner of tasks, including applying paint and underpaint to canvases. Indiana or his intermediaries—such as Simon Salama-Caro, his agent and dealer, and the American Image Art publisher Michael McKenzie—consulted with foundries that produced sculpture and printmakers who made the prints. Early in his career, Indiana was a hands-on printmaker, and a good one. But he had little involvement in the creation of the large-scale, three-dimensional sculptural pieces that came to define his public image. He left it to others to communicate his specifications to the craftspeople who actually made his art. Some he talked to, some he didn't.

Josh Dow and Lauren Holmgren—recent grads of MAS-SArt, in Boston, newly married and eager for work—made Indiana's original *HOPE* sculpture, a six-by-six-foot, stainless-steel behemoth that was set on a four-foot base for the Democratic National Convention at Green Foundry, an enclave of creativity in Eliot, Maine. They were finding their way in the art world when McKenzie called one morning early in the summer of 2008.

"He was talking a lot and really quick and he mentioned Robert Indiana, and did I know who Robert Indiana was. And I said, 'Well, of course,' because I went to many years of art school," Dow recalls more than a decade later.

That phone call began a bizarre short-term relationship with McKenzie, but they never met Indiana and barely even spoke with him. "We were allowed to come to his eightieth-birthday party. We saw him come out of the house, but

we were kept at arm's length," Dow says. "He did call me once. He said, 'Are you making Michael happy?' I said, 'I think so. I hope so.'"

When McKenzie enlisted Dow and Holmgren, they say he could offer no more than a concept of what he wanted produced. Dow asked for a drawing so he could formulate a quote, and McKenzie's assistant sent something that "looked like it was made on Microsoft Paint," Dow says incredulously, referring to an early and rudimentary graphics program. "It just had letters, but it wasn't art. We looked at it and said, 'What is this?' It was completely useless."

But they wanted the job, so they improvised. Dow's sister held a degree in graphic arts, and they asked her to design the *HOPE* sculpture based on McKenzie's crude rendering. "We spent a few nights at her house drawing the *HOPE* sculpture in vector graphics," Dow said.

They made two versions and sent both to McKenzie. After McKenzie told them Indiana signed off on one, they prototyped the piece by cutting flat versions of each letter from sheets of plywood and stacking them. When the prototype was approved, Dow enlisted a local company to manufacture the final parts in stainless steel and "called in all the people I knew," he says, to assemble the piece. Indiana had no hand in its fabrication, never met the artists who made it, or even saw the final piece before it was shipped to the Democratic National Convention.

Dow laughs at the experience today and is without regret. He chalks it up to part of his education in the high-end-art world. McKenzie—not Indiana—paid the foundry, eventually. He won't say how much, other than that it was a fair rate for a young couple with barely any track record—though far less than they deserved. "It was sort of circuitous and round-about and lumpy, but in the end everyone got paid," he says.

As for McKenzie, Dow just smiles. "We haven't been in touch."
When asked to confirm or comment on Dow's version
of how things went down with *HOPE*, McKenzie declined.

ROBERT INDIANA WAS flattered but somewhat confused when Susan Ryan visited him in the 1980s and asked if she could write her doctoral dissertation about him. He didn't know what a dissertation was but understood enough to know that it was usually was about someone who wasn't alive.

"So, I don't have to be dead?" he asked.

With a flash of a grin, Indiana said yes, deepening a friendship between the scholar and the artist that spanned four decades and was unique in Indiana's personal history. The artist had many friends in the media and gave hundreds of interviews, but he granted few writers or researchers the access he gave to Ryan. They first met in 1985, when Ryan interviewed him for a short-lived, Maine-based art publication. Ryan would eventually write the comprehensive biography *Robert Indiana: Figures of Speech*, published by Yale University Press in 2000.

Beginning in the 1980s and through the 1990s, Ryan made some twenty research trips to Vinalhaven, most lasting three or four days. She rented a room at the Tidewater Motel and walked to meet Indiana at the Star of Hope for their conversations. They talked over coffee or wine, and he would often

cook for her. Sometimes they sat in the kitchen, where he had a small TV perpetually tuned to the news, or in one of his studios with work in progress, or in one of the rooms on the second floor, which were always chaotic with growing collections of art and stuffed animals—and men.

Their talks felt private and intimate, but the two were never alone. Ryan remembers young men lurking nearby, always. They were fixing windows, fixing the roof, fetching groceries. It was always young men, and it was always three or four of them. He called them his "huskies."

Ryan remembers Indiana's humor, kindness, and playfulness. But it was a complicated friendship, too, fraught with drama. She came to Indiana with a genuine interest in his art, his life in New York and in Maine, the impact of *LOVE*, good and bad, and sensitive personal topics such as his parents, his childhood, and the biographical meaning of his art—though she avoided the scurrilous parts of his life.

Ryan and Indiana learned their way around each other in their early days. Ryan put up with his brooding moods and rudeness. He sometimes didn't answer his door even though they had an appointment and she'd traveled to the island at considerable expense to interview him and help tell his story—and even though she knocked three times. On the next visit, he'd apologize for standing her up, but she never quite trusted the sincerity of his apologies. "You learned to ignore the bad stuff as much as you could, and you moved on," she says.

Indiana let Ryan into a place in his life and heart that few people, especially women, occupied. In time, they became genuine friends, but as well as she knew him, she always felt there was a side to him she could never know, because of her gender. She always felt he distrusted women, though she nev-

er understood it. She assumed it had to do with his being gay and that he simply wasn't comfortable with women. "One of the first things he said to me was, 'I don't do very well with women,'" she recalls. "He made weird comments that made me think he just didn't know how to act around us. He had no idea how women are."

She accompanied Indiana on a trip to New York on a summer day, and Ryan wore shorts. He admonished her for her "semi-nakedness" and accused her of flirting with one of his studio assistants, who had joined them. She was incensed. "I was married. I thought he was crazy."

Susan Larsen, chief curator at the Farnsworth Museum in the late 1990s, had a brief professional relationship with Indiana and recalls it as generally uncomfortable. "I had the feeling that the fact that I was a woman was an issue," she says. When she met Indiana at the Star of Hope, Larsen accompanied a popular male curator who'd known Indiana many years. Indiana treated her colleague well but ignored her. When she remarked that she liked an early piece he pulled from a flat file, he shrugged his shoulders, declining to engage. "I found him really bright and really feisty, and not much interested in what I had to say," says Larsen, who now directs the Dorothea and Leo Rabkin Foundation.

"I've spent many hours with artists in my life and had even at that point in my career. I have a high regard and appetite for unusual characters, shall we say. I'm fascinated by aberrant personalities. He was very skittish," Larsen says.

Kathleen Rogers, Indiana's former publicist, had an entirely different experience. She met Indiana on a snowy New Year's Day in 1999, boldly calling from the mainland to introduce herself—the artist Neil Welliver gave her the secret ring code—and he invited for a visit. They soon discovered some-

thing in common: that their parents died when they were young, though Indiana had been much younger than Rogers when his parents died. "To lose your parents at an early age is really tough," he told Rogers. "We are the two orphans."

The line was much more than a passing observation. It became a real bond between the pair. Rogers also wonders if her living in Ellsworth, Maine, contributed to their friendship. Indiana appreciated connections, real or imagined. Ellsworth represented both the name of a former lover and the mainland town where Hartley came to die.

☆

THE ALMOST DICKENSIAN saga of Robert Indiana's Depression-era childhood affected almost every aspect of his life and art, especially at the end. Indiana's mother put him up for adoption as an infant; nothing is known of his biological father. He liked to believe he was conceived in the backseat of a car.

Indiana's adoptive parents, Earl and Carmen Clark, were always on the move. His father worked in the burgeoning petroleum industry and changed jobs frequently, and his mother spent much of her energy searching for a better home, a better life. Earl and Carmen were working-class people. During the Depression, Earl slid from oil executive to pumping gas at a Phillips 66 station; Carmen worked as a waitress, often in roadside cafés. Indiana lived in more than twenty houses by the time he was seventeen.

His parents split up when he was still in grade school. Both later remarried and he spent his youth going back and forth between homes and sets of parents for years at time. As an adult, after he found success as an artist, Indiana returned to his home state to track down and photograph the houses he had lived in growing up; by that time, some of them, di-

lapidated even when he lived in them, had been torn down or replaced. He used the word *nightmare* to describe the experience of moving constantly as a kid, Rogers says. Indiana's longtime friend the artist William Katz concluded that whereas many artists were able to come to terms with their sense of abandonment as children, "Bob never really has." From a young age, Indiana considered himself a loner.

Indiana was determined to be an artist from the age of six, in part because his parents told him he should not be. Their discouragement gave him incentive to succeed, he said in an early interview. Though he romanticized his parents in his artwork, he understood their flaws as human beings. He said of them once, "It dawned on me at a fairly early age that my parents were not very competent people. They were very bad at handling their own affairs."

And while he certainly struggled with his own affairs, personally and in business, he succeeded as an artist. In 1958, while working at the Cathedral of St. John the Divine and among the muscular columns of Vinalhaven granite that supported it—still unaware of Vinalhaven's pull but feeling the weight of the ballast it represented—Indiana completed a painting of the crucifixion, *Stavrosis*, and realized it was time for him to step away from his surname.

He chose the name Indiana as an homage to his home state, but he saw it as reinvention, not nostalgia. He knew he wasn't looking backward, even if he didn't realize exactly where he was headed. Working among the columns all day and sleeping in the shadows of the bridge at night, he just had to pay attention to the hints, connect the dots, and follow the stars and light.

"His new name signified that emergence into daylight, that symbolic rebirth," Ryan wrote in her book.

The trauma of Indiana's young life influenced the art he made and every relationship important to him. It's easy to argue that all art is autobiographical, but for Indiana it was especially true. And assuming that what we know about his life is true—adopted at birth, never knew his birth parents, his adoptive parents divorced when he was eight, he moved repeatedly during the Depression—it's bleak. It means never having friends, except for the briefest periods, "and always having your shallow roots ripped up," as one museum curator observed. He was poor and insecure, and had no semblance of a stable home life. It's no wonder that trust became an issue at a young age and remained so until his death; it's no wonder he suffered so much as an adult: he spent the last forty years of his life almost entirely alone, and knew the feeling of loneliness more than that of love.

Indiana's art can be viewed as a road map of his life, always reflecting autobiographical themes and important moments. After he settled into the name Indiana, in 1958, just four years after he arrived in New York, almost all of his important work told his personal story. He chose the colors for *LOVE*—the artwork that brought him the most fame—because they reminded him of the colors the Phillips 66 gas company and his father. *EAT*, which began as a painting and became an illuminated sculpture at the World's Fair in 1964 (and a late-career highlight when it was illuminated again in Rockland, Maine), was the last word his mother said to him on her deathbed.

With that in mind, every Mother's Day until 2013, when Rogers began losing access, she and her children spent the day with Indiana at the Star of Hope. She brought a cake from Larry's Pastry on the mainland and the two orphans toasted their mothers.

These moments of pure, uncomplicated tenderness were rare for the artist. With the first words of Ryan's biography of Indiana, she concisely describes countless people's experience with him: "Although the artist and I have not always agreed regarding the interpretation or relative importance of this work or that fact, discussions with him have always been challenging and rewarding." For those who knew him best, that was the essence of Robert Indiana.

He was a challenging yet rewarding man. He was fiercely loyal and generous with his time, his money, and his art. He welcomed people into his home, gave them tours, fed them, and—if he liked them—sent them home with a signed print or some other keepsake.

But he required something in return. People gave him flattery, because he encouraged it and liked it. It addressed his insecurities. But what he wanted and needed, and didn't often get, was sincerity, commitment, and a willingness to engage in serious conversation and maybe even a spirited debate.

Michael Komanecky was among the curators who earned Indiana's trust, and it was hard won over many years beginning in 2007, when he joined the staff of the Farnsworth Art Museum. He met Indiana right away, introduced by the museum's director, and their relationship evolved, always at Indiana's pace.

Whenever he went to Vinalhaven, Komanecky returned to the mainland physically exhausted—from the enormity of the Star of Hope, the dense, biographical nature of the art that filled it, and the sheer weight of Indiana's presence and personality. The visual overload of the Star of Hope was overwhelming, and Indiana made it more so with his relentless, exacting nature. Time after time it was the same questions,

"Michael, why are you doing this?" "Michael, why aren't you doing that?"

One day, Komanecky snapped.

The men were seated in a cramped office in the Star of Hope, with the art scholar John Wilmerding at the head of the table and Indiana and Komanecky on either side. They were collaborating on a Farnsworth exhibition, and Indiana started in: "Michael why aren't you . . ." and Komanecky sharply cut him off, almost rising from his chair. "You know, Bob, I'm tired of your criticisms."

There was a pause, and a smile. "I'm full of them, aren't I," Indiana said.

Komanecky understood it as a test he had finally passed. He stood up to Indiana, in his own way. "It said a lot to me about his need to develop some trust in the people around him, and that trust did not come easily," he says.

Wilmerding found two ways to stand up to Indiana. One was to ignore something flagrant. "Over time he would soften and often go on as if nothing ever happened. The other," he says, "was just to persist, and in his own way he would eventually find a way to agree and accept."

☆

SUSAN RYAN WONDERS how Indiana's life would have been different had he surrounded himself with more advocates who respected and cared about him but didn't put up with too much of his bullshit: fewer "yes men," fewer guys who let him win at Scrabble. Indiana could see through journalists who hadn't done their research and quickly lost patience with them. He loathed curators who came heaping praise and dismissed them as toadies. Indiana needed passionate people who liked to argue, joust, and debate politics, art, and current events.

Dan O'Leary, the Portland Museum of Art director who knew Indiana over many years and bought him his first computer, says the artist lost much of his intellectual engagement after he moved to Maine, and the loss accumulated over time, taking its toll on both his art and his personality. Indiana thrived in Manhattan because he was inspired to make art that was tied directly to the culture of the United States. When he left that environment, he lost direct contact with the things that made him want to be an artist in the first place.

In Manhattan, he interacted with people at every turn. He lived among artists and was part of a scene. In Maine, he lived alone on an island, a long ferry ride from the mainland, in a community where he was tolerated but not well liked, and in a state where the prevailing culture was to leave people alone.

"He ended up isolating himself in Maine and in the Star of Hope Lodge with a number of people on the island who were not very happy with him," says O'Leary. "It sort of spelled the end, unfortunately for Bob. I don't think he ever really grasped this, maybe not ever, but when he severed his daily relationship with Manhattan, he severed his connection to American culture. He unintentionally cut the umbilical cord with Manhattan and all the things that inspired him and opened him to new ideas and new subject matter. Bob just stopped being creative when he left Manhattan."

In coming to Maine, he chose isolation over living in the center of the country's art world in New York—but he never gave up his desire for fame. Indiana always blamed others for the fact that he never quite achieved what he thought he deserved. This became the theme of the last half of his career. "Part of him wanted to be famous for sure, but part of him wanted to be alone, just go away and don't bother me—however you're able to put those two together," says Ryan.

Indiana could oscillate between courting the fame he so desired and an obliviousness that made him appear not to care—not about his fans, his career, not his obligations, whether taxes or otherwise. He once showed Ryan a drawer full of unopened mail. "He just collected it. He didn't bother. It was shocking, but it didn't actually shock," she says. "He was self-destructive in so many ways, as we all know. It's not like he set out on his course with his oars in the water to go after fame. He wanted to be famous, that was clear. But he wanted fame to come to him. He wanted people to come to the island, because that meant they came to see him."

And yet, he turned away so many, or simply didn't answer their knock. There are dozens of stories of meetings declined, invitations ignored, opportunities lost.

During the worst days of Indiana's tax troubles, a prominent Portland attorney visited him on the island at the request of a mutual friend. He made the trip as a courtesy and out of respect to Indiana, to see if he could help the artist plot a way forward. The lawyer was even willing to work for free.

Indiana brushed him aside. He was rude and disrespectful.

"I'll tell you one thing about this guy," the lawyer told the mutual friend. "If things ever got rough, you couldn't count on Robert Indiana. He's unreliable."

Indiana's ego-driven bluster was the same when he demanded Michael McKenzie hand-deliver his annual $1 million check, instead of mailing him two for $500,000. He said he didn't trust the post office, but the Depression-era boy in him who'd known so much uncertainty—who once snagged a half-empty bottle of scotch discarded on the sidewalk because it was still good enough to serve to his huskies—liked fingering a check so large with his name on it. "He just felt it would be sexier for it to be a million dollars," says McKenzie.

More than just being rich and famous, Indiana liked that people knew he was rich and famous—even as he understood that they didn't actually like him. And this vanity made him an easy target. People took advantage of him because they could. As he aged and weakened, both physically and mentally, he became not only an easier target, but a much wealthier one as well.

When Ryan first met Indiana, the artist was a middle-aged man, in his early fifties—"really strong, full of life and full of piss, I guess you would say"—but when she last saw him in person at the Whitney for the opening of his retrospective in 2013, five years before his death, she barely recognized him. In those thirty years, he'd turned into an old man, which was entirely expected but hard to accept. She found herself wishing the exhibition had happened five years sooner, when he could have enjoyed it more. He deserved as much.

"It was his dream to have a great opening in New York—he wanted it at MoMA and not the Whitney—but there it was, and he was looking around like he didn't know what was happening," she says. "It hurt me to see that. I tried to talk to him. I held his hand, and he said, 'Oh, Susan? You are Susan?' But he couldn't quite remember who I was. I felt so sad."

The opening took place at the end of a long day for Indiana, after he had been ferried around New York by friends. By the time of the evening's festivities, he was worn out. It was almost as if he slept through the grand finale of his own career.

When you consider the bookends of Robert Indiana's life—the cruel trauma of his youth and the brutal isolation of his old age—the dichotomies begin to sharpen into focus: his inability to trust, his aching loneliness; his desire for fame, his need for distance; his lack of love, his loss of hope.

7

USUALLY MEDIA-FRIENDLY AND -savvy, in 2014 Robert Indiana began turning down interview requests, or simply ignored them. Perhaps most startling, *HOPE*-hustler Michael McKenzie suddenly began speaking for the artist.

"Bob's not up for a conversation right now," McKenzie told the *Portland Press Herald* in May 2016, when the newspaper sought to interview Indiana about an exhibition of new work going on display at Bates College Museum of Art, in Lewiston, Maine. In almost fifteen years, it was one of two times the artist declined an interview with the paper; the other was when he was asked to discuss his plans for his estate, a subject Indiana guarded closely and probably wouldn't reveal in the local press, if he were to announce it publicly at all. But he always enjoyed talking about his art. He appreciated the attention and enjoyed the banter. It was out of character to decline to a conversation about new work, and a clue that something wasn't right.

Another clue was the deterioration of his home, a source of pride and a place he envisioned as a museum of his life and legacy. Without consistent attention and maintenance, the 1880s structure quickly fell into disrepair. The paint was

chipped, the gutters leaked, and the clapboards showed signs of rot. Neighbors complained. After he died, people who visited the Star of Hope said they were shocked that Indiana allowed it to fall apart after enthusiastically investing so much time and money over the decades. But the Star of Hope had been seriously neglected and architects hired after he died to plan its preservation estimated it was less than ten years from collapsing.

There were other clues.

To mark Indiana's eighty-sixth birthday, in September 2014, McKenzie arranged an International Hope Day, with celebrations in cities on three continents, including Venice, Caracas, and New York, as well as on Vinalhaven. As a birthday gift, the hope was that fans would take photos with *HOPE* sculptures as backdrops and post them to social media with the #HopeDay hashtag.

Fans assembled on the street outside the Star of Hope. McKenzie sold *HOPE* prints for $200 and promised a visit and autographs from the artist. Kathleen Rogers, Indiana's Maine-based publicist, arranged local media coverage of the event.

But Indiana never showed.

After several hours, the door to the Star of Hope creaked open. Out stepped studio-assistant-turned-gatekeeper Jamie Thomas, who had only recently returned to Indiana's employ. According to Rogers, he said Indiana would not be making an appearance. "It ain't fucking happening," Thomas told the crowd. "He ain't fucking coming out."

Rogers described that moment as the lowest point in her career, and the moment she became suspicious that Indiana was being mistreated, though it would be four years before she reported her fears to authorities. The man she knew would never have treated his fans that way, fans who paid for a print and were promised an autograph by a world-famous

artist. For months after the incident, she dealt with angry fans asking for their signed print or their money back.

She says McKenzie and Thomas "took the Hope Day cake that I had brought from the mainland and celebrated with Bob. And they had the guts to send me an image of Bob with my cake."

Things would quickly grow dramatically worse.

☆

DURING THE WINTER and spring after the Hope Day fiasco, Rogers tried again and again to reach Indiana but was always rebuffed. She'd been contacted with a lucrative business proposal that included a collaboration with Jade Jagger, a jewelry designer and the daughter of the rock star Mick Jagger and the fashion designer Bianca Jagger. Jade Jagger was interested in creating a line of diamond jewelry based on some of Indiana's designs, and piqued the curiosity of her Pop-smart father, who years before had collaborated with Indiana rival Andy Warhol on the *Sticky Fingers* album cover. But the behind-the-scenes drama at the Star of Hope under Thomas's expanding influence—with the talk of lawsuits, legal rights, and growing distrust toward Morgan Art—made even basic business meetings impossible.

On February 24, 2015, Rogers emailed Indiana confirming Mick Jagger's interest:

Dear Bob,

I received an email from Lady JJ [Jade Jagger] this morning from London letting me know that her dad, Mick, has brought friends of his who are diamond dealers in Mumbai, on board as investors in the *EAT/*

DIE HE/SHE project about which I have been communicating to you.

They are willing to put in an initial investment of $250,000.00 and are eager to formalize this in terms of a contract. I didn't expect things to move so quickly, but suppose that if your dad is Mick Jagger it would help get things done.

Obviously, I need some feedback from you on whether or not you might be interested in the project and association with the Jaggers, not to mention me. JJ has been talking up the project to friends and family and everyone is very excited.

Please let me know your thoughts via email, phone or U.S. Mail.

LOVE,
Kathleen

Thomas, who was still more than a year away from holding Indiana's power of attorney, answered for Indiana the same day:

Hey, Kathleen,

I will talk to him. I think it is a good idea. Whoever is involved, let them know I will do what I can. Please, Please, PLEASE! Whatever you do, Do not let The Morgan Art Foundation, Or Simon Salama-caro, Or Mark Salama-caro, try to intimidate you. When and if they find out, they will try to tell you they own everything under the sun. I don't even think the Morgan Art Foundation is real. Try finding them on the web. If

you do, Try any contact info. They cannot be found/or contacted. If you can get Lady JJ and/or Mick's people to help get rid of these folks. I will help on my end. I will help no matter what, but it would go quicker if they were out of the picture.

Call if you or lady JJ would like to talk.

J[amie]

When Rogers wrote back the next day, she agreed to keep the project quiet and implored Thomas to avoid the kind of "studio drama" she sensed would imperil the project:

Hi Jamie,

I would ask that we keep this project under wraps until it's signed off on by Bob and the Jaggers.

The point is, Mick Jagger is known for his business acumen, and Lady JJ takes after her dad. No nonsense. The last thing I need is for studio drama to enter into this picture.

What time can I call you? We need to gauge Bob's interest before moving forward.

Please let Bob know that Mick's friends have raised £250,000 in British Sterling, not U.S. Dollars, which makes the amount more around $400,000.00!

Thanks so much for your response. I'd sent Bob a pink catalog with JJ's incredible designs, have you seen it?

Talk soon,
Kathleen

Thomas' reply underscored the already-existing drama and distrust among studio assistants, including Melissa Hamilton:

Hey, K

Unfortunately, Melissa has access to his email. I can delete it but, the cat may be out of the bag. You can send info directly to me first, and I can relay it. If you don't feel comfortable sending the info only to me. You can send it via U.S. postal. Again no guarantees she won't read it at a later date. She is not here right now so that helps. Hope all is well.

J[amie]

By spring, the project had progressed to the point that the financier associated with Mick and Jade Jagger flew from Mumbai to Maine to discuss details about a $400,000 investment—it was precisely the kind of treatment Indiana coveted and complained about not receiving enough of. Rogers and the financier rented rooms at the Tidewater Motel on the island, close to the Star of Hope, so they would be fresh and ready for the meeting the next day. As they emerged into the morning light, Rogers says Thomas darted out from the shadows of the Star of Hope.

"He told us Bob was tired and he could not receive anyone that day," Rogers says. "I said, 'Jamie, we have an appointment.'"

But it didn't matter.

"Maybe if you stay an extra day, he'll feel better tomorrow," Thomas replied.

The meeting never happened. All of Rogers's fears had come true and the collaboration fell through. Either Indiana

didn't feel like meeting or Thomas wouldn't allow the meeting to take place. "I cannot describe how embarrassed and humiliated I was," Rogers says. "I couldn't have apologized enough. I never heard from Jade again."

But Rogers should have known better. It wasn't the first time that Indiana let her down during a high-profile, high-opportunity moment when she put her reputation on the line. Five years earlier, in 2010, Indiana had stood up President Barack Obama at the Oval Office.

Two years after *HOPE* debuted at the Democratic National Convention in Denver, Rogers arranged for a studio visit to the Star of Hope with Mark Rosenthal, the former curator at the National Gallery of Art. During lunch, Indiana casually mentioned that Obama hadn't invited him to the White House, as former president Jimmy Carter had. Indiana seemed to think Rosenthal's previous position with the National Gallery somehow gave him entrée into Obama's inner circle.

Lo and behold, Rosenthal came through. Through a series of contacts, he put Rogers in touch with a White House historian, who connected her with the office of public engagement. After months of back and forth, they arranged a photo op in the Oval Office with Obama, Indiana, Melissa Hamilton and her husband, Rogers and her daughter, and studio assistant Sean Hillgrove, with a *HOPE* painting in the background. It was scheduled for a Tuesday.

The Thursday before the big day, Hamilton called Rogers in a panic. "You need to get out here right away," Hamilton told her. "Bob is making noise about canceling."

Rogers hopped on the first ferry the next morning. When she arrived at the Star of Hope, she was ushered into Indiana's office on the second floor and settled in at a meeting

table. Indiana presented her with a formal letter that Jimmy and Rosalyn Carter had written years before on White House stationery, inviting him to the White House.

To date, he had received no such letter from the Obamas. Until he did, he would not go, he told her.

"I told him, 'That was before the internet. This is all in place. It has all been handled,'" Rogers told him, but Indiana was insistent, and angry. "He was furious that I hadn't seen to this," she says.

Rogers scrambled to meet the unreasonable demand. She returned to the mainland as fast as she could and lit up her White House contacts, begging for an overnight letter. An invitation arrived as an electronic scan at Rogers's home in Ellsworth, on the mainland, on Friday but didn't arrive at the door of the Star of Hope until Monday because there's no FedEx delivery on Vinalhaven on weekends. It wasn't good enough for Robert Indiana, who pledged allegiance to the manners of Emily Post. When nothing arrived at his door by Saturday—when nobody knocked, three times or otherwise, with letter in hand—he canceled on President Barack Obama, a man whom Indiana claimed to admire, the first Black president of the United States, the man who had embraced *HOPE*.

More precisely, Indiana left it to Rogers to cancel.

"I called the White House and called it off. My name was mud. They were furious with me," says Rogers. "They blamed me and said I couldn't control my client."

She took the blow for Indiana and was left to absorb the aftershocks created by his vanity, ego, or self-loathing.

Rogers vowed to be done with Robert Indiana because of his rudeness—a strong stand from a woman who once worked for Rush Limbaugh. She wrote Indiana a stern letter explaining that his decision to bail on Obama was "beyond

anything" he had ever done before in terms of bad behavior. They didn't talk for months, until she called him around the holidays. Mostly, she missed him. "I was fond of him, despite our professional junk," she says.

When Rogers called, Indiana picked up right away. "I thought you would never speak to me again," he told her, then invited her out for Christmas.

When she arrived, he sat her down at the same table where she'd sat earlier that year, on that awful day when he had presented her with the old letter from Jimmy Carter and told her why he wouldn't be accepting Obama's invitation. She says it was one of the worst days of her professional life.

This time, with a slight smirk, he presented her with a personal Christmas letter he had just received from Barack and Michelle Obama wishing him holiday cheer, telling him how much they loved his work, and inviting him back to the White House anytime. "He was sticking it to me," Rogers says. "He looks good to the Obamas, but his silly publicist looks like the idiot."

Despite pledging to step away, Rogers kept trying to help Indiana—the *LOVE* license plate, the HOPE Day project, and the collaboration with Jade Jagger all happened between 2013 and 2015, and all ended in debacle, embarrassment, and humiliation. Finally, after being stood up, rebuffed, and disrespected one time too many, Rogers walked away for the last time.

And if she hadn't walked away, it wouldn't have mattered. Other than occasional sightings on the island, by early 2016 Robert Indiana vanished from public view.

☆

MANY ASSISTANTS CAME and went over the forty years Robert Indiana lived and worked on Vinalhaven. Sean Hill-

grove was present in one capacity or another for twenty-eight of them.

Hillgrove was edged out of Indiana's inner circle when Thomas gained more authority and influence inside the Star of Hope. By the winter of 2018, he was forced out for good. He was devastated. Hillgrove lived with his young daughter in a house Indiana had purchased for him just a few hundred feet from the fenced-in backyard of the Star of Hope. When he looked with his binoculars, Hillgrove sometimes saw the old man shuffling around inside the house—but he no longer worked for Indiana and no longer had access to the house, and Indiana wasn't answering his calls or messages, if he even received them.

Hillgrove was angry, but mostly he was worried. Indiana, who was forty years older, had become a father figure, and Indiana claimed Hillgrove as the son he never had. He was a studio assistant—stretching canvases, preparing and packing art for shipment to exhibitions, ordering supplies—but he was much more, too.

He was first hired to be Indiana's bodyguard, personally recruited for the job after the artist read about Hillgrove's skills in the martial arts in the local newspaper. Indiana had been mugged in Central Park during a trip to New York in the late 1980s, and it had rattled him. The mugging could have been much worse—Indiana didn't have any money on him but offered to cash a $500 check at a nearby bank in lieu of being beaten. It was an act of empathy, generosity, and recklessness that defined Robert Indiana's celebrity: the art made him famous, but money made a fool of him.

From then on, Indiana wanted protection whenever he left Vinalhaven. Hillgrove, who grew up on the mainland in Rockland when it was a notoriously tough little city,

was known as a common-sense kid with a sensitive heart and offered the feeling of security Indiana craved. He let the boss win at cards and gave him as much brooding space as he needed. With time, he came to understand that it was also his job to protect Indiana from some of his worst instincts. Hillgrove's common sense was a good balance to Indiana's recklessness.

After the artist's death, Hillgrove would be guilty in the island's merciless court of public perception of neglecting Indiana and taking advantage of him, drawing a $10,000 weekly salary beginning in 2017 and receiving gifts of valuable art. Hillgrove had struggled with addiction at times, something Indiana was made aware of by a mutual friend. Hillgrove earned the enmity of islanders who blamed him—and other members of Indiana's entourage—for all of the artist's troubles, and especially for the condition of the Star of Hope. The paint was peeling, the roof was leaking, and pigeons were roosting. What was once grand had become a wreck.

And they blamed Indiana for being an enabler.

"Bob was writing checks for astronomical amounts of money, but Sean and these so-called caretakers did nothing," says the island's former deputy sheriff, Rob Potter, who fielded regular complaints about the decline of the building during the final years of Indiana's life. "The place was falling down around them, and they were doing nothing about it."

That Indiana had been assumed guilty years earlier of sex crimes with underage boys despite being acquitted made it easy for people to also assume he was guilty of fostering an environment that attracted addicts. As far as locals were concerned, Hillgrove was thought to be drawing the salary of a Silicon Valley CEO and doing little to earn it—or worse, spending it on drugs.

Potter says the perception on the island was that the Star of Hope was a gathering spot for "druggies and criminals" and Indiana was so disliked toward the end of his life that, Potter says, "if they had found him in a ditch bruised and bleeding, they would have left him there." Another longtime island-er called him "a fair-to-middling artist and a shitty human being" who holds the public's interest only for prurient rea-sons: his wealth, sexual predation, dishonesty, and the scandals surrounding them. "He is our little Kardashian," the islander said, "albeit a physically repulsive one."

Given this perception of Indiana, it's easy to imagine his fear and paranoia. Island justice was tangible at times and elusive at others, but always hovering in the back of his mind. He knew if he went missing and ended up dead in the water, he wouldn't be the first. For almost his entire time on the island he was deemed guilty of something—from tax fraud and Social Security fraud to molestation and perversion—and he was well aware that many of his neighbors believed he never paid a proper price.

Island justice comes swift to those deemed guilty. And though it is swift, island justice is rarely subtle. Vinalhaven made national news early in 2020, when fear of COVID-19 began to engulf the country. After some visitors from New Jersey arrived on the island, a group of year-round residents enacted a forced quarantine by cutting down a tree to block the driveway so the visitors couldn't leave the property. In one report, the sheriff said the vigilantes were armed.

In a time of uncertainty, the small town reacted to the fear of city-dwellers fleeing to the safe haven of Maine and bringing the coronavirus with them. The visitors were as-sumed guilty of carrying the virus, and the locals took it upon themselves to make sure they didn't spread it. Island of-

ficials denounced what they described as a "vigilante action," and said it was an isolated incident.

But later that summer, an island fisherman was stabbed to death after a confrontation with another islander. The man was charged with homicide but testified that he acted in self-defense. A grand jury declined to indict, infuriating the slain fisherman's friends and many others in the community, who complained about shoddy police work and concluded that on Vinalhaven it was possible to get away with murder.

Potter, who by then was no longer working for the sheriff's office, agreed with the community outrage over the uncharged killing. "There is such a thing as island justice, but it only goes so far. If you have the right cop out there, things go along pretty smoothly," he says.

Robert Indiana notwithstanding.

When the island's most famous resident died, Brannan and Thomas executed their long-planned quiet removal of the body. After the fact, Potter complained loudly about not knowing Indiana had died until it was too late for him to do a meaningful investigation.

☆

BY 2016, AS the new inner circle around Indiana tightened, Hillgrove's long friendship with the artist grew more and more distant. In February 2018, the relationship came to a dramatic and sad conclusion. In the span of just a few weeks, he was fired from his job, threatened with arrest for trespassing at the Star of Hope, and on the cusp of losing the home Indiana had purchased for him eight years before, soon after his youngest daughter was born.

To save all of that, Hillgrove put his loyalty to Indiana on the line. He was certain Indiana had nothing to do with the

recent trouble and concluded that the artist was being isolated against his will, if not held hostage.

He blamed it all on Jamie Thomas.

Hillgrove and Thomas had a long and fractious relationship. On the island, locals heralded Thomas for stepping in and, as they saw it, cutting off the cash flow, arranging Indiana's care and healthy meals, and providing a path for a compassionate end of life. Hillgrove didn't have generations of family on the island, as Thomas did—he was viewed as a troubled mainlander.

When Hillgrove learned Thomas had been given Indiana's power of attorney, he couldn't believe it. It was unfathomable that Indiana would do something so important without telling him. But it was true. In response, Hillgrove helped arrange for Indiana's former attorney, Ron Spencer, to draw up paperwork to revoke Thomas's power of attorney. After a long delay, Hillgrove finally had the paperwork in hand. He believed that if he could get to Indiana, the artist would sign it. In addition to needing a signature on the revocation paperwork, Hillgrove wanted to give Indiana a phone number for elder services, so he could report abuse or ask for help. Without access to the Star of Hope, he needed a plan.

Indiana bought the house for Hillgrove because it was close by. Indiana could see Hillgrove's home from his backyard and had a clear, unobstructed view from an open balcony on the second floor. Likewise, Hillgrove could see Indiana when he walked by an open window. So he trained his eyes on the back of Indiana's house and waited. On a cold February night—according to what he later related to his daughter—Hillgrove made his way to the back of Indiana's towering home, placed a ladder against the clapboard siding,

climbed to the second-floor landing, and knocked. It was an experiment to see if the system would work. Hillgrove did not bring the legal document that night, which would prove a serious error because, much to Hillgrove's surprise, Indiana heard his knock and opened the door, which led to a second-floor bathroom. After a brief greeting—the two men hadn't spoken in several months—Indiana went to the kitchen to get a key to the new set of locks, which had recently been installed in the Star of Hope to keep out Hillgrove, Webster Robinson, and another recently fired employee, Wayne Flaherty.

While Indiana went to get the key, Hillgrove retrieved the number for elder services he had written on a piece of paper. He handed the note to Indiana as the artist handed him a new key. They agreed to meet again the next night, when Hillgrove would bring the legal document revoking Thomas's power of attorney for Indiana to sign. But that meeting never took place. Within twenty-four hours, the locks had been changed again. Indiana never answered Hillgrove's knock nor appeared again in the window.

Hillgrove assumed that Thomas found the paper with the number to report elder abuse. His efforts to help the old man resulted in further isolation, with the locks changed yet again, the windows boarded, and the door bolted shut. A chain-link fence around the back of the house was secured with a new lock, and a fire escape was removed, ensuring that no one had access. Soon, Indiana's in-home care shifted from meals only to around the clock. Hillgrove and Indiana never saw each other again.

Hillgrove documented his findings, feelings, and fears in a journal, which his adult daughter, Alexandria Aiken, has shown to very few.

He as far as I'm concerned [is] being held hostage, and
will pass before I'm able to see him. . . . What to do?
He's alone + dying
all call's forwarded to POA's home
all e-mail's
has only answered 1 email and 0 phone calls.

In another entry, he wrote:

The person that some how acquired POA . . . has taken
control over his estate. Mr. Indiana vehemently denies
giving "anyone" POA, and since asking for the revo-
cation paper's to relieve his present POA of his du-
ties, all lock's and SUCH HAVE BEEN CHANGED
and windows boarded up, yard locked with chain—on
fence. I WAS TOLD BY A NEW employee, that "I
need to go away, and let this man die in peace."

But Hillgrove did not go away. Instead, he called people
who knew and cared about Indiana—such as longtime pub-
licist Rogers—and sounded the alarm, and they lodged for-
mal complaints of elder abuse with the Maine Department
of Health and Human Services. State investigators followed
up with phone interviews with Indiana's attorney, James
Brannan, as well as his nurse, Jennifer Desmond. It is unclear
if they attempted to visit Indiana on Vinalhaven; the state has
refused to release documents related to its investigation.

Hillgrove's defenders say he earned his money because over
their three decades together he was trusted and obedient and
put up with a lot of Indiana's foul moods, and Indiana knew
it and appreciated his loyalty—he paid Hillgrove well be-
cause he recognized how much of a pain in the ass he was.

Hillgrove once confided to another in Indiana's inner circle, "I am getting paid a lot of money to be yelled at, basically. I am his whipping boy. I come in here and the whole time he is screaming at me: 'Get me coffee, do this, do that.' But it's worth the money to hear him scream at me all day long."

There's little doubt that the two men genuinely cared about each other, and even those who blamed Hillgrove for things such as the condition of the Star of Hope recognized the bond between them and the tragedy of their separation.

Whenever the pair traveled, Hillgrove did the driving and took care of the complications and stresses, from routes to parking to hotel check-in, and he watched over Indiana on the streets. Like many skilled martial artists, Hillgrove wasn't a towering or imposing figure—at five-foot, ten inches and 185 pounds, he was just two inches taller than Indiana, though certainly leaner and more muscular than the artist. But he was strong, quick, and wiry. With dark hair he usually kept short, Hillgrove had a conservative appearance that contrasted with Indiana's aging-hippie look of usually shaggy white hair, bandana, and beard.

They were together in New York on September 11, 2001, and had planned to be in the World Trade Center that morning for a licensing meeting related to Indiana's *Marilyn* paintings, which were about to go on exhibition at Galerie Guy Pieters, in Saint-Paul-de-Vence. Indiana and Hillgrove had plane tickets to leave for France the next day.

Indiana and Hillgrove were growing increasingly frustrated as they attempted to get the identification Indiana needed to renew a passport that he had just discovered was expired. Without a passport, there would be no flight to France. Then two hijacked planes struck the twin towers, and all hell broke loose.

"My problem with the passport office might have saved my life," Indiana said a few months later, while showing photographs of himself and Hillgrove in Manhattan with smoke billowing from the Trade Center towers in the moments before they collapsed. Together, they witnessed the events of 9/11 unfold in real time, watching with shock and disbelief, and then shared their grief—and anger—as the towers fell.

According to accounts by Indiana and those to whom Hillgrove related the story, after the planes hit, Indiana and Hillgrove raced to the apartment where they had been staying and grabbed a camera. The two men went back outside to chronicle the scene and were confronted by chaos. Hillgrove told Indiana they should go back inside, but Indiana insisted on heading toward the mayhem.

They were overwhelmed as a toxic cloud of debris, unleashed by the collapsing buildings, barreled through the streets of Lower Manhattan. Hillgrove physically picked up Indiana, who was then two days shy of his seventy-third birthday, and carried him into a store to take cover as the cloud exploded past them. Stunned, humbled, and in a state of shock, Indiana professed eternal gratitude: "What would I do without you, Hillgrove? You saved my life."

Indiana saved the shoes he wore that day, never cleaning the white dust that caked them.

When they returned to Vinalhaven, Hillgrove and Indiana placed six large American flags at the very top of the Star of Hope so they would be visible from the water, and painted four panels covering the street-level windows with stars and stripes, a gesture of patriotism that was both intentional and spontaneous. "This is the one thing I did the town probably approved of," Indiana told the *Portland Press Herald* a year later, on the first anniversary of 9/11.

A deeply symbolic person who believed in fate, after 9/11 Indiana began giving Hillgrove more room in his life and more authority in the studio. His friend had earned Indiana's elusive trust, as well as his gratitude. Hillgrove juggled a wider range of responsibilities, such as returning calls to galleries and museums and maintaining Indiana's calendar. He became one of the artist's chief photographers and helped organize Indiana's archives.

They grew closer as they aged, and Hillgrove pledged to help Indiana in every aspect of his life, and to protect him—as a son protects his father—until he died. Hillgrove had struggled with substance abuse and addiction, but Indiana either didn't care or chose not to do anything about it. In return for Hillgrove's loyalty, in May 2010 Indiana bought for him the home behind the Star of Hope so he wouldn't have commute on the ferry from Rockland. Indiana bought the house at 7 Windy Way, but never put Hillgrove's name on the deed.

Hillgrove lived free of charge in the modest Saltbox with a tall brick chimney, small windows, and a sun-splashed yard that begged for a vegetable patch or perennial gardens. The house was in a perpetual state of disrepair and the interior was so cluttered that it suggested evidence of a hoarder; there was little room even to sit comfortably. Outside, propane grills, lawnmowers, and kayaks spilled across the yard. Hillgrove was earning more money than he'd ever earned before, and the detritus of impulse purchases piled up.

In addition to paying him well and buying a house for him, Indiana gave Hillgrove gifts. As an expression of appreciation and in recognition of their bonding experience in New York and their planned trip to France for the *Marilyn* exhibition, Indiana gave Hillgrove one of his *Marilyn* paintings, a gen-

erous act and one indicative of the trauma they had experienced together. It's a $1 million painting.

Hillgrove's *Marilyn* sustained water damage while hanging in the Sail Loft studio, turning Marilyn's blonde hair a little off color. Indiana decided that the water damage added character and gave her a full head of dark hair. After that, he referred to the painting as his "Monica Lewinsky," and suggested that the stain in her hair was thanks to Bill Clinton.

The painting was among the possessions left behind when Hillgrove was forced out of his house and off the island following Indiana's death; the painting eventually ended up in disputed possession of Indiana's estate, yet another example of the details Indiana left for others to resolve.

☆

A MERCURIAL YET charismatic personality such as that of Robert Indiana often creates conflict when employees look to win favor and jockey for position in the hierarchy. Tensions between Sean Hillgrove and Jamie Thomas dated to the 1990s when both worked for Indiana at the same time. In his first stint as an employee, Thomas was a studio assistant, which meant preparing the studio for painting and drawing, cutting stencils, and other art-related tasks. Hillgrove and Thomas coexisted uneasily for about six months, until Indiana fired Thomas "for creating drama," says studio assistant and factotum Webster Robinson, who wasn't working for Indiana at the time of the "drama" but was told of it by Indiana, Hillgrove, and others. A lifelong friend of Hillgrove, Robinson joined Indiana's employment in 1994.

"What I heard and what I was always told is that [Thomas] was shit-canned for creating problems among other people.

He was stirring the shit, creating drama, and creating infighting," Robinson said. It was the sort of drama Kathleen Rogers feared—and encountered—in 2015, when she brought the Jade Jagger project to Indiana.

In court testimony, Thomas offered an entirely different timeline of his employment with Indiana, saying he worked for the artist "for about 10 years," beginning in 1989 or 1990.

From the time Robinson started working for Indiana, in 1994, until 2013, when Michael McKenzie bought a house on the island and McKenzie and Thomas began showing up regularly on weekends, Robinson remembers Thomas at the Star of Hope just one time. That was in 1998, for a production of the play *Red Eye of Love*, cowritten by Tony Award–winning director and Vinalhaven resident John Wulp. Thomas, who was involved in the local theater scene, helped transport a backdrop Indiana painted for the production across the Fox Island Thoroughfare to North Haven Island.

Internationally famous men in the arts, Indiana and Wulp had a friendship as cantankerous old men who happened to live on the same remote island, and had a mutual friend in Jamie Thomas. After Indiana died, Wulp defended Thomas publicly. "Jamie was devoted to Robert Indiana," the *New York Times* quoted him as saying. "I believe he kept him alive during the last few years of his life."

Robinson says it was McKenzie who invited Thomas back into Indiana's inner circle. He alleges that Thomas lied when he testified in probate court after Indiana died that he had worked for the artist for a decade, beginning in 1990, before being rehired back in 2013. "Other than that time in '98, I didn't see him again until McKenzie showed up. But after McKenzie bought the house, he would show up at Bob's with McKenzie all the time," he says. "McKenzie would

show up on the island on weekends and he and Jamie would pitch ideas to Bob."

McKenzie also disputes Robinson's account. He says Indiana needed more reliable studio help in 2013 because of the renewed interest in his work following the retrospective at the Whitney and his continued success with *HOPE*. McKenzie didn't think Hillgrove, Robinson, and the others were dependable or trustworthy, so he suggested that Indiana find more help. He says he asked Indiana whom he would like to hire, and says it was Indiana who suggested Thomas. It's during this same period that McKenzie was telling Indiana he should not trust Salama-Caro or his family and, even though Indiana had an attorney, McKenzie was actively searching for a lawyer who would explore legal options against Morgan Art.

"Bob described Jamie as his best friend, and he was looking for another employee. I didn't even know Jamie Thomas," McKenzie testified in probate court in Rockland. "And based on him saying that Jamie was his best friend, I then researched more and found that he also had painted for Bob for several years, and [Bob] actually owned one of Jamie's paintings."

With his P.T. Barnum–like, slippery charm, McKenzie arranged to meet with Thomas. "I said, 'Look, Bob is looking for somebody that can run the studio that isn't a jackass. And you seem like a nice guy. I don't know if you're interested.'"

Thomas told him Indiana was tough to work with and he wasn't sure. "And then the next time I came up he was working for Bob. And Bob always described Jamie as his best friend, his best living friend," McKenzie testified.

That description might be an example of McKenzie's hyperbole, even under oath. But it's also true that Thomas was close enough to Indiana in 2008 to warrant an invitation to his eightieth-birthday party, a fairly exclusive shindig that

included guests from across the United States and Europe, as well as islanders and employees closest to the artist. Among the latter group were Melissa Hamilton, Valerie Morton, Sean Hillgrove, and Webster Robinson. Thus, Thomas's presence suggests he had some personal standing with Indiana long before he returned to his employ, although "best living friend" is a strong assertion.

It's also unclear whether McKenzie and Thomas met at the party or already knew each other. In any case, five years later they were fast friends and remained loyal to one another throughout legal ordeals.

<div align="center">☆</div>

When Jamie Thomas returned to work for Indiana in 2013, he served as the artist's personal assistant, bringing Indiana his meals at night, after the others had gone home, and "making sure that he was put to bed at the proper time, making sure that his dog was OK," Thomas testified at that same probate hearing. "All of that, and whatever else he wanted me to do—get his mail, small things like that."

At first, Thomas bartered with Indiana, which is not an uncommon arrangement in small Maine towns, though perhaps less common with internationally famous artists. In return for helping out, Indiana designed a logo for a seafood business Thomas and his family started on Vinalhaven. There's a video posted to YouTube that shows Indiana showing off the logo, saying, "Here we are, my most recent endeavor. This is done just a few days ago. I have friends who are starting a seafood company and they asked if I would do the logo for them. I'm not very fond of lobster myself."

When Thomas's work with Indiana became more regular and his duties expanded, so did his pay. In 2013, Indiana

paid Thomas \$1,000 a week. By 2014, it had risen to \$1,500 a week. After Thomas was given Indiana's power of attorney, in 2016, he quickly increased his own salary to \$5,000 a week. At the probate hearing after Indiana's death, Thomas defended giving himself a raise to more than a quarter of a million dollars a year to work as a personal assistant. "By then I was on call 24/7. I had a cell phone that was hooked to an alert system that was around his neck. I didn't go anywhere," Thomas, who was fifty-three at the time, testified. "I was always within ten minutes of his house. Again, I was on call 24/7, plus all the other duties I had."

During the final two years of Indiana's life—from the time Thomas first held power of attorney, in May 2016, until Indiana died, in May 2018—Thomas paid himself more than \$490,000. He'd also received more than 118 works of art from Indiana, which is far more artwork than other individual employee or friend had ever received.

In addition to the close to half million he'd been paid and the gifts of art, Thomas withdrew \$615,010 in cash from Indiana's accounts, often in denominations of hundred-dollar bills. In contrast, from 2011 to 2016—the five years prior to Thomas holding power of attorney—Indiana had withdrawn just \$38,300 from the same accounts.

In the last years of Indiana's life, as his health rapidly declined and he rarely left the Star of Hope, his money seemed to get around Vinalhaven more than he did: after the artist died, Thomas's wife, Yvonne, turned over a bag containing \$179,800 in cash, according to court documents, and the art handlers and assessor hired to move Indiana's art found another \$95,800 in cash hidden behind a filing cabinet in an island building Thomas had leased to store Indiana's artwork; no one will say who hid it there. There are stories of people

close to Indiana knifing his furniture after he died in search of hidden stashes of cash.

Thomas never explained why his wife had a bag of Indiana's cash or why he'd withdrawn all that money in hundred-dollar bills. The difference between the money Thomas withdrew and the money returned or recovered is $344,410; no one has said where that money went, although Thomas's lawyer implied that it was to help cover payroll Indiana shielded from tax collectors.

When allegations of abuse, neglect, and fraud surfaced against Thomas in legal filings, one of his attorneys, a criminal defense lawyer named Thomas Hallett, told the *Portland Press Herald* that the accusations were "scurrilous," and said the bulk of the allegations were "untrue, and that's a real problem from where I sit."

Thomas said he had authorization from Indiana for everything, and downplayed the significance of the gifts, saying many of them were prints or cards, with little monetary value. Another of his attorneys, John Frumer, strongly objected to the characterization that Thomas had pocketed cash and gifts. He defended his client in U.S. District Court, telling the probate judge in March 2019 that Thomas had limited funds and limited ability to pay court costs. "Much of it was returned to the estate," Frumer said. "Some of [the cash] was . . . taken out for Mr. Indiana so that Mr. Indiana could give it to people like [his other assistants,] who got literally on a weekly basis four to eight thousand dollar a week."

The gifts of artwork, he continued, were not as black and white as suggested in court filings. Many were "literally postcards. There may be four or ten works of art—in air quotes—that do have some value, but because of certain market conditions, you can't just go and sell everything at

once. He would be willing to put those up, in some respect to pledge it," Frumer said, "but to suggest that he is a man of significant means is quite frankly preposterous."

Indiana gave lavish gifts, so the idea of Thomas receiving valuable pieces of art would not have been out of character. After all, the artist gave Hillgrove the *Marilyn* painting, as well as a house; he also bought homes for Webster Robinson and Wayne Flaherty, and, according to Deputy Sheriff Potter, another man on Vinalhaven. He gave Marc Salama-Caro something from his *Autoportrait* series. He routinely gave away artwork to other assistants, islanders, and art-world friends. Everyone who knew him well says Indiana was profoundly generous to many of those who were loyal to him. It's entirely plausible that Thomas also earned Indiana's trust and was rewarded with one of those jaw-dropping gifts. It had happened more than once.

Indiana was generous in other ways. Frumer was correct that Indiana paid his other assistants remarkably well. Hillgrove was making $10,000 a week at the end of his employment, according to his daughter, and Robinson says Indiana boosted his pay to $10,000 a week when his sister became sick. "He knew I was paying all my sister's bills, so he essentially paid for her care," Robinson says. "He treated me and Sean like his kids, and he wasn't seeking publicity for it."

In the final year of Indiana's life, the artist's weekly payroll for three assistants was $25,000. Their responsibilities ranged from gofer and caretaker, to studio aide, to financial and medical overseer. That's a $1.3 million payroll in one calendar year for three people—and that doesn't include the money he was paying under the table to Wayne Flaherty, who later pled guilty to drawing Social Security benefits while he was working for Indiana. Between 2012 and 2018, Flaherty

earned almost $850,000 from Indiana—while Flaherty was being investigated by the Social Security Administration after the artist's death, he said the payments were "hush money" because Indiana had sexually abused him as a teen.

When Thomas began looking into Indiana's books, he was appalled at what the artist was paying Hillgrove, Robinson, and Flaherty. The rumors of freeloaders living off Indiana's largess looked to be true, he concluded, and he had the ability to do something about it. Using his recently acquired power of attorney, Thomas took control of Indiana's checking account at Camden National Bank on the island, as well as money-market accounts, an attorney-client trust with Indiana's lawyer James Brannan, and other checking accounts from New York City–based banks that were transferred to Camden National.

Desmond, the island nurse who oversaw Indiana's passing, said she and Thomas talked about the sensitive nature and ethical concerns regarding the control of Indiana's finances: "Jamie and I talked many times about when is it time to take someone's rights away when it comes to a checkbook. When is the right time? When does it get to the point that the doctor needs to say, 'It's time for somebody else to make the decisions.' I know Jamie struggled with this. He wanted Bob to retain his independence, to do the things he did to live the way he did for all those years, but at the same time, when do you step in when you see Bob writing these enormous checks over and over again? I can promise you, Jamie struggled to make the right decision, and he did not just randomly say, 'I'm taking over the checkbook.'"

That said, she is not sure how to balance those ethical concerns in conjunction with the bag of cash and the hidden cash that turned up after Indiana died.

"I don't know how to reconcile it," she says. "I've thought a lot about it. I guess I thought Bob was sort of—he request-ed some wacky things and he paid people for wacky things. I thought, Well, maybe. . . . But I really don't know. I don't know how to reconcile it. I felt like Jamie was very con-cerned about it, but it was interesting finding out afterward about this bag of cash that just appeared."

Not everyone has had Desmond's degree of confidence in Thomas. But the influence he exerted on the last years of Indiana's life is undeniable.

☆

ONE MORNING IN February 2018, Indiana's regular crew—Hillgrove, Robinson, and Flaherty—showed up for work only to find that their keys no longer worked at the Star of Hope. As the trio fumbled with the locks, Deputy Sheriff Potter showed up and told them they had been fired, they were no longer welcome on the premises, and they had to leave the island.

Potter says he was acting at the request of Thomas, who asked him to come to the Star of Hope to tell the trio they had been fired. "Jamie had the locks changed, and he called me and told me they were over there, and they were try-ing to get in the back door. 'Are you going to come down and explain to them what is going on?'" Potter says Thomas asked him.

"I went down. Jamie never showed up. I told them to go home, and they got on the next boat. Jimmy Brannan paid them off and told them never to return," he recalls.

Although Potter had no legal authority to force anyone off the island, Robinson left, despite holding a twenty-year lease on the house Indiana bought for him. He figured there was

nothing but trouble to be gained by staying, and he needed the money. And then there was the threat of island justice, which Robinson might have faced had he stayed. He and Flaherty, who lived on the mainland in a trailer also purchased by Indiana, accepted what Indiana's on-and-off-again-attorney James Brannan later described as "severance pay." Each man was offered $25,000 to walk away if he would sign a letter stating he'd say nothing of his time working for Indiana. Others called the letter an NDA, a nondisclosure agreement, a legal tool often used to silence former employees who witnessed wrongdoing by their employer or coworkers.

When Robinson returned to his former island home in hopes of claiming his possessions, the front door was screwed shut and the windows boarded up, he says. He had to get permission from Brannan to get his belongings. Artwork that he says Indiana had given him, including a Chinese *LOVE* and a *HOPE* print, were gone. Some pieces he was able to recover later, he says; others he never saw again.

Hillgrove was offered the money but refused it and wouldn't sign the NDA. He also refused to leave the island and instead hunkered down for the winter in the little Saltbox with the clear view of the Star of Hope. Brannan persisted. After severing his alliance with Thomas, he returned to Hillgrove with more offers of money in exchange for incriminating information about Thomas and the nature of his friendship with Indiana.

Between February 2018, when Hillgrove was locked out, and Indiana's death, in May 2018, Hillgrove begged Brannan to let him see the artist. According to Hillgrove's journal as well as interviews with Hillgrove's grown daughter and his mother, Brannan refused Hillgrove's request unless he agreed to accept the $25,000. Hillgrove's daughter describes the of-

fer as bribery, dangled in front of her desperate father. When Hillgrove declined, the dollar amount went up, according to his journal: "I have former employee's that can vouch that he [Indiana] was everyday asking for me, and still nothing but 'What's your number? Give me a figure' is pretty much all I'm getting [from Brannan]," he wrote. Hillgrove never did business with Brannan. And after his trip up the ladder in February, he never saw Indiana again.

On a slowly warming day in May, Hillgrove's mother called to tell him she heard on the news that Robert Indiana had died. He put down the phone, grabbed his binoculars, and went to look once more for any sign of life or any reason for hope.

Hillgrove was still in shock and reeling with grief, guilt, and bewilderment when FBI Special Agent MacDonald arrived at his doorway the next day with a long list of questions. Mac-Donald fits the personality traits of a textbook G-man: stern and tenacious. He has investigated the highest of high-profile cases in the Northeast, such as that of the fugitive gangster Whitey Bulger and his girlfriend, Catherine Grieg, and art heists from the Isabella Stewart Gardner Museum in Boston and others of N. C. Wyeth paintings worth $50 million from a Portland apartment. That MacDonald was involved in the Indiana investigation and showed up on Vinalhaven so soon after the artist's death suggests how seriously this case was being treated by the FBI's field office in Boston. The FBI has repeatedly declined to make MacDonald available to discuss the case; and nothing ever publicly came of the investigation.

Hillgrove remembered MacDonald as serious and no-nonsense in a friendly way, but not in a friendly-joking way. "He just showed up and asked if I had a little bit of time," Hillgrove told the *Portland Press Herald*. "But I don't believe I had the option."

MacDonald broke the ice by asking about Indiana's lifestyle and Hillgrove's relationship with the artist, but he mostly asked questions about art fraud. What did he know about some of the work made under Indiana's name in recent years? Who was creating that work? What did Indiana know about that work? Did Hillgrove see any artwork being loaded out the back door of the Star of Hope in the days since Indiana's death?

"He kept asking about the art that was being sold and if I knew anything about it or who was participating in it," Hillgrove said. "He was very thorough."

When Hillgrove met with the media the next morning, he looked tattered and defeated. He was tired, with heavy lines in an unshaven face. He wore suspenders over a sweatshirt and avoided eye contact. Once sinewy, he was now soft. His hair seemed to be turning gray in front of reporters. He left many of his sentences unfinished. He was forty-nine going on eighty.

The days continued to warm, but Hillgrove didn't likely care much about the coming summer. On June 21—a little more than a month after Indiana died—Deputy Sheriff Potter served an eviction notice. Hillgrove was given thirty days to leave but refused to go, until Potter acted on a forcible entry and detainer complaint issued through the District Court in Rockland on July 23.

Hillgrove and his daughter moved in with his mother in Rockland, and he fell into a spiral of depression. In early February 2020, he checked into the hospital with pneumonia, linked to non-Hodgkin's lymphoma, and died there in April, less than two years after Indiana's passing. He was fifty-one.

Hillgrove's symptoms first appeared in 2016, when he lost a significant amount of weight and noticed lumps on his neck. He told his daughter in early 2017 that he was getting

an ultrasound on the lumps, which led to the non-Hodgkin's lymphoma diagnosis that spring. Doctors later wondered if he had bone cancer, but never confirmed their suspicions.

Alexandra Aiken says her father died a broken man: "Ultimately, he gave up. He stopped caring about himself. He said he felt like he was such a failure because he was not there to protect Bob at his final moment. He felt like he had failed him, because my father made a promise to Bob that he would take care of him until the day he died," she says. "That's why Bob bought him his home, so he could be close to him."

Even though Hillgrove had refused Brannan's offers of money as the attorney was building his case against Thomas, Hillgrove's death didn't deter Brannan from trying again: he called Hillgrove's mother after her son's death and asked if he had told her anything about Thomas that might be of interest to him. As 2020 turned to 2021, Aiken was still fighting with Indiana's estate for possession of the *Marilyn* painting the artist had given to her father.

Aiken spent many hours with her father in the hospital and promised him she would seek the truth about what happened, to see if her father's instincts about Indiana being mistreated were correct—and, if so, expose them.

Mostly now, she wants to stand up for her father, because his image had been tarnished. She acknowledges his addiction and says his substance abuse was the only thing that could be used against him. And it was, exploited by those who gained the most by removing Indiana's strongest protector, his most loyal friend in Maine, and the last man on earth who was willing to fight for him.

AFTER SEAN HILLGROVE died, Alexandria Aiken took over her father's commitment to Indiana. When stories in the media portrayed Thomas as Indiana's longtime personal associate and not Hillgrove, Aiken began a Facebook page called Sean Hillgrove's Truth, "to let the world know who he truly was as a person and his importance to the late artist, Robert Indiana, and his life." She fills the page with photos of Hillgrove and Indiana going back decades, as well as articles from ongoing coverage of the court case.

Aiken soon moved beyond simply posting on social media. In spring 2020, she wrote a long letter to the Maine attorney general expressing concerns about Indiana's isolation at the end of his life, her father's relationship with Indiana, and her suspicions that his final will was signed under duress.

"I'm going to hold the people involved accountable, because my father couldn't shake the pain inside of him that made him feel like he failed Bob, and that things would have been different, and that Bob might still be here if he had just broken into the house and forced his way in," she says.

The first person in her sights was Jim Brannan, a longtime Rockland attorney and Indiana's personal representative. She

accused him of abuse of power in her letter to the attorney general and tangled with him over the estate's possession of what she says is her father's *Marilyn* painting. Brannan is a Maine native who has spent much of his career doing a sort of menial legal work, such as real-estate deals and writing wills—the kinds of legal matters necessary for a small community to function. He keeps a modest office downtown, just off Main Street, close to both the ferry terminal and the courthouse, which makes him convenient counsel for islanders in need of legal services: if you're getting off the ferry and have business at the courthouse, you have to walk right by Brannan's office.

But not all of Brannan's clients are locals. Chief Justice of the U.S. Supreme Court John Roberts retained Brannan as his personal attorney in Maine after purchasing a home on an island off the coast of Port Clyde in 2006. When Roberts gaveled open the first day of the first impeachment trial of President Donald J. Trump, in the winter of 2020, Brannan was there to witness history, with a seat in the Senate gallery as a guest of the chief justice. Earlier that day, Roberts invited Brannan to sit in his guest box to watch oral arguments in unrelated cases.

Not bad for an ambitious Maine kid, who left the then-hardscrabble town of Rockland when he was drafted into the Vietnam War and returned to practice law as his town transformed from one built on the lime and fishing industries into one based on art galleries, restaurants, and tourism. Through his law practice, Brannan had a hand in Rockland's evolution. Here he was, all these years later, playing eyewitness to history because of his successful hometown law practice.

Brannan still has a disciplined edge. He keeps himself in shape and moves quickly. He's thin and strong, with a firm

handshake, tight jaw, and tightly cropped white hair. He's got a friendly smile and a hearty laugh, and is both well spoken and polite. Brannan is respected in the community; his friends call him Jimmy.

Bob Indiana and Jimmy Brannan had a complicated relationship. Although that can be said of almost all relationships people had with Indiana, who could be prickly with anyone at any time, he was always impatient with lawyers and generally distrusted them. If he'd held a different disposition toward the legal class, Indiana might have avoided his trouble with *LOVE* in the first place, as well as other messes he created or stepped in over the years.

Beyond the artist's woes over the 1990 solicitation charges and his tangles with tax collectors, he spent a fair amount of time in court over his art. As recently as 2012, Indiana was in a dispute with a man named John Gilbert regarding an agreement the artist signed in 2007 to create and fabricate the word *prem,* "love" in Hindi, into a sculpture. There were issues surrounding authenticity, with Indiana saying he never approved the work and Gilbert suing for Indiana's acknowledgment of the sculpture so he could sell it. Gilbert lost; Indiana was granted a summary judgment.

Brannan, who didn't represent Indiana in that case, liked to say that he was not Indiana's longtime attorney but that he had been Indiana's attorney over a long period of time. "He hired and fired me on many occasions over the years. He just hired me one more time than he fired me," Brannan says, attributing his relationship with Indiana to the transactional nature of his work.

The pair first met in 1979, in an auspicious beginning that would seem to offer an appropriately complex bookend to their close to forty-year association. When Brannan returned

home to New England after serving in Vietnam, he landed first at Suffolk University Law School, in Boston, and then back in his hometown on the coast of Maine to practice law in the offices of an established Rockland attorney. Indiana had only recently moved to Vinalhaven full time and needed an attorney.

Shelley Lieberman, a friend of Indiana's New York days, had begun paying unwanted visits on Vinalhaven in hopes of working his way back into the artist's life. But Indiana was intent on keeping a low profile, and on an island where any stranger draws notice, Lieberman, a transvestite, stepped off the boat in drag and walked down Main Street and immediately became the talk of the town. Lieberman challenged Indiana's desire to quietly settle in, and Indiana sought Brannan's firm's help to secure a protection order, which was never issued for lack of cause.

A friend from those days remembers Lieberman from an island party. "Shelley was an attractive, flirty, I assume gay fellow and definitely not in drag at the party," he recalls. "I believe he was from New York. That was the only time I saw him." Later, this friend was told, Lieberman showed up on the island "with some rough types" but was turned away "by Bob's protectors."

Sometime after that, Lieberman was found floating in the water, dead.

"I think Shelley and Bob were in love, and I think that's why Bob let Shelley in and out of his life. But like many relationships, it just didn't work out," Brannan says. "I guess you could say that was an interesting angle that brought me into Bob's life."

For decades, Brannan and Indiana, too, went in and out of each other's lives. For example, Brannan drew up the real-es-

tate paperwork for the homes that Indiana purchased for his assistants. Eventually, though, everything changed: Beginning in 2015, when he was recruited to work for Indiana in more complex legal capacities, Brannan became one of the most powerful forces in Indiana's life, and grew even more influential after the artist's death.

<p style="text-align:center">☆</p>

ACCORDING TO JAMES Brannan, on April 18, 2016, which was Patriot's Day in Maine, a state holiday that marks the beginning of the Revolutionary War, one of Indiana's assistants, Bo Dodd, knocked on Brannan's office door in downtown Rockland to tell him that Indiana wanted to draft a new will. Brannan called the Star of Hope and left a message saying he would come to the island whenever Indiana was ready. More than a week later, Jamie Thomas—not Indiana—returned Brannan's call, and they made arrangements to meet the next day at the Star of Hope. On April 30, Thomas picked up Brannan at the ferry and they drove the short distance down Main Street, past the boatyards, bank, and post office.

Brannan knew the route well; he was a regular visitor. He says he had seen Indiana "on a number of occasions, maybe fifteen times" between 2000 and 2016.

Thomas led Brannan upstairs to the kitchen to meet with Indiana. The lawyer observed that the artist's eyesight was poor, and that he was frail and gaunt, but otherwise in decent physical shape for an eighty-seven-year-old man who shunned medical care. "I made a note that he was actually better than I had seen him prior on fairly recent occasions. He was with it," Brannan says.

But he sensed a shift toward melancholy in his old client's demeanor.

"I spent a good amount of time with him going through things" Brannan says, "and it was pretty clear to me that there had been a lot of death around him and people were ill. Valerie had died, Bo was ill, and Sean was looking terribly ill. I think Bob was finally confronting his mortality, and it was very important to him that he get this done. He told me this, he said, 'My time is coming to an end and I need to get my will done now.'"

As their meeting began, Indiana told Brannan he wanted to purchase the Sail Loft, the large studio kitty-corner from the Star of Hope that he had occupied as a rental since soon after he arrived on Vinalhaven. He had received a letter from the building owner's attorney offering to sell the property, and Indiana desperately wanted to buy it.

According to Brannan, the conversation then moved to the artist's will, which was relatively simple. There were only two significant changes: Brannan would become the executor of the estate instead of Indiana's then attorney and longtime executor, Ron Spencer, and Jamie Thomas was given power of attorney and named executive director of the Star of Hope Foundation, a nonprofit organization formed to maintain Indiana's home after his death and transform it into a museum. For Thomas, his new roles—along with his medical power of attorney—gave him enormous authority to shape the artist's legacy, as well as control of an art collection worth tens of millions of dollars. Thomas, who has performed occasionally as a musician and dabbled in the local theater troupe the Vinalhaven Players, has no formal art training, nor any experience running a nonprofit institution.

The fast-walking attorney hustled back to his Rockland office and redrafted the will based on Indiana's direction; he

also drew up the paperwork for the Sail Loft transaction. Brannan says he wasn't shocked to be asked to serve as executor. The artist was eccentric and had a penchant for sudden changes of mind. Indiana was tightening his circle and wanted the convenience of a local attorney he trusted and who could respond quickly to his needs, he says.

Brannan also knew he was in line for a big payday. In Maine, a personal representative draws fees based on several factors, such as the nature of the work involved, the size and complexity of the estate, and the person's experience and capabilities in the role. For a $25 million estate, which was the initial estimated value at the time of Indiana's death, Brannan could expect to earn up to $700,000 for his duties as personal representative. The more valuable the estate, the more he could charge.

Brannan says he contacted Indiana's former attorney Ron Spencer twice to request a copy of Indiana's current will, but never heard back. Spencer says that's not exactly true. "Brannan did indeed twice demand a copy of the original will, but I would not provide the original to Brannan without a letter signed by Bob, as opposed to a letter from Bob's lawyer. Eventually, we got a letter, and my law office provided the original will directly to Bob," Spencer says.

Brannan then contacted the people he usually hires to serve as witnesses and arranged a return trip to Vinalhaven for the signing a week later. But he changed plans when Indiana objected. According to Brannan, Indiana didn't like his idea. He was a private person and at a point in his life when he didn't want to meet new people or deal with strangers, especially if it meant those strangers would be coming into his home. He insisted that the witnesses be people he trusted, people from the island, Brannan says.

Brannan and Thomas recruited Jennifer Desmond, the nurse practitioner, who would eventually be one of the last people to see Indiana alive, and Rachel Noyes, who owned a store next to the Star of Hope.

For a notary, Brannan sought out Catherine Bunin-Stevenson, a mainland attorney and long-ago former assistant attorney general for the State of Maine with generational island roots and personal connections to Indiana through his friendship with her parents. In addition to her legal career, Bunin-Stevenson earned her dentistry license and practiced for many years on the mainland until 2019, when she was censured by the Maine Board of Dental Practice—she was not only restricted from providing patient care but also ordered by the board to seek treatment with a psychiatrist. In local press reports, the closure of her dental practice was attributed to an "unforeseen illness."

Three years before that censure and discipline, on May 7, 2016, a raw and overcast Saturday, Bunin-Stevenson met Brannan at the ferry. They made their way to the Star of Hope, where they joined Indiana, Thomas, and the others in the second-floor living room to witness the last time Robert Indiana would sign away his rights against his best interests.

Although he had made the decision many years earlier to turn the Star of Hope into a private museum and leave his art to his own foundation, Indiana had guarded that choice closely. He liked to keep people guessing and treated museum directors as if they were fish and he the fisherman, teasing them with his bait. One museum director called Indiana's decision about what he would do with his estate "the biggest one we are all waiting for." Another described it "as a big middle finger" to museum directors and curators everywhere.

Before everyone else showed up that morning, Desmond went to the Star of Hope to see Indiana alone. She was serving as a witness for the signing ceremony, but as his primary caregiver she felt a sense of duty to speak with him privately to test his mental acuity so she could document in her files that he was competent. They spent about thirty minutes together.

As with others in Indiana's inner circle at the end of his life, Desmond knew of his intentions with the Star of Hope and had for many years. It wasn't a secret among them, and the only change in the new will involved personnel: naming Brannan as his executor and Thomas as the future director of the foundation. Desmond also says it was common knowledge among those closest to Indiana that Thomas was being given authority with the power of attorney.

"It was a very nice conversation," Desmond recalls. "He just outlined to me what he wanted, which he had outlined to me before. This was not a new thing. He talked about how important this was to him. I sensed that he was very relieved."

Soon, the others showed up. Thomas set out some sliced fruit and drinks, and everyone mingled and made small talk. Indiana asked Bunin-Stevenson about her parents, and the two exchanged memories of friends they had in common.

Indiana and Brannan retreated to the kitchen, followed by Thomas. Brannan asked Thomas to step out, because he wanted to be alone with Indiana and to ensure that Thomas wasn't trying to influence the artist. According to Brannan, Indiana objected to Thomas leaving, but Brannan insisted. Thomas left the kitchen and Brannan says he read the will out loud, word for word, to make sure it was accurate and to see if Indiana had any doubts or second thoughts. Brannan says Indiana reiterated his eagerness to get the paperwork signed and be done with things.

After their private meeting in the kitchen, Brannan says he and Indiana rejoined the others in the living room. He again asked Thomas to leave, again to remove any chance that Thomas might influence Indiana, the attorney says. He then explained the legal process and each person's duty. As the will was read again, Indiana signed every page with his flourish of a signature that began with a large capital *R* and quickly descended into a wavy scribble.

Brannan gave Bunin-Stevenson a standard script to read to Indiana, asking him if he signed the will freely and voluntarily and without undue influence, and asked similar questions of the witnesses. As notary, Bunin-Stevenson's responsibility was to attest that Indiana signed the will without undue influence and that he had the mental capacity to do so. Bunin-Stevenson had no doubt that Indiana was of sound mind that morning. "Oh, he was very cognitively aware," she says. "It was actually a very good time."

Bunin-Stevenson, who was responsible for gauging Robert Indiana's mental capacity, would in three short years be ordered to seek treatment with a psychiatrist if she wanted to practice dentistry in Maine.

The four-page will is surprisingly standard given the complexities of Indiana's estate and holdings, and reads like that of an average Mainer, not a world-famous artist. The language Brannan crafted is boilerplate and common, other than the clause that bequeathed "all works of art created by me, including, but not limited to, my paintings, prints, sculptures, other art, artifacts, photographs, records, and archives" to his foundation, which Thomas would direct. There's also what's known as a "catch-all" clause, or a safety net, leaving anything else that might have been missed in other parts of the will to the discretion of his personal executor, who was Brannan.

The process took just a few minutes, and Thomas returned to the living room for a champagne toast. It was a joyous moment, Desmond says. "Bob seemed happy. Jamie seemed happy. Everybody seemed happy," she says, "and nobody questioned anything."

Brannan says Indiana gave him a check for $505,000, far more than enough to the cover the cost of purchasing the Sail Loft. The deed on file with Knox County says the price was "one dollar and other considerations," but Robinson and others say it was about $300,000.

On May 20, 2016, less than two weeks after Indiana signed the will that made Brannan executor of the artist's estate, Brannan and his wife paid $635,000 in a short sale for a con-do in Florida.

Despite having met with Indiana on many occasions during the previous decade and a half, despite numerous trips to the island to confer with Thomas and others about Indiana's legal affairs, Brannan never again saw Indiana in person.

☆

RONALD D. SPENCER served as Robert Indiana's attorney and executor of his estate for a decade—until spring 2016, when a brief note from Indiana's email account fired him without explanation. "I got an email that just said, 'Ron, I am going to retain another lawyer.' That's about all it said." When Spencer called and wrote emails in reply to ask why he had been let go, he received no answers. "He was impossible to get a hold of. His people were keeping him from communicating."

Eventually, he gave up.

Whether Indiana made the decision to fire Spencer himself, was talked into it by others, or his email account

was used—as it so often was—by someone else, it was a foolish decision in regard to Indiana's financial well-being and artistic credibility. Spencer was exactly the attorney Indiana needed: sharp, experienced, and willing to fight for his clients. He represented the Krasner-Pollock Foundation since close to its founding, in 1985, and became its CEO and chairman in 2018. Among his clients were the Gala-Salvador Dalí Foundation, the Andy Warhol Art Authentication Board, and the estate of Piet Mondrian. A few years before he went to work for Indiana, he edited a collection of essays for Oxford University Press called *The Expert Versus the Object: Judging Fakes and False Attributions in the Visual Arts*. And he was among the experts interviewed for the documentary *Made You Look*, about the forgery scandal surrounding the New York City gallerist Ann Freedman and the Knoedler Gallery. He has serious credibility in the art world.

Spencer also represented the Morgan Art Foundation, until the company began contemplating suing Indiana, which presented Spencer with a conflict of interest. In 2017, while Nikas was deeply involved in defending Freedman, he replaced Spencer as Morgan Art's attorney and began preparing the case against Spencer's former client.

Spencer worked closely with Indiana in the early part of their relationship and remembers the artist as gregarious and engaged. He enjoyed visiting him on the island, despite Indiana's difficult nature and shifting opinions and general waffling. One thing he was clear and direct about, though, was his vision for and commitment to the Star of Hope Foundation. "Bob was on board. He wanted the foundation, and he wanted the foundation to own the Star of Hope and his artwork. That is what he wanted," Spencer says.

Their last conversation, in late winter or early spring of 2016, involved the composition of the board. "We were in his kitchen," Spencer says, "and there was a snowstorm and I almost got caught on the island. It was snowing like hell, and we were talking about who would be on the board." The lawyer made the ferry and established the legal parameters of the foundation exactly as Indiana wanted it and filed all the paperwork to make it happen. After Spencer's work was done, he received the one-line email firing him.

Spencer alleges that Indiana signed his final will under undue influence, and the attorney petitioned—without apparent success—Maine Attorney General Aaron Frey to intervene. "It's a very common issue that an older person like Bob comes under undue influence. Not whether he signed the will, but that it was procured under undue influence," he says. "You can be competent, but if someone puts a gun to your head to sign and you sign it, you are unduly influenced."

In the flurry of paperwork Indiana signed on May 7, 2016— the will, the power of attorney, and the real-estate deal—and amid what was indeed a toast-worthy moment of joy for completing the purchase of the Sail Loft, some speculated he affixed his signature to whatever papers were put in front of him without fully knowing what they were. His eyes were poor by then, and he would soon be almost blind.

In the legal cases stemming from the effects of Indiana's new will and the assumption of power of Thomas, both Brannan and Morgan Art said they had evidence alleging the use of signature machines around the same time. Some people close to Indiana have speculated that one of those signature machines was used to replicate Indiana's signature on his will or the power-of-attorney paperwork.

Robinson wasn't usually on the island on weekends, so he wouldn't have been around to witness the meeting. But he doesn't believe it happened as Brannan describes and doubts that Indiana ever signed his final will at all.

Spencer says the Morgan Art lawsuit filed against Indiana the very weekend the artist died was a sideshow to the most important issue: he believes that Robert Indiana signed his final will under undue influence and the Maine attorney general failed him by not investigating more thoroughly. Spencer is incredulous that his inquiries got little response. "The State of Maine and all its authorities—the attorney general, the district attorney— they have all dropped the ball. They all failed Robert Indiana."

Sean Hillgrove and Webster Robinson didn't learn about Indiana's new will and Thomas's status as holder of the power of attorney until more than a year after both were enacted: a teller at Camden National Bank on the island refused to cash their paychecks and informed them that Thomas had to authorize the checks. That had never happened before. Indiana had always signed their checks, and there were no questions asked. They were angry and confused and went to the Star of Hope to confront Indiana, who Robinson says professed no knowledge of the new check-cashing protocol and denied he had given Thomas power-of-attorney privileges a full year prior.

"He swore up and down that he never gave Jamie power of attorney," Robinson says. "I used to order Bob's checks online whenever he got low on checks, but then Jamie ended up ordering these big, huge checks and put his own name underneath Bob's name on the check, and when Bob found out he was so fucking furious: 'How can Jamie put his name on these fucking checks?' That's when we told him that Ja-

mie's got power of attorney, and Bob just went right off: 'I never gave Jamie no such power.' He got right ugly."

Indiana was frail and growing weaker but found the strength to roar with a flash of his famous temper. Robinson says he watched as the old man, shaking with rage, ordered Hillgrove to contact Spencer to fix things—he seemed unaware that he had fired Spencer the year before. Hillgrove sent Spencer an email nonetheless, and Spencer responded by drawing up paperwork revoking the power of attorney Indiana had conveyed that rainy day in May 2016.

Spencer's one-sentence letter of revocation was simple and concise: "I REVOKE my May 7, 2016 Power of Attorney for Jamie L. Thomas and his successor, James W. Brannan." He sent it via FedEx overnight priority to Flaherty, who lived in Waldoboro, about a thirty-minute drive from the ferry to Vinalhaven. Hillgrove asked Spencer to send the revocation letter to Flaherty on the mainland because they feared it would be intercepted if sent to the island, even if addressed to Hillgrove or Robinson at home. It's a tight community, and Thomas was well respected, but they didn't trust that Spencer's overnight package would arrive without being opened, or that it would arrive at all.

After Flaherty received the document, he would give it to Hillgrove, who would arrange for Indiana to sign it, and then he would file the paperwork with the court. Things would, they thought, soon return to the way they had been. Indiana wrote a large check to Flaherty to pay for Spencer and all the hasty arrangements. Flaherty, who had a reputation for being unreliable and later confessed to Social Security fraud, cashed the check and took off for Florida, with the revocation paperwork from Spencer stashed in a safe in his home in Waldoboro. He didn't tell

anyone that the document had arrived until after he returned from Florida.

"I never heard another word," Spencer says. "Not a single word, which I thought was strange."

When Flaherty came back that winter, he went to see Brannan about an unrelated legal matter. During their conversation he casually mentioned that he had the paperwork from Spencer revoking Thomas's power of attorney in his safe. Soon after that meeting, Thomas abruptly fired Wayne Flaherty, Sean Hillgrove, and Webster Robinson; this was the day the locks were changed at the Star of Hope, and Potter, then the deputy sheriff, told the men to get off the island. And it was soon afterward that Hillgrove climbed the ladder on that cold February night to test his covert communication system with Indiana.

Brannan and Thomas were ready to act the moment Indiana's new 2016 will was threatened and moved with precision to blunt that threat by forcing out and attempting to silence the men. They had prepared for this day just months before. During a Star of Hope Foundation board meeting on December 22, 2017, Brannan, Thomas, and attorney John Frumer agreed, according to minutes of the meeting revealed in court documents, that "Bob is safe and secure and Pinkertons are ready. Jamie is concerned that Salamacaros [sic] could still somehow get in to [sic] the building and get Bob to change his will."

The paperwork that would do exactly that by revoking Jamie Thomas's authority with the power of attorney—paperwork the artist's former studio assistants insist Indiana wanted to sign—remained locked away in a safe in Flaherty's mainland home, purchased for him by Indiana.

Retelling the story, Robinson shakes his head at the Key-

stone Cops escapade of his buddy. "Wayne's kind of got a big mouth and he sometimes shares information he shouldn't," he says.

It got a lot worse for Flaherty. Early in 2021, at age fifty-three, he admitted to receiving $141,214 in Social Security disability payments over an eighteen-year-period while he was also earning money, sometimes paid in cash, from Indiana, who was referred to in U.S. Justice Department documents not by name but as "another individual." Flaherty admitted to receiving $1,500 monthly from "the individual" when he began drawing benefits in 2000, and his pay steadily increased. From 2012 to 2018, Flaherty earned $846,615.18, according to the U.S. Department of Justice, all while earning disability benefits.

With the critical paperwork in Flaherty's safe, Indiana faced his final months mostly alone in a drafty old house.

In May 2021, Flaherty was sentenced to three years of probation, 240 hours of community service, and ordered to pay $141,214 in restitution.

☆

AS THE LAWSUIT filed by the Morgan Art Foundation against Indiana the weekend the artist died worked its way toward an awkward settlement, the estate incurred approximately $10 million in legal fees. Through early 2021, Brannan had personally paid himself $1.8 million as the estate's personal representative, according to court records. The Maine attorney general accused Brannan of breaching his fiduciary duties by overpaying himself and the law firms he hired, and by dragging out the litigation when a settlement was within reach.

Brannan assembled a legal team in New York City to defend himself and depose witnesses in the Morgan Art and re-

lated suits. He also had a team of lawyers in Maine represent him in probate proceedings and legal tangles with Michael McKenzie. With a team of lawyers, and some billing $800 an hour, fees added up fast: a 2021 review of Brannan's expenditures by the Maine attorney general's office found he'd billed the estate nearly $8.5 million in legal invoices from seven separate law firms; Brannan's own firm had billed $1.45 million, of which he'd paid himself $1 million.

Brannan hired longtime friend Bruce Gamage to appraise the art in the Star of Hope, the Sail Loft, and other storage buildings on the island. Though Gamage is best known as an antique appraiser more comfortable with a seventeenth-century sideboard than he is with Pop art, he spent several days on Vinalhaven going through Indiana's collection and many more pieces on the mainland later. He billed the estate close to $294,000 for his evaluation. His fees were the largest among the $404,831 billed to the estate for appraisal and removal of art from the Star of Hope and other buildings. Melissa Hamilton received $33,000 for the appraisal and removal of art.

To Bannan, the cost of the appraisal was worth every dime. At the time of Indiana's death, his estate had an estimated value of $25 million. In early 2021, the Brannan legal team contended it was worth $100 million. The more valuable the estate, the easier for Brannan to justify his fees.

The estate shelled out $211,000 in security costs in the days after Indiana died, including $206,000 to Pinkerton Security, who were hired to protect the Star of Hope. Potter, the former deputy sheriff, describes the scene as a "shitshow. The vultures came out of the woodwork. My office phone was off the hook. There were people who were outright hostile with me over the phone because I wouldn't grant them ac-

cess to the Star of Hope so they could get their belongings," he says.

Reporters badgered him with questions. People claiming to be Indiana's relatives demanded to be let in. "But Bob had nobody," he says. "He had no relatives, and I knew that."

Brannan and Thomas hired Pinkerton to provide general security and surveillance. Guards watched the front and back of the house, keeping reporters and gawkers at bay while also making sure art wasn't pilfered. But their expressed concern about reporters and "vultures" was a front for their real goal, which was to make sure no one from Morgan Art entered the lodge.

Douglas Calderbank, a private investigator from Portland, was part of the scene, hired by attorneys for Morgan Art to serve legal papers on Thomas and McKenzie days after Indiana's death became public. He showed up on the heels of the FBI, adding to the drama unfolding on Vinalhaven, where strangers stand out. Calderbank was told to be discreet, because Thomas might be evasive. He arrived on the car ferry late in the morning on Wednesday, May 23. After driving around the island to become familiar with his surroundings, he cased Thomas's house, parking nearby and observing from his car.

From what he could tell, there was no activity in the house. He wondered if Thomas had skipped out. Before long, Potter showed up to ask what he was doing, summoned by a neighbor who reported Calderbank's suspicious presence. After a brief conversation, Potter told him that Thomas was probably home.

It took Thomas a few minutes to answer Calderbank's knock. "He was probably sleeping. His hair was a mess," the private investigator says. "He looked at the paperwork, and

he was surprised he was being served. But he wasn't evading being served or didn't appear to be evading. He was taken aback. He was looking down at the paperwork. He didn't really talk to me, he didn't really say one word. He was skittish. Our encounter was very brief."

He wasn't there to investigate, but a private eye—even while playing tourist after his work is done—can't help but start conversations and ask questions. He spent the day on the island, talking to people and learning a little about Robert Indiana while waiting for the return ferry. He says he spoke with Scott Hamilton, the husband of Indiana's former studio assistant Melissa Hamilton, who expressed concerns about Thomas and the misuse of Indiana's funds. Other people he talked to vouched for Thomas. "They told me Jamie Thomas was a great caregiver and was always there for Indiana," Calderbank says.

He sensed a certain level of energy and tension on the island, embodied by a growing presence of people and media buzz around the Star of Hope. It was still springtime on Vinalhaven, before the summer residents and tourists returned and the population swelled to roughly four thousand, some four times the number of year-round islanders. But it felt like the circus was in town.

Calderbank was back two days later to serve McKenzie. For this trip, Calderbank brought his bike instead of his car so he could explore more of the island, which beguiled him with its hills and webs of roads that took him to bays, quarries, and woods. He knew McKenzie's general travel plans and preceded him to the island. With a few photos from social media as his guide, he eyed every passenger who walked or drove off all the boats that day, looking for a middle-age guy with ruddy cheeks.

"When the second-to last ferry arrived with a male driver matching the social-media photos of McKenzie, I approached his Jeep with New York plates in the parking lot and blocked access for him to leave the area," Calderbank recalls. "I knew this would be the only opportunity to serve him, as my ferry was leaving in 15 minutes. He was surprised by my behavior for stopping in front of his vehicle."

But McKenzie soon understood that he was being served, and appeared humbled. "He was surprised I was serving him coming right off the boat, but he seemed fine. He didn't seem upset," Calderbank says. "He was quiet. He said nothing. He was just served by an agent of the New York courts. He continued on his way to his island home."

Calderbank, worn out from a day of island biking, walked his sore body onto the waiting ferry to depart from an island he enjoyed getting to know. He was intrigued by the case and smitten with Vinalhaven. "It's one of the nicest places I've ever served anyone," he says, "and one of the prettiest ferry rides to an island in Maine I've ever experienced."

Kathleen Rogers, Indiana's former publicist, was among those contributing to the buzz around the Star of Hope the day Calderbank served Thomas. She came over on the morning ferry to place flowers at the heavy wooden doors with the three stars. It was her first trip to the island since 2015, and aside from the sadness she felt about Indiana's death, she was shocked and distressed at the condition of the Star of the Hope. The back fence was chained and locked, the fire escape had been removed, and a blue tarp fluttered from the roof.

She had been coming since 1999 and never recalled it looking in such disrepair. "It had all gone down so quickly," she says.

Amid her grief and the chaos of the afternoon, Rogers encountered Potter on the street as she was preparing to leave the island after she paid her respects. She didn't know who he was, and in all her years visiting Indiana she never remembers seeing any law enforcement on the island. "I've been expecting you," Potter said, which struck Rogers as awkward. She replied she was glad law enforcement was on hand, because she had heard people were removing artwork from the Star of Hope and taking it to another building on the island.

According to Rogers, Potter told her the estate was in good hands with Jim Brannan in charge. This was the second time someone close to Indiana had casually mentioned the name Jim Brannan to her in recent years, but Rogers, who began working for Indiana in 2000, knew nothing about him. "Who is Jim Brannan?" she asked.

"He is the best thing that ever happened to Robert Indiana," Potter told her.

<div align="center">☆</div>

MONEY POURED OUT of Indiana's estate the way rain poured into the crumbling Star of Hope.

Brannan justifies the expenditures by arguing that he was doing exactly what Indiana asked him to do many times over the course of their relationship: protect his legacy and, if he could, expose how Morgan Art Foundation took advantage of him.

But as the bills to the Indiana estate racked up, both Maine Attorney General Aaron Frey and Star of Hope Foundation Chairman Larry Sterrs lost patience with Brannan. After haggling over fees for a year, Frey sought supervisory authority over Brannan. Frey—the attorney general who doesn't appear to have acted on Ronald Spencer's assertion that Indiana had

signed his final will under undue influence—now wanted to prevent Brannan from selling art to pay the estate's bills and asked the Knox County Probate Court to review his expenses.

"They're not happy with me," Brannan said in the fall of 2020, as the case dragged on, seemingly resigned that he would be removed from the case because of the mounting fees. "But I can't settle the case for the sole purpose of getting rid of legal fees. Morgan stole Indiana's money. They treated him unfairly. They didn't follow the contract, and Bob knew it."

In his discussions with Indiana, Brannan says he committed "to doing something about it. Bob would tell me from time to time that Morgan was screwing him. He discussed my role as personal representative and that he expected of me to pursue the breach of his agreement with Morgan. I told him I would do what I would do, and that is what I am doing now."

Brannan assured the attorney general that he wouldn't sell anything without getting the approval of the Star of Hope Foundation, but flaunted that agreement by immediately signing a $5 million loan with Bank of America and pledging nineteen Indiana artworks as collateral, including his *Mother and Father* diptych, a painting loaded with personal imagery and perhaps the most valuable art in the Star of Hope. One panel shows a woman, her breast exposed and one hand on the passenger-door handle of a Model T. The other panel shows a well-dressed man in a jacket and tie, but without shoes or socks. Indiana displayed them on either side of the cast-iron stove that came with the house. In his narrated tour of his home and life, it all began with *Mother and Father*.

Also risked as collateral for the loan was a piece from Indiana's *American Dream* series, which he once described to

Rogers as his "most important painting"; *Afghanistan*; the lighted sculpture *The Electric Eat*, a version of *EAT* that brought the artist so much acclaim at the 1964 World's Fair; several early paintings; and a few *LOVE* canvases.

Brannan got a good interest rate from Bank of America: 2.61 percent.

The attorney Sigmund D. Schutz represented Brannan when the attorney general and the Star of Hope Foundation raised concerns about Brannan's fees and actions. They petitioned the probate court to wrest away supervision of the estate. Schutz says Brannan needed the loan to pursue the estate's legal claims if a settlement couldn't be reached with Morgan Art. He characterized the estate, estimated to be worth as much as $100 million, as "asset-rich but cash poor" and says Brannan followed the advice of Sterrs, the Star of Hope chairman, in applying for a loan after he'd lost the authority to sell art.

According to Schutz, Sterrs directed Brannan to Camden National Bank, a Maine bank for which Sterrs also served as chairman of the board. In his court filing, Schutz said Brannan opted to do business with Bank of America because the local bank offered less money, a higher interest rate, and wanted all of Indiana's artwork as collateral. "Despite making no loan, Camden National invoiced the Estate for legal fees it incurred in preparing loan documents," Schutz wrote. Those fees totaled $4,267.50 for a loan never executed—another five grand drained from the estate.

An attorney for the Star of Hope Foundation denied it was a conflict of interest for Sterrs to steer business to his own bank, saying Sterrs simply made a referral and was not involved in the loan-approval process. But Brannan and Sterrs had feuded on other issues, and Brannan spurred Sterrs by going to Bank of America rather than working with the local bank. Whichev-

er bank he did business with, the move further alienated Brannan by enraging the art world. The art scholar and longtime Indiana friend John Wilmerding told the *Portland Press Herald* that using the artist's work as loan collateral was "nothing less than a tragedy" and "irresponsible folly at its most blatant."

When news of the loan became public, one attorney described Brannan as "a really good probate guy, but he's way out of his league." Schutz defends Brannan "as a born-and-raised Rockland boy who's lived there his entire life and has a vested interest in his community, and he's been thrust into this challenging, complex, and difficult estate. He's got to sort that out in a way that makes sense, with tens of millions of dollars of legal claims at stake."

Kathleen Rogers says the news nauseated her, and within a month she enlisted Spencer's help with her plea to the attorney general's office to do more due diligence in the case, specifically regarding what they believed was Brannan's mishandling of Indiana's legacy by risking his art as collateral for a loan to pay for court cases that had gone on too long.

Later, on the advice of the Maine attorney general, Spencer wrote a letter to the probate judge, asking her to transfer ownership of the artwork to the Star of Hope Foundation, to remove it from Brannan's control. But Spencer had no legal standing, and the judge could not consider his letter.

Early in the court battle with Morgan Art, Brannan drew the ire of the art world when he sold paintings in Indiana's private collection by Ellsworth Kelly and Ed Ruscha for $2.3 and $2.7 million, respectively, to raise cash for the court fight. This eroded the ability of the eventual museum at the Star of Hope to tell Indiana's artistic story by undermining its personal and professional foundations. "If the estate is ever going to be preserved or studied or visited, whether it's a museum

or research center, it seems to me works like that are essential as part of a bigger picture," Wilmerding told the media.

But Brannan was marshalling cash for a battle.

When Luke Nikas, the attorney for the Morgan Art Foundation, joined the New York office of Quinn Emanuel Urquhart & Sullivan, in 2017, the legal press covered his arrival, calling him a "litigation star" and one of the country's top young lawyers. An art journal anointed the Harvard Law graduate as one of the world's "highly influential" art lawyers.

Nikas was the lead counsel in the sensational art fraud trial of Ann Freedman, the New York gallerist who directed Knoedler & Co. when it was accused of selling fakes by Robert Motherwell, Jackson Pollock, Mark Rothko, and others. The case revealed the allegations to be true, but Nikas managed to keep Freedman out of legal jeopardy—and prison. The story shocked the art world. Knoedler, one of the world's oldest galleries, closed. Eighty million dollars in claims were brought against Freedman and the gallery. On the day Freedman was to take the stand, the case was settled. Nikas ended up as a featured interviewee in *Made You Look Made You Look*, a Netflix documentary about the case.

Back in Maine, Brannan's goal was to keep the Indiana estate lawsuit with Morgan Art active long enough that his New York legal team could depose Simon Salama-Caro and other principals in the Morgan Art chain of command, so he could begin piecing together the mystery and history of Morgan Art's thirty-year relationship with Indiana. Meanwhile, Nikas fought to keep Salama-Caro from having to answer questions under oath about alleged underpayments, accounting, missing contracts, and the potential of Morgan Art's own unauthorized use of Indiana's name and artwork.

But after a judge foiled those efforts and Salama-Caro and two of his children were ordered to sit for depositions, a settlement offer emerged and was signed in spring 2021—and held under a seal of confidentiality. Just before the settlement was scheduled to take effect, the Maine attorney general began aggressively questioning Brannan's fees charged to the estate and petitioned the probate court for the return of millions.

When the case between Morgan Art and the Indiana estate began, James Brannan, a small-town attorney best known for drafting wills and executing real-estate transactions, was seen as naïve and at risk of being schooled by a well-funded New York legal team with impeccable credentials in the worlds of art and celebrity. As the litigation moved slowly toward a settlement, the country lawyer had the audacity to use Indiana's most cherished paintings as pawns in a high-stakes game of chess, gambling it all on the hope that Nikas and Morgan Art would settle before they ever allowed Simon Salama-Caro to be deposed or Robert Indiana's legacy to be further degraded.

"We knew what he was going to say," Brannan says, "and he knew he had to tell the truth."

SIMON SALAMA-CARO CAME into Robert Indiana's life, in 1987, by chance. The artist was seen as
a one-hit wonder, other early successes notwithstanding, still riding the long-ago exposure of *LOVE* but
otherwise largely passed over. He'd be in Maine almost a
decade, with little more to show than his *Indiana's Indiana*
exhibition at the Farnsworth Museum, in Rockland. The
art had eclipsed the artist: more people recognized *LOVE*
than knew of Robert Indiana.

In the late 1980s, Salama-Caro operated a gallery in London. A slender, quiet man, Salama-Caro is unassuming and
exudes an air of ease in the expensive suits he wears at gallery openings and charity galas. While in the States for the
Chicago Art Fair, a work by Indiana caught Salama-Caro's
attention. Through a mutual friend at the fair, he learned that
Indiana had closed his door to curators and dealers and was
not answering his correspondence. His friend told him, "If
you can bring him back, it would be a great achievement, but
I don't know if you can succeed."

Salama-Caro made it his mission. The shy Londoner has
succeeded resoundingly well over three decades. He promoted and sold Indiana's art around the globe and helped

Indiana realize two major goals: his vision for large, culture-defining sculpture installed around the world and a career retrospective at a major museum. Salama-Caro succeeded because he invested in Indiana's trust, visiting Vinalhaven to cajole and encourage the artist and supporting him through some of his darkest days. After more than thirty years of work and mountains of legal troubles later, Salama-Caro could claim righteous success—but it's come at the cost of time, energy, money, and at least a small piece of his reputation. For all the credit Salama-Caro has received for rebuilding Indiana's profile, he's left a long trail of mixed opinions.

When Salama-Caro first connected with Indiana by phone to discuss working together, the artist was pleasant but negative. He had little interest in showing his work and was especially reluctant to work with a European art dealer. "It's too far," he said, insisting that Salama-Caro not bother visiting him in Maine.

But Salama-Caro persisted. In an extensive interview with Albright-Knox Associate Director Joe Lin-Hill, Salama-Caro said he traveled from London to Maine several times, and eventually had a fax machine installed in Indiana's island home so they could correspond more easily. Somewhere around the fourth visit, Indiana relented: Salama-Caro had passed the test. The reluctant artist told the eager art dealer, "Nobody has ever come back four times, so we better sit down and see what we can do."

The discussion turned to money and Salama-Caro's financial means. Indiana had big plans and big ideas and if he was going to have a partner, he wanted one with deep pockets. Indiana took Salama-Caro to the top floor of the Star of Hope, where he had arranged a display of wood and iron

assemblages, which he called *herms*. He wanted to cast them in bronze, an ambitious and costly project.

"Well, I never wanted a poor dealer," Indiana told Sala-ma-Caro. He asked pointedly, "Do you have the means the do the following project with me? I've always wanted, since I was a young artist, to turn these sculptures into painted bronze."

He called bronze a "noble material" that would last thousands of years. Whatever his fate on earth, Indiana wanted to ensure that his art would outlast him.

Salama-Caro was beguiled by both the art and the artist. "When I saw in his home the great paintings that he had, beautiful works, very meaningful, and in my many conversations, I was more and more convinced that I was in front of a great American artist," he recalled years later. "Forgotten perhaps—for reasons that I didn't know at the time—although his work already, from a young age, had been acquired by great institutions and some great private collections. But obviously, something had happened. But I decided to go ahead and do the project."

The dealer and the artist's first show together was in London in 1991, *Robert Indiana: Early Sculpture, 1960–1962*. The show was not commercially successful, but it marked the first time Indiana exhibited the bronze casts made with Sala-ma-Caro. Many of Indiana's old friends attended, and it was clear to Salama-Caro that they admired Indiana. It made him curious as to why Indiana had placed so much distance between himself and his past.

Those answers came quickly.

Indiana's gallery exhibition in London coincided with *The Pop Art Show* at the Royal Academy. Indiana's art was included in the Royal Academy show, but to far less a degree and

with far less prominence than that of, for example, Warhol. Salama-Caro noticed it right away, as did Indiana. "You see, Simon, they don't like me," he said, repeating a rehearsed line of betrayal.

Looking after Indiana, Salama-Caro asked a curator friend at the Royal Academy about the slight and was told that Indiana ignored repeated requests to more fully participate in the exhibition. When Salama-Caro confronted Indiana about it, the artist told his new dealer and partner he couldn't remember any details but "maybe I did something wrong."

That was the moment when Salama-Caro understood Indiana probably created most of his own problems; he played an eager and easy victim, then clung to feelings of bitterness. Indiana had no one to blame but himself for not taking care of the rights to *LOVE*, but he blamed the world forever. And perhaps the reason he was alone among his peers without a solo exhibition in New York for so long was not because "they don't like me," as he liked to say, but because he was difficult to deal with—he frequently changed his mind and belittled those who chose to work with him. No wonder he'd found himself alone on an island in Maine.

Salama-Caro financed the bronze sculptures in the early 1990s and, after closing his London gallery, in 1994, he became Indiana's agent and represented his work in international markets. But Indiana's ambitions for his sculpture were monumental, and Salama-Caro soon lacked the funding to realize them.

"And, you know, Bob is Bob," Salama-Caro told Lin-Hill. "He wanted everything to be done, at once. He said, 'I have no interest in things being done in twenty or thirty years,

one by one, I want everything to be done so I can see it.' So there was a need for a whole lot of money."

Enter the Morgan Art Foundation.

☆

A PRIVATE LIMITED liability company formed in the Bahamas in 1993, the Morgan Art Foundation is a foundation in name only. It's neither a charitable organization nor one that evolved from the artist's estate to fund a mission according to the will and wishes of the artist. It's a for-profit company, whose chairman, Robert Gore, purchased three Indiana *herms* at Salama-Caro's London gallery show.

Despite numerous lawsuits, legal filings, and motions that produced thousands of pages of documents in the battle after Indiana's death, relatively little is known about Morgan Art. The foundation and its lawyers have closely guarded information about ownership stakes in Morgan Art and declined to explain the relationship among Morgan Art and several other New York–based LLCs associated with it. Morgan Art's legal counsel says businessmen Philippe Grossglauser and Robert Gore based the company in the Bahamas for business reasons, and it's not much more complicated than that. "It's a private business in an art world that is often private, and so the owners want to keep it that way," Nikas says. "There is nothing that if I told you about the structure would cause any concern whatsoever. There is no one involved with criminal backgrounds, no one involved who is engaged in commerce that would be concerning or controversial. Literally, there is nothing controversial whatsoever that makes up the ownership structure. It's a private business, and this market operates in a private way."

When given the opportunity in court, Nikas consistently objected to disclosing any more information than absolutely

necessary about his clients. "The corporate structure history or ownership of Morgan is not relevant as to whether the estate has claims against Morgan or Morgan has claims against the estate," he argued.

Indiana estate attorney James Brannan contends Salama-Caro and members of his family, or "persons unknown," control Morgan Art, as well as the New York LLCs, at least partly. He alleges they control an interlocking web of entities "to carry out their schemes to take advantage of Indiana," he said in an interview.

Based on testimony, Robert Gore serves as Morgan Art's chairman and Philippe Grossglauser identifies himself as director of the Morgan Art Foundation Ltd. and a related company, Morgan Art Foundation SA; the latter is registered in Switzerland but has no physical presence there, the former has no offices.

Gore was an old friend of Salama-Caro and a fan of Indiana. Salama-Caro asked Gore to become involved with Indiana as an investor, Salama-Caro told Joe Lin-Hill. "I went to Morgan Art Foundation and asked if they could literally invest in funding the work of this ambitious program and support Bob Indiana, so that I could facilitate his work and promote him as best as I could," he said.

While acting as both agent to the artist and adviser to the company, Salama-Caro persuaded Indiana to sign two agreements with Morgan Art. The first was an intellectual property agreement in which Indiana signed his rights to *LOVE* over to Morgan Art in exchange for Morgan Art both protecting and policing those rights, through an agreement with the Artists Rights Society. A second contract permitted Morgan Art to fund and fabricate a sculpture program, based on Indiana's desires and direction.

As is common in deals of this kind, Indiana would be paid a percentage of money Morgan collected for the sale or reproduction of his art, from mass-produced *LOVE*s sold in museum gift shops for twenty-five bucks to large-scale sculptures that sell for $1 million or more.

The intellectual-property agreement was necessary because *LOVE* was so widely pirated. It wouldn't have made sense for Morgan Art to invest heavily in Indiana when his best-known work had little actual value unless its usage rights were enforced. The act of clawing back the rights to *LOVE* was long and costly, and the process was more complicated than it needed to be because of Indiana's neglect and lack of attention to detail when he created *LOVE*, Salama-Caro explained to Lin-Hill: [W]e all know now, especially in the case of the *LOVE* image—without the artist's approval, the image had been abused and extensively used by all kinds of commercial applications and the artist hadn't done anything about it. It is recorded in certain publications that he didn't see the need in the '60s—or perhaps it wasn't in the spirit of his work then—to copyright the work. But that had very serious consequences. So Morgan's lawyers at the time advised that they should research to what extent Bob and Morgan could be protected from that point of view in the future."

As the relationship evolved, Salama-Caro became, in essence, Indiana's gallerist and Morgan Art the gallery backer—though there was no physical gallery. Salama-Caro's job was to promote and protect the legacy of Robert Indiana through the fabrication and promotion of the artist's collected works, including paintings, prints, and sculpture.

Later, Morgan Art increased its collection by buying works from other sources, based on Salama-Caro's advice. The idea was for Morgan to acquire the core of Indiana's collection,

to both make it easier to arrange exhibitions and control the value of Indiana's work in the international art market.

Salama-Caro came to Indiana in a time of need. The contracts Indiana signed with Morgan Art reflected his desire to remain a relevant artist, as well as his naiveté. The same mistakes he made with *LOVE* three decades earlier—he didn't seek legal counsel and he didn't pay close attention to the details—happened again with Morgan Art.

In their first agreement, signed in April 1999, Indiana transferred all of his trademarks, copyrights, and other rights he might acquire in the future, "including the right to sue for past infringement," related to *LOVE* and other works closely associated with it, specifically the word *LOVE* in other languages. In addition, he transferred and assigned his rights to "any and all paintings, sculptures, constructions and other art work" that appeared in previous, specific exhibitions and catalogues, among them a massive forty-year retrospective in France in 1998 and a catalogue of prints from 1951 to 1991 published by a New York gallery. The lone exception was Indiana's design for the *LOVE* stamp in 1973, because the post office owned the rights. The contract covered a vast body of work, going back to Indiana's earliest days as an artist.

Rather than deliver physical paintings, prints, or other artwork, Indiana's contract transferred to Morgan Art his trademarks and copyrights to the enormous body of work he'd created, giving Morgan Art the opportunity to reproduce, promote, and sell the images at will: "The foregoing transfer and assignment to Morgan includes the exclusive right throughout the world in perpetuity to reproduce, promote and sell Images in such forms and sizes, singularly or in any combination, in such manner, at such time, for such price

and subject to such terms and conditions as Morgan in its sole discretion shall determine."

In exchange, Indiana would receive 50 percent of net income, that is, after expenses, and the contractual guarantee of a quarterly accounting of income, expenses, and payments.

Soon after he signed that contract, Indiana inked his name to an agreement that allowed Morgan Art to "inscribe or set forth my signature and the copyright date on all reproductions" it created. Between the two contracts, Indiana essentially allowed Morgan Art to reproduce and promote anything from his past without his knowledge or consent—and sign his name to it.

Then Salama-Caro quickly came back to Indiana with another plan. In December 1999, Indiana signed a sculpture agreement that gave Morgan Art "the exclusive right, in perpetuity" to produce and fabricate the *LOVE* sculptures, as well his *Numbers* sculptures—large-scales pieces of the numbers 0 through 9—and others. He gave Morgan the right and sole discretion, again in perpetuity, to promote, market, and sell the sculptures, which at that point had not been produced and existed in concept only. In return, Indiana would receive not 50 percent of receipts from the sale of the sculptures, but instead just 20 percent.

This new sculpture agreement gave Morgan Art the right to produce and fabricate new copies of specific works, and Indiana agreed that "upon the completion of fabrication of each Sculpture, title to such Sculpture shall pass from me to Morgan." The intent to pass the title was confirmed by bills of sale that Indiana executed for each work, in which he stated that he "bargained and sold" the work to Morgan for $10 "and other good and valuable considerations."

In other words, he was likely earning considerably less than his art was worth. Again.

Even more startling, Indiana forfeited his own artistic oversight. The April 1999 agreement between him and Morgan Art suggested Morgan Art would review and discuss its projects with Indiana, but it did not require Morgan Art to defer to the artist's aesthetic input. In fact, the contract's language allowed Morgan Art to "enter into an agreement with respect to each such project on such terms and conditions as Morgan shall determine."

And because Indiana gave Morgan Art the right "to inscribe my signature" on artwork, Indiana was neither required nor permitted to approve the final form of any image or sculpture before Morgan Art sold it. The contracts gave Morgan Art and not the artist the right to decide not only what to sell—to whom and at what price—but also what to actually *make* under the name "Robert Indiana."

Within weeks of signing the sculpture agreement, Indiana had misgivings. He signed a modification agreement on January 5, 2000, changing the terms from "20% of the receipts" to "20% of the net income received by Morgan" after the deduction of the same expenses allowed in the April contract. But that modification was signed only by Indiana—it never took effect.

There were other modifications to the sculpture contract over the years, but not in regard to its terms of payment. It was a bad contract, and eventually Robert Indiana had realized that.

☆

WHEN THE LEGAL battle broke out between Morgan Art and Indiana's estate, details of the contracts emerged. Indiana

estate attorney James Brannan called the agreements with Morgan Art "unconscionably lopsided." But during a hearing in New York in the summer of 2019, one of the judges in the case, Barbara C. Moses, held Indiana to account for his own ignorance and described him as "unsophisticated in the ways of the world."

"He was not a child," she said. "He wasn't under the threat of force or blackmail."

Within a trove of more than fifty thousand pages of documents that Morgan Art was compelled to turn over to the Indiana estate during discovery, Brannan and his team of lawyers said they found evidence that Morgan Art and Salama-Caro fabricated and sold numerous works without paying Indiana, and underpaid him by deducting expenses they shouldn't have—expenses that ranged from "joint venture fees" worth hundreds of thousands of dollars to fees paid to a consulting firm run by one of Salama-Caro's sons.

Through his attorneys, Brannan accused Salama-Caro of being a double agent. When Morgan Art found a buyer for an Indiana work, rather than sell the work directly to the buyer it engaged in what Brannan called a "sham sale" of the work to Salama-Caro's company, Shearbrook LLC: Morgan Art would sell the work to Shearbrook, then Shearbrook would sell the work to the buyer at a markup, according to court filings. Indiana's commission would be calculated on the first, lower sale price. Brannan asserted that every Indiana sculpture Morgan Art has produced has been sold to Salama-Caro's company, Shearbrook.

Morgan Art has made a blanket denial of the allegations of underpayment, and said it honored its contracts with Indiana and paid him what he was due. If the detail of accounting was suspect, they say, it was because Indiana asked not to

be inundated with paperwork, and Indiana wasn't likely to question why every piece was sold to Shearbrook, because the reports from Morgan lacked specificity.

Throughout the legal proceedings, Nikas and his associates worked to shield as many details as possible about sale prices, the names of buyers, and inventory. It petitioned the judge for secrecy, confidentiality, and "attorneys' eyes only" status for hundreds of pages of sensitive documents.

In one exchange, Morgan Art attorney Maaren Shah interrupted Judge Moses as the judge began describing details of a *LOVE* sculpture transaction. "Oh, your Honor—oh, yes, I'm sorry," Shah said, cutting off Moses mid-sentence. "I just wanted to caution your Honor that to the extent that we're trying to keep everything public here, the next description might be—you know, get into the realm of things we're sensitive about."

The judge told Shah, "I'm trying to be careful. You'll let me know if I overstep . . ."

Examples of the alleged "sham sale" method are staggering.

According to the estate's allegations, on September 29, 2016, Morgan Art sold a 72-inch red/red polychrome aluminum *LOVE* sculpture to Shearbrook for $675,000. That same day, Shearbrook sold it for $900,000—a $225,000 mark up. When calculating payment to Indiana, Morgan Art not only used the sale receipt for $675,000, but also further reduced it by deducting commissions and other expenses incurred by Shearbrook.

Again, according to court filings by the estate, on November 14, 2012, Morgan Art sold a 96-inch blue-and-red aluminum *LOVE* to Shearbrook for $1.4 million. Shearbrook promptly put the piece up for auction at Sotheby's. The next day, Morgan Art chairman Robert Gore purchased the sculpture at auction for approximately $1.7 million. When

calculating payment to Indiana, Morgan Art accounted for the sale to Shearbrook and deducted expenses from the $1.4 million sale price, and then also deducted the entire $1.7 million that Gore paid to purchase the same sculpture as an "acquisition expense."

In the course of roughly twenty-four hours, Morgan Art bought and sold the same sculpture while creating more than $2 million in deductions to reduce what it owed to Indiana, Brannan's legal team alleged. It also served to raise the value of Indiana's art in the global market, which directly benefited Morgan Art's vast holdings of Indiana's work.

And so it went with Morgan Art and the art of Indiana.

When Morgan Art and Salama-Caro offered Indiana art at auction, they sometimes bid on it themselves or enlisted others to bid to drive up the price and value of anything else in Indiana's market, according to the Indiana estate. When they were successful bidders—in other words, when they bought their own art—they deducted "acquisition costs" from the amount owed to the artist.

During the first decade of the arrangement between Morgan Art and Indiana—from January 1, 1999, to December 31, 2008—Morgan Art sent checks or wire transfers to Indiana's account without details. The memo lines on the checks simply said "for royalties from Morgan art" or something similarly vague—these were checks for $1 million or more.

In 2009—the year after Michael McKenzie began working with Indiana on *HOPE* and promising the artist $1 million per year—Morgan Art provided a decade's worth of statements noting income received, expenses incurred, or payments made, but without details. The statements didn't say what sculptures Morgan Art made or sold or at what price, nor did they itemize expenses.

The accounting improved in 2010. Morgan Art sent more-frequent summary statements, but still without accounting of the receipts, expenses, and payments. In June 2016—just a month after that overcast day when Indiana had signed, perhaps under undue influence, his final will—Morgan Art sent a statement for the 2015 calendar year. The entire statement contained just two lines of data: Indiana received $22,750 on the sale of artwork licensed by the Artists Rights Society, a third-party copyright-licensing organization, and $1,041,331.57 from Morgan Art from sculpture sales, according to Brannan. There's no information about what or how many sculptures Morgan Art made or sold, who bought them, or for how much. Nor did it detail expenses deducted or how the figures were calculated.

According to Nikas, Morgan Art made its final payment to Indiana in December 2017 for more than a $1 million. It owed him no money in 2018 and for most of 2019, because of permissible deductions related to the litigation, he says. At last accounting, before the settlement was signed, it owed Indiana $75,000.

The contracts Morgan Art had drafted and Indiana had signed without legal counsel allowed the organization latitude in its expenses. They included the cost of packing, storing, and shipping art; reproduction and manufacturing; promotion; photography; commissions and fees; travel and entertainment; finance charges and expenses; and attorney fees and administrative costs such as postage, phones, and faxes.

Between 2012 and 2017, Morgan Art deducted more than $4 million in consulting fees from sales revenues to PSC Consulting, the company operated by Salama-Caro's son Paul, the estate claimed. During that same time, Morgan Art deducted $1.1 million in fees paid to lawyers and others that

had nothing to do with the fabrication, marketing, or sale of Indiana's artwork and "in no way benefited Indiana," according to court filings. The money, Indiana estate attorney James Brannan says, was used to "assist Morgan in maintaining a labyrinth of offshore companies and anonymizing intermediaries" doing work unrelated to Indiana's art.

In 2017—when eighty-eight-year-old Robert Indiana vanished from public life, hidden away in the Star of Hope, with other people answering his phone calls and speaking on his behalf—Morgan Art spent $700,000 to store and insure unsold artwork, then spent another $600,000 to fabricate new work despite the unsold inventory, all charged to Indiana, according to court documents. By Brannan's accounting, Morgan deducted close to $3.5 million in joint venture fees in the six-year period from 2012 through 2017, none of which was authorized under their contracts, he argued.

The estate also raised alarms that Morgan Art was using money from the sale of Indiana's art to pay for its legal case against him and the estate. Although legal fees were an allowable deduction according to the terms of the agreement between Morgan Art and Indiana, nothing in the agreement permitted Morgan to use Indiana's money to sue him.

☆

JAMES BRANNAN NEVER got the chance to prove that the things Indiana suspected of Morgan Art were true. The settlement also shielded more details about the existence of—or lack thereof—the one-page agreement Morgan Art says gives it rights to Indiana's artwork between the original 1999 agreements and 2006. When pressed, Morgan Art failed to produce the contract, which consisted of a fax. This left Morgan Art open to the potential of having to de-

fend itself from allegations of producing fraudulent artwork under Indiana's name.

Nikas insisted that the missing contract was irrelevant and says the search for it ended with the COVID-19 pandemic and the emergence of other, more pressing problems. "Most of the images at issue are not part of that agreement, anyway," he says.

Nikas also insists that the allegations of double-dealing are misleading and inaccurate. He likened Simon Salama-Caro to a gallerist without a brick-and-mortar gallery, acting as both an agent to Indiana, who had work to sell, and an adviser to Morgan Art, which was in the business of buying art and selling art—specifically, Indiana's art.

Salama-Caro was a middle-man, not a double agent, Nikas says. Over their decades working together, Salama-Caro never received payment from Indiana or Morgan Art, and he did nothing else to earn income. "His sole business was advising Morgan and representing Indiana," Nikas says, and he earned his money in the exchanges in between— all legal and all allowable by contract. It was similar to a commission a gallery would earn, but on a much smaller percentage, Nikas contends.

But Salama-Caro's lack of a brick-and-mortar gallery insulated him from the financial uncertainties of running an actual showcase. Instead of taking on the risk of exhibiting an artist's work in a gallery, finding buyers, then taking a commission on sales, he operated more as a wholesaler: Salama-Caro advised Morgan Art to buy art from Indiana for a certain price, then found buyers willing to purchase it for a higher price; he almost always had a buyer waiting.

"This is how Simon got paid," Nikas says. "Simon made reasonable compensation for the work he did. He had real

risk in this, and his compensation was within a reasonable range for his work—and Indiana didn't suffer from this at all, financially."

Only Indiana knows whether he suffered in other ways.

Perhaps egged on by McKenzie, Indiana believed he was being paid less money than he should have been, given the prices he knew were being paid for his art. But he could never figure out how or why, and never took the time to pursue an answer. Instead, he complained, often with rage—and McKenzie, Thomas, and others encouraged his anger. All the while, the fog grew ever thicker around him at the Star of Hope.

Whenever Indiana grew agitated, Salama-Caro or his son Marc found ways to mollify the increasingly ornery artist. "As long as they could fly out with a gift basket every couple of years and give him some money, it was okay," says Brannan. "I think they had gotten comfortable with their system and had no expectation that anybody would ever look into it."

To the end, Nikas maintained Morgan Art operated within the boundaries of the contract. Whatever the full extent of the discrepancies in accounting—alleged or actual—they too were hidden within the private settlement between the Morgan Art Foundation and the Robert Indiana estate.

That settlement also enabled Salama-Caro to avoid facing a deposition in the federal suit, a victory for Nikas—and another example of him protecting his client, first and foremost.

Salama-Caro was, however, forced to take the stand in Rockland in 2018 in a state suit. Suffering from a slight hearing loss, he looked unsettled. But appearances can be deceiving. Just as he'd stood up to *HOPE* art publisher Michael McKenzie over the years, Salama-Caro asserted himself and challenged the opposing counsel's attempt to pin him down, especially about his business with Morgan Art. "I've never

participated in the management of Morgan. You see, with all due respect, there is confusion between me and Morgan. I've only been their adviser," he said.

He also defended himself on the charge of flimsy accounting and said Morgan Art didn't send Indiana copious paperwork because Indiana insisted on it. "He told me at the time, I'm not a businessman, I'm an artist. I don't wish to receive hundreds of pages. He just wanted to know how much he was due and whether he was paid. So his wishes were respected," Salama-Caro said.

Susan Larsen was working as chief curator of the Rockland's Farnsworth Museum when Salama-Caro began representing Indiana. Before her arrival at the museum, in 1996, the Farnsworth had worked to build a relationship with Indiana, through exhibitions and generally courting him and talking with him about his goals for his collection, as well as for the Star of Hope. About that time, Larsen recalls, the conversations shifted toward the possibility of the Farnsworth taking over the Star of Hope as a satellite museum.

"And then in came Simon Salama-Caro," Larsen says. "I remember him just speaking about the fact that he was now in control of Robert Indiana's art and any plans of any kind would have to go through him, that he owned the licensing."

She saw Salama-Caro "as a man defending his turf. He seemed like a high-end art dealer in a fancy suit." He was abrupt and firm, and told Larsen to steer clear of the Star of Hope. "Before you barge in there, you have to go through me," Larsen says he told her.

Susan Ryan, Indiana's biographer, was on the scene when Salama-Caro first began showing up at the Star of Hope, in the early 1990s. She remembers him as persistent and "just a little slimy, but I don't mean that in a bad way. . . . He was

always trying to use Robert to make money, and Robert knew that." She recalls a night when she and Indiana were dining at a Vinalhaven restaurant when Salama-Caro walked in. She says Indiana wasn't thrilled, and tried to hide. "Oh no," he said, according to Ryan, before finally acknowledging the man.

In one of his first acts representing Indiana, Salama-Caro sold some of the artist's paintings "that I never would have parted with," says Ryan, to pay Indiana's mounting tax debts. "I remember going into the lodge and not seeing the paintings that I had seen." She was disappointed, but not surprised.

Whatever mixed feelings Ryan had when she met Salama-Caro, she mostly resolved them years ago. She's not certain if Indiana ever resolved his own misgiving about Salama-Caro. She believes Indiana appreciated all Salama-Caro did for him, but he always expected more.

Salama-Caro and Ryan have collaborated on various projects, motivated by their mutual interest in elevating and understanding Indiana's art. Ryan has been paid by Salama-Caro to write about Indiana. She has contributed research and donated her interview tapes to the Indiana archive maintained by Salama-Caro and his family. She says Salama-Caro asked her to lead the project to create a catalogue raisonné, but she declined—and she likely won't consider another offer from him.

Ryan was upset when Salama-Caro told her she couldn't mention *HOPE* in an essay she was writing for him because of the artwork's association with Indiana's time with McKenzie. "Since I was talking about words, I wanted to use *HOPE* to end my essay, and Simon said, 'Nope, you can't mention it.' I was taken aback and upset. He never gave me a reason why, except something about a court case and I couldn't mention

HOPE in my essay about Robert Indiana's word-art. *HOPE* was the total aftermath to *LOVE*. It had to be in there."

But Salama-Caro said no. After that edict, Ryan stopped working with Salama-Caro.

O

THE FIRST TIME Star of Hope studio assistant Webster Robinson saw Robert Indiana really angry as an elderly man was when the artist was told—he'd apparently forgotten—that Vinalhaven fisherman-turned-assistant Jamie Thomas now held power of attorney over his estate.

The second time was when Michael McKenzie came to Indiana with an idea about wine.

Robinson recalls that McKenzie was throwing all kinds of ideas at Indiana for new pieces, but he was particularly persistent with one for a design based on the word *wine*. Indiana grew tired of McKenzie's badgering and wanted him thrown out of the Star of Hope.

"Bob finally flat-out told him no fucking way—'I'm not putting my name on that crap.' That's when he asked Sean [Hillgrove] to throw him out of the house. 'Either he leaves, or you forcibly remove him,' is what Bob told Sean," Robinson remembers.

McKenzie left on his own but the idea for *WINE* persisted, and in May 2018—the month Indiana died and Morgan Art sued his estate over the creation of fraudulent work—*Wine Enthusiast* magazine published a "One on One" interview

with Indiana about his love of wine. The issue's cover featured a photograph of the sculpture *WINE*, attributed to Indiana; the sculpture is ill-balanced and clunky, unaccomplished.

Indiana's friends were surprised by the *Wine Enthusiast* interview in no small part because they didn't know Indiana as a wine drinker. He might have had an occasional glass with dinner and was fond of an aperitif, but he was hardly a "wine enthusiast." If he was enthusiastic about anything, it was cigars. Further, by the spring of 2018, Indiana hadn't been heard from in almost two years. Friends who tried to reach him were rebuffed. He ignored interview requests. He hadn't even been seen on Vinalhaven. At the time the *Wine Enthusiast* interview was published, Robert Indiana was close to blind and in failing health.

To many who knew Indiana, nothing about the interview rang true. It was widely alleged that McKenzie answered the questions, posing as Indiana. McKenzie peppered the interview with references to himself: "Michael, who is a wine lover and a silk screener, had the idea that we could print with wine, so I said give it a try. And we did. We printed *HOPE* with Malbec."

By 2018, McKenzie was adept at speaking for Indiana. He had already been doing it for at least four years.

McKenzie had been perfecting his Indiana surrogacy since he'd begun curating the traveling exhibitions of the artist's late-career work that he'd had a hand in creating. These traveling shows took advantage of renewed interest in Indiana stemming from his high-profile Whitney retrospective in 2013, *Beyond Love*, the high-water mark of Indiana's exhibition career and his association with Morgan Art. Tellingly, Whitney curator Barbara Haskell included none of the work Indiana created with McKenzie.

Beyond Love contained no *HOPE*.

These traveling exhibitions helped McKenzie pay his annual $1 million guarantee. The initial *HOPE* contract, in 2008, was for a five-year term and guaranteed Indiana $1 million a year, whether or not he earned it, with payments due each March and September. Indiana could terminate the contract if McKenzie was late with a payment.

Under their deal, American Image Art paid Indiana 25 percent of gross sales of *HOPE* sculptures and 33 percent of gross for canvases, and Indiana retained copyrights and trademarks. The contract prohibited McKenzie from creating anything based on *HOPE* without Indiana's written approval, and it didn't allow him to make or sell any other artwork by Indiana.

They later signed an addendum, extending the term with an annual renewal, payable with a $1 million royalty. To meet that royalty, McKenzie, the modern-day P.T. Barnum, had to make and sell a lot of *HOPE*. He started pulling together a mixture of older and new work that he made with Indiana—always with Indiana's approval, he says—and sending it out on tour.

In October 2014, McKenzie gave an interview to *The Morning Call*, in Pennsylvania, about a traveling exhibition he'd organized, "Robert Indiana A–Z." The artist, he told the newspaper, wasn't feeling well: "He's a bit of a recluse," he said. He highlighted stories and yarns from throughout Indiana's career, including the old chestnut about John Lennon seeing a display of *LOVE* at the Stable Gallery in New York, leading the Beatles to record "All You Need Is Love."

McKenzie ended the interview by calling attention to *HOPE*, the piece of work in which he had the most financial interest. "Bob told me that right now the message is hope," he said.

Two years later, McKenzie put together the exhibition "Robert Indiana: Now and Then," which included a new series of silkscreens that combined early work by Indiana with the lyrics of Bob Dylan. In the run up to the exhibition's opening, he told to the *Portland Press Herald* that Indiana wasn't up for a conversation—but that he himself would be happy to talk about it. McKenzie said he proposed the Dylan project to Indiana in a conceptual way after taking a liking to an Ed Ruscha book that incorporated the words of Jack Kerouac.

"I showed some of that to Bob and said, 'Maybe you would like to do a project with a writer.' He said, 'Great idea. You know I write poetry myself?' And I said, 'So who would you like to work with?' and he said, 'If I could work with any writer ever, it would be Bob Dylan. I'd have to say no singer influenced me as much as Dylan and no poet influenced me as much as Dylan, either.'"

McKenzie told the newspaper they chose "Like a Rolling Stone" because Indiana related to the "drifter quality" of the lyrics, which reminded him of his driftless youth moving from house to house in the aftermath of the Depression. He said Indiana chose to pair his *American Dream* series with Dylan's lyrics because of its rootedness in the idea of America as home. The art and the song matched the Zeitgeist of the country and the creative heights that the men shared in the mid-1960s.

He went on to say Indiana related to Dylan in general, as artists from the Midwest who left home as a young men, settled in New York, and changed their name and persona to match a new identity. "There's a kinship of spirit there," McKenzie said, adding that neither he nor Indiana had any contact with the songwriter or his team.

But the newspaper did. The *Portland Press Herald* asked Dylan's manager, Jeff Rosen, about the use of the lyrics in Indiana's artwork and if Dylan had any interest in seeing the exhibition, on view nearby at the Bates College Museum of Art, when his tour came through Maine that summer.

Rosen replied that Dylan wasn't interested and would not be stopping at Bates College. "Not the type of thing Bob really keeps track of," he said. The use of Dylan's lyrics in Indiana's art was never authorized.

<p style="text-align:center">☆</p>

PEOPLE WHO KNEW Indiana and followed his career were startled—and confused—by his late-career surge. After the Whitney show, he withdrew, perhaps in triumph with all of his goals finally satisfied—and not a moment too soon either, with his frailties of old age, such as poor eyesight, irritability, and depression beginning to present themselves in unflattering ways; never mind that he was rail thin and unsteady on his feet. Yet all these new shows were popping up with new work. He'd long relied on the help of studio assistants to execute work, but Indiana didn't seem physically or mentally capable of the volume of work being produced. Indiana's creative energy was as much a mystery as was his new taste in wine.

"It all has to do with this shadowy figure, Michael McKenzie," says John Wilmerding, the art scholar and a long-time Indiana friend. He became suspicious of Indiana's association with McKenzie as early as 2009, when Wilmerding collaborated with Farnsworth Art Museum curator Michael Komanecky on the exhibition *The Star of Hope*, which focused on the artwork in Indiana's home as well as the home itself.

Wilmerding spent a lot of time at the Star of Hope and at

Indiana's Sail Loft studio in preparation for the Farnsworth show, which followed the successful unveiling of *HOPE* the year before, which McKenzie had orchestrated.

"McKenzie seemed to be very involved in doing posters for Bob," recalls Wilmerding. "He actually produced some window shades for the Sail Loft studio that said 'HOPE,' which had become the working theme in Bob's mind at that time. This guy seemed to be—Bob kept referring to him as 'my publicist.' I guess he was very good at that sort of thing."

During his visits, Wilmerding began noticing cookie-cutter painted canvases in Indiana's studio, which he later suspected McKenzie made at his studio in Katonah, New York, and transported to Vinalhaven. During one visit, he says "there were a dozen if not a hundred 'HOPES' and they were all pretty awful." Some were the colors of sunsets, others orange and gold—uncommon colors for Indiana. That was Wilmerding's first inkling that McKenzie was exerting undue influence on Indiana's creative output—and he wasn't surprised. "Bob was no saint, he was always susceptible to these kinds of things. With cash coming in, he would go along with deals if he thought it would help," Wilmerding says.

Michael Komanecky, the curator from the Farnsworth, was also skeptical. During a June 7, 2017, meeting with Brannan and Simon and Marc Salama-Caro, Komanecky called McKenzie a "thief" who was "overcome with greed," according to notes of the meeting taken by Marc Salama-Caro and included in court filings. "Believes those works are entirely McKenzie creations," he wrote, without specifying the works of art in question. Brannan chimed in to say he saw "McKenzie as a foe and not a friend," according to those same notes.

But Indiana and McKenzie went way back. An early ex-

ample of one of McKenzie's deals with Indiana was a *LOVE* ad for Absolut Vodka. McKenzie helped make the ad happen when he began working with Indiana, in 1994—not long after Indiana's acquittal of solicitation of prostitution charges and during his tax troubles with the State of Maine. Indiana needed money and a positive image, and McKenzie promised both. "I thought he should be bigger," McKenzie said later, "so I sat down with Bob and said, 'Why don't you design an Absolut ad?'" Other artists, from Indiana's Pop Art peer Andy Warhol to the graffiti artist Keith Haring, had already worked with the Vodka maker almost a decade earlier.

Indiana created an image of the vodka bottle with his letters, adapting *LOVE*. At the bottom of the ad in a banner: ABSO-LUT INDIANA. After the dark few years on Vinalhaven, the ad put Indiana in front of a mainstream audience, and the artist liked the positive attention—and the money that came with it. He began listening to McKenzie and taking his advice.

About that same time, in the mid-1990s, before Indiana signed his contract with Morgan, McKenzie's American Image Art published a portfolio of twelve *LOVE* prints with twelve of Indiana's poems. The idea was McKenzie's; Indiana dismissed it as foolish, believing *LOVE* had run its course. But McKenzie didn't let it go, and eventually won the argument. This push-pull dynamic became their pattern: McKenzie proposed ideas, Indiana resisted; then McKenzie badgered until Indiana nodded his approval or just looked the other way.

With time, McKenzie wore Indiana down. Or perhaps Indiana just didn't care, because unlike others he got into bad deals with, McKenzie paid Indiana what he said he would: $1 million a year, whether or not Indiana earned it.

One lawyer who battled McKenzie threw him grudging respect. "When we compare the Morgan Art Foundation

folks to the McKenzie folks, there's a lot of hassle and drama that goes with McKenzie, but the virtue he had, he paid Indiana what he was supposed to pay him. At least until he died. Then it stopped. But until that point, he did what he was supposed to do. He did other things, like haranguing him into making works Indiana wasn't interested in making, but at least he paid him."

That said, in the scrum of lawsuits following Indiana's death, McKenzie demanded back $3.5 million of the $10 million he paid Indiana over ten years, claiming that amount as the sum of unearned royalties over the course of their contracts. Meanwhile, he continued to peddle *HOPE*, defying the estate's demand that he cease and desist.

That demand mystified John Markham, McKenzie's latest in a long parade of lawyers he's retained throughout the legal tussle; with a tendency toward snarky behavior under oath and a general lack of grace, McKenzie has all the hallmarks of a challenging client.

When McKenzie was cut out of settlement talks, Markham told the *Portland Press Herald* his client was prepared to fight. "If they do not make a settlement with us, we will assert our rights . . . to continue making *HOPE* sculptures, and we will continue the litigation with Morgan in federal court," he said. "Both the Star of Hope and the estate have expressed an interest in settling with us, but they have not as yet wanted to formally discuss it, which is curious. What is mind-boggling about it is that everybody should know the fact that Michael McKenzie made $10 million for Robert Indiana on the *HOPE* sculptures and is willing to continue doing so and in fact claims he has a right to do so. Why they wouldn't want that income stream to continue is something we can't understand. It makes no sense to us."

McKenzie says Indiana encouraged him to suggest projects and signed off on all of them. But even if he didn't, McKenzie and Jamie Thomas, with his power of attorney, seem to have struck a working arrangement. Thomas had the authority to interpret and act on Indiana's wishes during the last two years of the artist's life. McKenzie boldly told the *New York Times* in 2019, "Jamie at one point becomes Robert Indiana in effect. Jamie is head of Indiana Inc."

As Wilmerding's suspicions about the quantity and quality of art coming out of the Star of Hope grew, the last straw was the traveling exhibition "Robert Indiana: Now and Then," which ran first in Maine, at the Bates College Museum of Art, in 2016 before moving to the Baker Museum, in Naples, Florida.

The exhibition included a piece called *The Alphabet*—twenty-six individual silkscreen prints of each letter encircled, then hung in rows—as well as prints and paintings of *HOPE* and *EAT* in colors uncommon for Indiana: an orange and gold *HOPE*, and *EAT* floating against a sky-blue background in such a way that it made the letters look like they might be drifting into the wild blue beyond.

The centerpiece of the exhibition was the series of silkscreen prints that incorporated the lyrics of Bob Dylan's masterpiece "Like a Rolling Stone" arranged in small lyrical segments around the exterior of a reworking of Indiana's *American Dream* series.

The series riffed on themes present in Indiana's life and American culture—highways, pinball machines, and roadside cafés—and is among Indiana's earliest successes; the first painting in the series, *The American Dream, I*, was purchased by the Museum of Modern Art in 1961, Indiana's first museum acquisition.

The reimagined works Wilmerding saw at Bates College Museum of Art combined silkscreen prints of that existing work, completed decades ago, with Dylan's lyrics spread over twelve pieces.

Wilmerding didn't trust the Dylan work, *The Alphabet*, or much of what he saw in the exhibition. The lettering was off, the colors not right. "It was a surreal experience. The phrase I've used several times, it was Bob's vocabulary but not his voice," Wilmerding says. "They were Bob's letters, but they were just distorted in coloration, and I guess Michael McKenzie at one point said, 'Bob can move in a different direction if he wants to experiment,' but I just didn't buy that."

Dan Mills, director of Bates College Museum of Art, doesn't think it's fair to condemn all of Indiana's late-career work as fraudulent, because Indiana was aware of its creation and gave his approval, if not his hand. That Indiana acknowledged as much to Wilmerding during the studio visit in 2015 is proof that the work, and thus the exhibition at Bates, was legitimate. "Who's to say what's original and what isn't," Mills says. "There were a few works in the show that I was less excited about than others, but when can you not say that?"

To Mills's point, the art world has many examples of legitimate artists who entrust aspects and elements of the production of their work to studio assistants and others—from Rembrandt and Michelangelo to Sol LeWitt, Jeff Koons, and Andy Warhol, who didn't call his Factory the Factory because of neighborhood aesthetics. Warhol pioneered a commercial-production approach to his art, in which he came up with the idea, then others did the work. At times, Indiana did much the same.

Nikas doesn't know if Indiana knew about the Dylan work. "Did Bob give his approval for some of this stuff? Maybe.

Maybe he did," he says.

But Wilmerding is certain Indiana had nothing to do with producing the Dylan work and doubts he had much to do with its final outcome beyond looking the other way. "I assume McKenzie discussed them with Bob, but who knows? The lettering is Bob's, but their design seems too tight and congested for him."

Susan Ryan agrees. "It doesn't look like a Robert Indiana to me," she says. "The text on the outside is not integrated with the text on the inside. Robert was very precise about things like that, and I don't see it here."

Further, Ryan says that in all of their conversations over years and years, she and Indiana had many discussions about poetry and music and the culture of New York in the early 1960s, but Dylan never came up. "I never once remember Robert Indiana mentioning Bob Dylan. He and Bob Dylan certainly had the same cultural profiles in many ways. And I remember him playing me all these odd songs by the poets in New York from the Beat period, but never Bob Dylan."

In the early 2000s, Wilmerding spoke with Indiana about revisiting the idea of working with American literature, as he had with Hart Crane, Walt Whitman, and Herman Melville early in his career: "His reply was it was getting to be too challenging technically. He was moving to shorter phrases and fewer words."

That he would do the opposite a decade later—and with Dylan's famously dense, complex lyrics—was unlikely if not impossible given the artist's physical limitations, which had begun to be obvious as early as 2013, Wilmerding says.

For years, the art scholar visited with Indiana every summer, mostly as a courtesy but also for interviews and research for

books and essays. They'd known each other a long time, and Wilmerding was a regular and welcome friend. During his last visit with Indiana, in September 2015, he noticed some of *The Alphabet* prints in one of Indiana's studios resting against the wall. "I said, 'Bob, this is sort of odd. It looks like the School of Indiana.' He mumbled something about 'Yes, it is sort of a school.' And lo and behold, it was all in the Bates show the next year. It was all part of this huge McKenzie project."

McKenzie produced the catalogue and traveled the show around the country, as he had done with other exhibitions of artworks produced during his time with Indiana. There were a few authentic works in exhibition, Wilmerding says—just enough to give it credibility, "but it felt to me like kind of a funhouse," distorting Indiana's talent and legacy.

Wilmerding wasn't sure what to make of it at the time, because Indiana had been through periods when he didn't pay attention to details or didn't care about outcomes as much as people close to him thought he should. "Bob was his own undoing," he says. "There was a duality at play. On the one hand he deeply cared about his posterity, but on the other hand he did almost nothing to make that possible by being susceptible to the whims of those who wanted to take advantage of him."

Another piece attributed to Indiana that Wilmerding is certain is a fake is a sculpture called *BRAT*, which was installed at the headquarters of Johnsonville Sausage, in Sheboygan County, Wisconsin, in September 2018, a few months after Indiana died. The sausage maker had worked with McKenzie to commission the sculpture in 2017, and it's all that its name implies: a giant sculpture in red, green, and blue that mimics Indiana's *LOVE*, but with the *R* of "BRAT" standing upright where the *O* was tilted. The piece is corny and tacky: a piece

of pure commercialism with no redeeming artistic qualities beyond the flattery of imitation.

Wilmerding is convinced that the sculpture went out without Indiana's authorization because it doesn't work aesthetically. He doesn't doubt that the artist would have been interested in the commission for the money, but he wouldn't have approved for reasons of art. "I don't believe Bob himself would have put those four letters together in a block. *LOVE* and *HOPE*, both with their tilted *O*s, was classic Bob playing with formalities and shapes to get the proper balance between weight and lightness." *BRAT* is heavy-handed: the Clarendon typeface is his, but the composition is not.

"It's just not something he ever would have done," says Wilmerding. "One of his great strengths is that he knew design. Not just the shape of the letter, but how to put them together, and that's why they worked."

That's the same reason Wilmerding was sure that *WINE* was fake: the sculpture wasn't balanced, and Indiana would never tilt an *I*.

Many years ago, Morgan Art organized an Indiana-exhibition reception in Nice. It was one of the earliest shows arranged by the group and they went all out to make the artist feel comfortable by flying trusted friends, such as Ryan, to France. At the reception, the mayor of Nice suggested that Indiana make a sculpture of the word "NICE" for the city.

"Bob thought about it for a minute and then said, 'No, because the *I* won't work. I can't just have it standing up like a telephone pole and if I have it tilted like an *O* it will look like a fallen tree,'" Wilmerding argues.

The capital *I*, unlike the *O* in *LOVE*, wouldn't work for formal reasons: It's too thin and there'd be too much space around it. "That was the great success of the *O*," Wilmerding

says. "On the one hand, it's a little unstable, but at the same time its curves and oval nestle into the right-angle frame. That's why it works so well."

Years before Indiana died, Wilmerding was elbowed out of the artist's life. He came to the conclusion that Indiana was "clearly being manipulated" at the end of his life and it was showing in the poor quality of the artwork being made in his name.

After *BRAT* was installed in Wisconsin, Indiana's former assistant Webster Robinson texted a contact at Johnsonville Sausage. "That bratt [sic] sculpture from McKenzie was a fake. I worked for Robert Indiana for 25 years. Was there when bob told him no . . . He and Jamie Thomas faked it."

His contact replied, "It's been an interesting ride since the art was installed, we can't deny that! Regardless, it's a beautiful piece of art that members and community continue to enjoy."

Indeed, one of the owners of the sausage company, Shelly Stayer, told the *New York Times*, "We have a signed sculpture by Robert Indiana and we absolutely love it. Nothing else matters."

McKenzie has defended the authenticity of *BRAT* in court and in interviews, and says Indiana was both aware of *BRAT* and signed off on it. In addition, he says that Indiana received $320,000 for the piece, perhaps the last big payment for a new piece of work he received while he was alive.

McKenzie wouldn't discuss the final cost of *BRAT*, but it was likely a little more than $1 million, based on Indiana's cut of $320,000 and interviews with people with knowledge of the deal. McKenzie says he had to fight for the final payment because of a dispute with the estate over who should receive that money. "We informed Johnsonville that if we were not

paid in ten days we would confiscate the sculpture as per contract, and Johnsonville finished payments," he wrote in an email.

A spokesperson for Johnsonville did not reply to emails seeking corroboration or elaboration.

<div align="center">☆</div>

IN 2013, ONE of Michael McKenzie's assistants posted a video to social media showing an automated machine in McKenzie's New York studio signing Indiana's name to prints McKenzie produced. McKenzie admitted using the machine, and said it was for one series of two hundred prints. He said Indiana endorsed the idea, and told the *New York Times*, "For me, if he blesses the signature machine, that's the same thing as signing."

Under oath, McKenzie testified that he used the machine with Indiana's permission and at his direction, and that Indiana favored the signature machine because signing prints was physically tiresome. There is no way to corroborate his testimony.

"It takes a little bit of stamina to sign 200 pieces," McKenzie testified. "So, when he saw the volume of the stuff, he was overwhelmed. He couldn't take it. And it sat there for, I'm going to say, eighteen months, with the cats pissing on it. It was not a good thing." The signature machine was "a better solution," Kenzie testified. "I told him that I had seen this thing before, because I had done a lot of books with celebrities. They use it all the time. I knew it existed."

McKenzie's assertion here means that at the exact same time he was pushing the narrative that Robert Indiana was physically and mentally vigorous enough to be producing large quantities of new work, he somehow lacked the "stamina" to sign that new work.

McKenzie has claimed many things over the years; for example, he says he met Indiana at the World's Fair in Queens in 1964 when he was eleven years old, but that story is almost certainly apocryphal, because he describes meeting Indiana among the chaos of crowds expecting food as a result of the artist's illuminated *EAT* sign, but Indiana never saw *EAT* illuminated until it was atop the Farnsworth, in Rockland, more than forty years later. Regardless, Michael McKenzie and Robert Indiana did become business partners, as well as friends and confidants of sorts, and that relationship—whether purely transactional or tinged with something more—sustained itself until the artist's final days.

In death, Indiana became someone McKenzie loathed—though McKenzie had apparently loathed him for years: Back in 2008, after the eightieth-birthday party on Vinalhaven, Simon Salama-Caro met with McKenzie in New York to talk about *HOPE* to appease Indiana, and during that meeting McKenzie told Salama-Caro he hated Indiana and suggested they work together, according to court documents.

During the height of the legal battles after Indiana's passing, when McKenzie was the one left most exposed to legal jeopardy, he lashed out at his old friend as "an asshole prima donna" who made a lifetime of bad decisions and always left his friends out to dry.

"He was just a fuck-up," McKenzie says.

McKenzie talks fast and swears a lot. He's a name-dropper and hanger-on who can be cuttingly unkind. During a probate hearing in Rockland, a lawyer asked McKenzie if he had ever received any gifts from Indiana. He replied, "He gave me coffee." When pressed as to whether or not he ever received any gifts of art, McKenzie answered, "Never. I'm the guy who gives people stuff. He never gave me anything."

☆

IN THE DAYS before Robert Indiana died, Michael McKenzie and Jamie Thomas exchanged ideas, via text, for potential new pieces using Indiana's sculptural forms of *LOVE* and *EAT* with different themes and with different markets in mind.

"Hey Michael I am going to send you a pic of a new idea I just came up with just give me a minute to draw it out," Thomas wrote on May 1, 2018, less than three weeks before Indiana died.

"Awesome can't wait to see it," McKenzie replied.

Back and forth, they traded ideas—some serious, based on drawings from Indiana's notebook, as well as their own creativity, and some silly. "What about LOL," McKenzie suggests.

They liked "VINO," "BEER," "LUV," "YES," and "JOY."

The texts suggest that McKenzie and Thomas knew they were on murky legal turf. They reference attorney John Frumer, who was working with Thomas and Brannan to explore the scope of Morgan Art's legal rights pertaining to *LOVE* and other artworks. And though they would turn against each other within a year, at the very the moment when Thomas, Brannan, and Frumer were plotting their legal strategies against Morgan Art, Luke Nikas was putting the final touches on a lawsuit he had prepared over the past year, one that would land in federal court in New York on the very weekend Indiana died.

On Vinalhaven and in Manhattan, the legal gears were churning. The symmetry and poetry between the artist's life in Maine and his life in New York were expressing themselves not in the quarries of the island or on the windswept streets of Coenties Slip—those vowels of Vinalhaven and

consonants of Manhattan, where hope and love were born—but instead in modest law offices and high-rise boardrooms from Rockland to New York.

In death, the artist's creative life was defined not by his ideals and accomplishments, but by ownership claims and rights disputes—the very things he despised and spent his life avoiding. Everything was finally coming due. Checkmate.

"If you have any questions about what you can [and] can't do," Thomas wrote, "have your lawyer check with John [Frumer] or check with John directly we don't want to get in any mess while we're working on resolving this. It's not a question about what people want it's what we can do without getting into trouble."

McKenzie agrees, and replies he won't do anything "unless John clears it."

He advises Thomas that as holding Indiana's power of attorney, he should pursue quick legal action against Morgan Art, and suggests that Morgan Art's nonpayments and noncompliance of their contracts will make for an easy win. Thomas seems to understand that things are more complicated and tries to convey as much to McKenzie.

"John [Frumer] knows what he's doing," he texts McKenzie. "Bob has signed the things that [do] not make it easy to just do whatever we want."

Later, he writes to McKenzie, "I don't think we know for sure what rights they have completely that's what we're trying to determine."

On May 8, Thomas messages McKenzie a photo of one of Indiana's notebooks from 1969 with the word *SOUL* as an idea. "I did not know he had considered 'SOUL' that far back. He did not remember either," Thomas writes. The text implies that Indiana—little more than a week from death—

was still of sound enough mind to be involved in the discussion and offered feedback for using the word *SOUL.*

But when news of Morgan Art's lawsuit reached Thomas on Vinalhaven and news of Indiana's death reached McKenzie in New York, the texts go from casual to urgent and then angry.

Thomas reacts defensively: "I have sworn statements from his doctor saying he wasn't up for any visitors," he wrote on the evening of Friday, May 18, a few hours after the suit was filed and the night some people believe Indiana actually died. "Just doing my job."

"Agree," McKenzie replies on Saturday, May 19, the day Indiana is said to have died. "The thing is more complicated than that. His [Morgan Art attorney Luke Nikas] accusations accuse me of making fraudulent work and bob essentially of the same. If bob has been dismissed as incompetent it's a problem. If not w[e] need him to comment on pieces as his. Particularly Dylan. And now is the time to come back totally against Simon [Salama-Caro] with demand [for] accounting etc. federal court moves fast and if we let it linger, it makes the plaintiff stronger."

Thomas replies that it might be too late: "So no comments until we all talk," he texts, "but that is to [sic] late thanks."

"What's too late?!" McKenzie writes back urgently. "Can bob still speak on this or is he out of it."

Clearly, he was.

Michael McKenzie didn't know it, but at the moment he was texting with Jamie Thomas about getting Robert Indiana to vouch for the authenticity of the work featuring lyrics by Bob Dylan, the artist was on his deathbed, having either already passed or so deep in a drug-induced unconsciousness that there was no coming back.

"As they stand they accuse me of making fraudulent works which makes everything I did worthless," McKenzie texts to Thomas, "and that won't happen."

☆

IN THE FINAL hours of his life, Robert Indiana was without the grace of a better angel, as the people closest to him covered their tracks, plotted their defenses, and planned their next money-making venture. He'd been born to parents unable or unwilling to care for him. From a childhood of wanting—of twenty-one homes in the first seventeen years of his life—Robert Clark reinvented himself as Robert Indiana and became an internationally revered and fantastically wealthy artist. He used his wealth to transform the Star of Hope into a fortress and a shrine, and a permanent declaration of his earthly existence, fraught and imperiled though it was.

When Robert Indiana died, he died alone.

There were people around him, and some of them cared, but at the end of his life, Indiana was surrounded by people whose interests in him were transactional. Hours after McKenzie learned that Indiana had died, he texted Thomas again: "On a brighter note, *Wine Enthusiast* wants to do some licensing deals."

Robert Indiana died alone because that's how he lived.

During the entirety of Indiana's life in Maine—from 1978 until his death forty years later—he lived alone in a sprawling house. He had romantic liaisons, but never a lasting, committed relationship based on love. Without hope, the loneliness took its toll. His distrust grew as hard as Vinalhaven granite. His explosive bursts of anger disguised his pain. In the end, the perilous troughs of self-doubt made the artist vulnerable to anyone who pretended to care.

Abandoned as an infant and neglected as an old man, Robert Indiana was as alone at death as he was at birth, the final circle of his life—that imperfect tilted O—completed for the final tragic time.

EPILOGUE

IF THERE'S A small blessing to Robert Indiana's passing, it's that the artist almost certainly never knew the public shame of being sued by his own art dealer. When Morgan Art attorney Luke Nikas filed the civil action in the Southern District of New York at 2:21 p.m. May 18, 2018, Indiana was oblivious to the chaos and acrimony soon to unfold as he lay in a morphine slumber on the second floor of the Star of Hope.

Had he been more alert as he drew his final, labored breaths, Indiana might have thought back to the afternoon in September 2008 when he celebrated his eightieth birthday with friends and admirers gathered on a green Vinalhaven lawn to toast his long life and career. Many of the most important people to him were present. They all signed their names to an oversized *LOVE* birthday card: Sean Hillgrove, Webster Robinson, Valerie Morton, Melissa Hamilton, and Cheryl Warren, among others. Michael McKenzie signed the card with the word *HOPE*, the *O* in the shape of a tilted heart. Simon Salama-Caro signed, "Much Love–Great to be with you today!"

It should have been an untroubled day of celebration. Yet everything bad that happened at the end of Indiana's life was set in motion on that sunny day. Salama-Caro arrived on the island excited to fête Indiana, but left alarmed that McKenzie—the outlandish New York art publisher with a carnival-barker's flair—had taken the momentum of the *HOPE* sculpture and turned it into a production line of oil-on-canvas prints. Indiana, who was responsible for initiating the whole mess through his own impatience and negligence, was caught in the middle. There too that day was Jamie Thomas, the once-fired studio assistant who would soon reinsert himself in Indiana's life with a force no one could have predicted.

To most people at the eightieth-birthday party, it would have appeared to be a festive day of smiles and laughs, a big cake, and drinks all around. But Indiana's glassy eyes betrayed the fear that lurked within and a premonition of what was to come. For the artist, it was less a celebration of his life behind him than a foreshadowing of his complicated days ahead.

☆

AFTER ROBERT INDIANA's major retrospective at the Whitney Museum of American Art in 2013, which served as a burst of late-career validation, one by one the people closest to the artist were locked out of his life, by the increasingly powerful Jamie Thomas. First his friends were rebuffed, then his professional associates, and finally his closest studio and personal assistants. The big wooden door at the Star of Hope would swing open no longer.

Some, though, wouldn't go without a fight.

Kathleen Rogers, the former publicist, was so upset by what she feared was happening to her old friend that she raised alarms, unanswered, of elder abuse. Ronald Spencer, Indiana's longtime attorney, questioned his dismissal, then tried to revoke Thomas's power of attorney. After Indiana died, Spencer pleaded with the Maine attorney general to invalidate Indiana's final will. And Sean Hillgrove, the loyal assistant of some thirty years, never gave up his attempt to reclaim Indiana as a father figure and help nurse him through a peaceful passage.

But they all failed.

Rogers last saw Indiana in early 2014, when she witnessed him excoriate Morgan Art emissary Marc Salama-Caro over the organization's demand for compensation for *LOVE* to be used on a Maine license plate. Years later, Rogers tried and failed several times to see Indiana before lodging a for-

mal complaint with the Maine Department of Health and Human Services. Her complaint prompted an investigation, but no finding was issued. Minutes after Rogers learned of Indiana's death, she emailed McKenzie a copy of the *New York Times* story with a terse warning for him and Thomas: "You two are toast." And then she wept.

Spencer saw Indiana for the final time in the winter of 2016, when he visited Vinalhaven to draw up paperwork for the Star of Hope Foundation. He was fired by email soon after. Spencer's removal was the key to all that followed. It opened the door for others to exert legal authority over Indiana's affairs, present and future, and cleared the way for Michael McKenzie to pursue bizarre projects such as *WINE* and *BRAT*. If the goal was to make it easier to create new work under Indiana's name, it made sense to push out Spencer, the art-smart attorney with expertise in fraud. And it wasn't difficult to do: Spencer lived in New York, and visiting the island of Vinalhaven wasn't exactly convenient; if he did, he certainly wasn't getting into the Star of Hope.

Hillgrove's final encounter with Indiana came on that strange winter night in 2018, when he says he climbed a ladder at the back of the Star of Hope, knocked on the second-floor door, and briefly spoke with Indiana about meeting again so the artist could sign paperwork revoking Thomas's power of attorney. But they never met again.

☆

PEOPLE AROUND ROBERT Indiana relished wielding the power and respect the acclaimed artist commanded, even if they had done little to earn them. Many in Indiana's rotating cast of assistants saw themselves as protecting the artist and his legacy; others say their bizarre actions were simply fulfill-

ing the old man's wishes. The only person who can speak to the validity of any of these assertions is gone.

Many of the allegations in this book come from court filings made by the Indiana estate, Morgan Art, and various other parties. Many of these lawsuits never went to trial; thus, the allegations were never formally adjudicated. And because so many of the lawsuits swirling around Indiana were settled out of court and those settlements are confidential, we'll never know how a judge would have ruled on the validity of those allegations.

But we do know that the last years of Robert Indiana's life were blanketed with a quilt of characters who stitched together relationships of convenience in order to benefit from their associations with the world-famous artist.

James Brannan, the seemingly folksy attorney from the mainland, and Jamie Thomas, the scrappy, resourceful islander, made an unlikely pairing when in 2016 they oversaw the major modifications to Indiana's will. Brannan took control of Indiana's estate; Thomas seized the power of attorney that gave him authority over Indiana's artwork, financial affairs, and healthcare. In 2017, the pair began scheming, with the help of attorney John Frumer, to reclaim the rights to *LOVE* from Morgan Art and then resell them. And they planned how to handle Indiana's death: quickly and quietly. In 2018, they executed their plan to near perfection, provoking Morgan Art into a protracted legal battle and hustling Indiana's body off the island, all within roughly twenty-four hours.

But in the chaos and acrimony that followed, Brannan and Thomas turned on each other.

Thomas found himself at the heart of a legal case that threatened to turn from an island brushfire into a mainland

wildfire. In July 2019, a little more than a year after Indiana died, Thomas sued Brannan and the estate for $2 million to pay his legal fees. Then Brannan turned on Thomas, accusing him of allowing Indiana to live in squalor, of stealing his money and plundering his art, and of violating his authority as power of attorney—ironically, it was the very authority that Brannan himself helped create and confer to Thomas.

The pair never mended their differences but settled their legal claims in secrecy.

Thomas had also allied himself with Michael McKenzie. Their friendship has outlasted the chaos and bitterness. McKenzie continues to defend Thomas. He rails against those who accuse him of abusing or isolating Indiana and calls allegations of murder or a hastened death libelous. Of course, McKenzie has a lot riding on his association with Thomas. McKenzie maintains he needed only Thomas's approval to pursue his artistic agenda: He says he received Indiana's blessing for the prints and sculptures he produced under Indiana's name, but that Thomas had the authority to approve them— even without the artist's knowledge—regardless.

Aside from his allegiance with Thomas, McKenzie has found himself the odd man out. In fact, as a court settlement involving everyone except McKenzie eased toward secret resolution, the most unlikely of allies stood together: the Indiana estate and Morgan Art. Brannan and Nikas, the rival lawyers at the heart of the dispute, who had spent more than two years trading accusations and trying to reveal each other's closely guarded secrets, decided it was time to take a new approach with McKenzie: the enemy of my enemy is my friend.

"Sometimes the divide-and-conquer approach is the right one," Nikas says, explaining the legal strategy to settle with

the Indiana estate so each could pursue or defend individual claims against McKenzie.

When Nikas's client Simon Salama-Caro began his professional collaboration with Indiana, back in the 1990s, he wasted no time assuming some of the artist's power and respect and flexing his new authority: he asserted himself as the gatekeeper, and demanded that curators and others go through him. When Thomas was given legal authority over Indiana's affairs, years later, karma came full circle when Thomas treated Salama-Caro as Salama-Caro had once treated others: Thomas restricted Salama-Caro's access to Indiana, while maximizing profits for his own interests.

During all the turmoil, the ever-elusive European art dealer was exposed as being kind but ruthless, deferential but aggressive: with an extended hand and a smile, he'd take any steps necessary to protect his turf. He was powerful but mysterious; as someone close to Indiana put it, "Salama-Caro seemed to be everywhere, but you didn't really know where."

Simon Salama-Caro declined—through his attorney—multiple interview requests for this book.

☆

UNTIL CONTROL OF Robert Indiana's enormous legacy came into play, near the end of the artist's life, James Brannan's presence in Indiana's sphere involved mostly real-estate transactions, befitting the small-town attorney's experience. Then Brannan found himself quite suddenly in the innermost circle of power around Indiana. Until the artist's death, Brannan, Thomas, and McKenzie were allies of convenience working in active opposition to Morgan Art. Then they were not.

Brannan says he was a regular visitor to the Star of Hope until May 2016, when he met with Indiana and others to sign

the will that made him executor of the artist's estate. After that, he seems to have stopped visiting the Star of Hope altogether. He's claimed ignorance of Indiana's decline in health and the building's deterioration. In 2019, he accused Thomas of forcing Indiana to live his final days in squalor. Yet Brannan himself is open to at least the charge of neglect: As the lawyer for one of the country's greatest living artists—a man who had no children and no heirs and whose only known family was a cousin in the Midwest—Brannan should have been more invested in Indiana's care and well-being. He knew he would make a lot of money when Indiana died, but failed to show his client the respect he deserved by advocating for him while he was alive.

Days after Indiana died, Brannan filed the paperwork that officially named him Indiana's personal representative. In doing so, he placed himself in line for a payday of somewhere around three quarters of a million dollars—more if the litigation carried on. And carry on it did. For years.

As the chaos and acrimony after the artist's death dragged on, Brannan believed the Maine attorney general was going to remove him as personal representative of the artist's estate "any day." But it never happened. However, the Maine attorney general did bring in experts to review legal invoices Brannan had billed to the Indiana estate. The attorney general's office concluded that nearly $3.7 million in legal fees billed through March 2021 should be returned to the estate, characterizing them as "excessive" and arguing that Brannan should be held personally responsible for returning the money since he authorized its expenditure.

The attorney general's office contended that $400,000 of the roughly $1.8 million Brannan paid himself as the estate's personal representative was excessive. Court documents cit-

ed improper billing, billing for clerical duties and non-legal tasks at full, lawyer rates, and improper charging of meals and travel expenses at full, lawyer rates. The attorney general asked the court to find that Brannan breached his fiduciary duty by over-paying himself, by overpaying the law firms he hired, and by prolonging the litigation when a settlement could have been reached sooner.

The court motion said two New York legal firms were overpaid $3.3 million, and two Maine firms were overpaid about $240,000. Maine Assistant Attorney General Christina M. Moylan wrote that Brannan's pace of spending made the matter "a truly urgent situation" during a hearing in spring 2021. According to the motion, in February and March of 2021 alone, Brannan billed the estate $1.6 million in new fees: more than $876,000 for law firms and $741,000 for Brannan himself.

But the probate judge handling the attorney general office's motion said they lacked the necessary information to determine if the fees were excessive, and said if the attorney general's office wanted to recover those fees, it should pursue its claims with the firms who filed the invoices and not with Brannan.

As this book went to press, the matter remained unresolved.

Brannan survived long enough to wield the power and authority required to significantly influence the outcome of the settlement. As something of an underdog when compared to Morgan Art's deep pockets and sophisticated legal team, even he might be surprised with how things have resolved.

But Brannan might have dug in a little too long. The settlement on the table in fall 2020 was largely the same as the one everyone signed in spring 2021. By dragging out the New York litigation through the winter, Brannan exasperated both Larry Sterrs at the Star of Hope Foundation and the Maine attorney general, who determined that all the fees

incurred by the estate related to New York litigation after the fall 2020 settlement were excessive.

The fall 2020 settlement spelled out the future business relationship between Morgan Art and the Star of Hope and, equally important, a process for resolving the past accounting and royalty disputes between Indiana and Morgan Art that Brannan had raised in his court filings. By simply signing on to that agreement, Brannan could have claimed victory, walked away, and retired to Florida. But he refused, despite Sterrs repeatedly urging his consent. After mediation during the winter of 2020-2021, Brannan finally signed on to a new settlement—but it was substantially similar to the one that was already in place and had been awaiting his signature for months. That's when the Maine attorney general filed paperwork accusing Brannan of breaching his fiduciary duty to Robert Indiana's estate—largely the same thing Brannan had accused Morgan Art of doing to the artist when he was alive.

The outcome of his dispute with the attorney general over his fees notwithstanding, Brannan has still accrued significant new personal wealth in just a few short years.

☆

ASIDE FROM JAMES Brannan, one of the most influential characters in the story of the last days of Robert Indiana's life is someone we know very little about: Jamie Thomas.

Thomas declined numerous requests for interviews over the course of the legal battles and during the reporting of this book. But through anecdotes, emails, testimony, and court documents, he emerges as a man of paradoxes: Thomas is liked and respected by the peers who supported his efforts to clean up the so-called riffraff at the Star of Hope, but loathed by

Indiana's art-world friends, who accused him of keeping them from the artist and providing cover for McKenzie's projects.

When in 2018 Thomas took the stand for a probate hearing on Indiana's estate, he appeared confident and assertive, answering every question asked and rising to his own defense when prodded. He was smart, confident, and in control. When asked about his responsibilities as holder of power of attorney, Thomas ticked off the list: "I started to make sure that his finances were in order. He hadn't paid his taxes for quite some time, so that was quite an ordeal. Just whatever he wanted me to do. I wanted to make sure that the foundation was up and running. Just sat with him most nights talking about what could happen in the future with the foundation."

Yet Thomas is a man of contradictions: for each question he has answered assertively, there are countless others he didn't respond to and that only he can answer. Just a few of those questions are:

Why did he withdraw $615,000 in cash from Indiana's accounts, often in denominations of $100 bills, over the course of two short years?

Why did his wife turn over a bag of cash with $179,800 after Indiana died?

And who hid $95,800 in cash behind the filing cabinet?

Why did Indiana, a Christian Scientist with a distrust of Western medicine, die with a system full of morphine, lorazepam, atropine, and isopropanol?

Did Indiana die on Saturday, May 19, 2018, as Brannan reported, or on Friday, May 18, 2018, as people close to Indiana have asserted and still believe?

And where—*where*—are Robert Indiana's ashes? Will there ever be a public memorial?

Jamie Thomas has never been charged with any crimes

related to Robert Indiana. He has denied all allegations of wrongdoing and neglect. He has settled with Indiana's estate. He was removed from his promised role as executive director of the Star of Hope Foundation, but throughout the aftermath of Indiana's death, he has maintained the steadfast support of the Vinalhaven island community.

However, says one of the lawyers involved in the legal battles, "Thomas is a nobody now. In terms of his ability to influence this business, he is out of the picture."

<div align="center">☆</div>

WHEN LONGTIME INDIANA studio assistant Wayne Flaherty pleaded guilty to Social Security fraud in early 2021, documents filed in federal court during the sentencing included not only accusations that Indiana began sexually abusing Flaherty when he was in his teens, but also implied that both Brannan and Thomas were aware of the accusations when Indiana was still alive.

During its investigation of Flaherty, the Social Security Administration uncovered details of his troubled life. Molested as a child, he dropped out of school around eighth grade and never earned a GED. He drifted into drug abuse and suffered from mental health issues. Flaherty was approved to receive Social Security disability benefits in January 2000 after receiving a diagnosis for Anxiety and Affective Mood Disorder; he was thirty-three years old at the time.

In the court documents, Indiana is identified as "Individual A," a "famous and wealthy" person who had employed Flaherty since the early 1990s. "He was nice to me and gave me things," Flaherty wrote. "He started having sex with me when I was about 16. [Individual A] gave me drugs and later money for sexual favors for a long time."

A Social Security investigator reported: "Sometimes [Individual A] would give money to [XX] and [YY] to then pass on to him. ... FLAHERTY said at that time [ZZ] an attorney for [Individual A] had FLAHERTY sign an agreement saying he would not talk about [Individual A] to anyone. FLAHERTY explained that [Individual A] molested him when he was a juvenile."

Who were the other anonymous individuals mentioned in the investigator's report? It was Thomas who withdrew $615,000 from Indiana's (Individual A) accounts during the period when Flaherty was receiving the cash payments he failed to report to the Social Security Administration while also receiving benefits. It was Brannan who served as Indiana's attorney during this period and who, according to studio assistant Webster Robinson, offered $25,000 in "severance pay" if Flaherty would never talk about his time in working at the Star of Hope.

Arrested in Massachusetts in 2018 while illegally purchasing opiates, Flaherty has since sought treatment for his addiction and engaged in mental health counseling. Given the findings of their investigation, the Social Security Administration did not seek the highest possible penalties against Flaherty: five years in prison and a $250,000 fine. Instead, he received three years of probation, 240 hours of community service, and was ordered to pay $141,214 in restitution.

Some who were close to or familiar with Flaherty's time in Indiana's employ dismiss Flaherty's accusations as an effective ploy for sympathy and a sentence without jail time. They believe he's being untruthful and that he embellished the nature of what they described as a consensual relationship between Flaherty and Indiana. Indeed, a couple of years before Flaherty accused Indiana of sexual abuse, he supported

his former boss in a 2018 affidavit on Morgan Art's behalf. He affirmed he was part of Indiana's working inner circle—with Hillgrove and Robinson—and that Thomas began intentionally "isolating" Indiana in 2016.

In the signed affidavit, Flaherty gives accounts of what he believes equated to Thomas and McKenzie conspiring against Indiana. He wrote that Indiana did not knowingly sign over his Power of Attorney to Thomas in 2016 and that Indiana was skeptical of McKenzie: "Bob told me he didn't want any part in the 'HOPE shit.'" About the works featuring the lyrics of Bob Dylan, Flaherty wrote: "Bob also said that the Dylan works 'have nothing to do with me' and that he didn't 'know what McKenzie's intentions are with them.'"

In the document, Flaherty also appears sympathetic to the idea that Indiana had been abused. He writes that before Thomas isolated Indiana, "I went to Bob's house about two times per week, throughout the year, to give Bob baths and change his clothes. Sean [Hillgrove] often shaved Bob and cut his hair." That all ended after Thomas's arrival.

But when Flaherty faced jail time, he changed his story, saying Indiana had abused him and the money he received mostly wasn't compensation for work, but money to keep quiet.

Robinson dismissed Flaherty's accusations out of hand. "He's lying through his teeth," he said.

Whatever the truth, Flaherty appears to have received a relatively light sentence in part because the government believed him. Soon after being sentenced in June 2021, Flaherty answered a reporter's phone call. "I don't really want to talk," he said. "I have so many people calling me and bugging me, and everybody else is going to get rich off of it."

Before hanging up, he said "everybody" was lying about him, "about everything," including the government prose-

cutors. He said the government exaggerated the amount of money Indiana had paid him. "I never got $841,000 off Bob. I wish. I might have blown $300,000, but not $800,000. I had to plead guilty to it. I didn't want to fight it and drag it out."

For someone who said they didn't want to talk, he had a lot to say.

Flaherty said he didn't actually work for Indiana. "I just kept going back out there to get what was right," he said. "I wanted an apology, but that never happened. He was a sick man."

When asked about details of his relationship with Indiana and what he was being paid for if not work at the Star of Hope, Flaherty said he was uncomfortable talking about it. He said he would call back if he changed his mind about an interview.

He never called back.

Wayne Flaherty's allegations have caused some of Indiana's friends to wrestle with the likelihood that the man they so revered had paid people for sex over a very long time—and some of them might have been boys. People on Vinalhaven detested Indiana because they believed those stories to be true. With time, others have begun to believe them, too.

"Bob set himself up for the fallout that happened. For that I have zero sympathy," said one friend. "It also makes him look like a dirty old man."

None of Wayne Flaherty's accusations against Indiana have been proven in a court of law. With the artist long dead, they never will be. And the only individual legally empowered to defend Indiana, his attorney James Brannan, declined to comment.

☆

ISLANDS HAVE A way of keeping their secrets and protecting their own. Only those who live on Vinalhaven know how

it was when Robert Indiana lived there—though many of their stories are seeded with suspicion and even hate. For better and for worse, the artist was always, like his house, larger than life.

Indiana settled in Maine in 1978 to escape the art-world drama of New York City. But he brought the drama with him. He wanted to fit in—or at least said he did—but spent many of his forty years on Vinalhaven distancing himself from the people he hoped to win over. In four decades, he earned the acceptance of some islanders, but never the respect of the island.

The end of Robert Indiana's life was murky because, given how he'd lived, what else could it be? We don't have a medical examiner's report of the man at the time of his death because of those who surrounded him at that moment; we have a medical examiner's report of the man at the time of his death in spite of them. Those in Indiana's inner circle moved to have the artist's body spirited off the island and swiftly cremated, and that plan was only narrowly averted: the island rumor of Indiana's death reached the *New York Times* via a tip from Indiana's former attorney Ronald Spencer. The *Times* called Morgan Art attorney Luke Nikas for confirmation; Nikas called the FBI; and the FBI halted Indiana's cremation and ordered an autopsy.

When the *New York Times* contacted Brannan to confirm Indiana's death, Brannan answered this way: "How did you find out?" It's an odd response to a simple question, but apparently he hadn't anticipated anyone asking it so quickly.

On Monday, May 21, 2018—either two or three days after the artist died, while the cocktail of drugs in the Christian Scientist's system dissipated by the hour—the *New York Times* broke the news: Robert Indiana was dead. Of course, the fight to shape Indiana's legacy and lasting reputation was only just beginning.

On a brisk late-winter afternoon early in 2021, two high school students stood on the front steps of the Star of Hope. Their artwork hung in the windows of the old building, which for the first time in as long as anyone could remember were no longer boarded up. Indiana had covered the south-facing windows many years ago because of vandalism. Now, sunlight poured in. The refurbished windows were open to the community. The storefront looked as it did before Indiana ever arrived on Vinalhaven.

The high school students, ages fifteen and eighteen, are lifelong islanders. But they know of Indiana only from what they learned at school: neither ever saw the small island's most famous resident in person—not at the post office, not in a store, not even just walking down the street.

Robert Indiana was gone, and now even the traces he left behind were vanishing.

On the ferry ride back to the mainland, a young man struck up a conversation with another passenger about the artist. He knew Indiana as a generous but difficult man whose poor reputation was worse than reality. "Maybe he did some things years ago that weren't so cool, but the last few years he did a lot of good for the island and for people on the island," the man said. "He just grew old and lonesome. After a while, he kind of became like this king who never came down from his castle."

Despite the legal settlements among the myriad litigants, Robert Indiana's artistic legacy is messy and unsettled. From his early success in New York to his impressive second act on Vinalhaven, his own carelessness and seeming inability to come to terms with himself allowed others to trade his talent like a commodity. In the end, he has left his friends and enemies alike to sort through the chaos and patch together the broken circles of his legacy. ✪

CAST

Alexandria "Allie" Aiken The adult daughter of Indiana's longtime bodyguard and studio assistant Sean Hillgrove. Aiken continues to fight for her deceased father's reputation.

Edgar Allen Beem A Maine-based arts writer. Beem interviewed Indiana soon after the artist moved to Maine. Indiana regularly opened his home to Beem and his family, and the pair became friends.

James Brannan A small-town Maine attorney. After representing Indiana mostly in real-estate deals, in 2016 Brannan became executor of the artist's estate. In 2021, the Maine attorney general's office filed a motion in probate court accusing Brannan of breaching his fiduciary duty to Indiana's estate, citing what it described as "excessive" billing.

Douglas Calderbank A private investigator from Portland. Calderbank served paperwork on Jamie Thomas and Michael McKenzie in May 2018, after both were sued by Morgan Art.

Alden Chandler The longtime director of the Maine Arts Commission. Chandler, formerly known as Alden Wilson, was friendly with Indiana, both personally and professionally, for three decades.

Christopher Crosman Founding chief curator of American Art at Crystal Bridges Museum, in Arkansas, and the former director of Maine's Farnsworth Museum. Crosman was an instrumental curator during Indiana's career and knew him from the 1970s until the artist's death.

Jennifer Desmond Vinalhaven's island nurse. Desmond cared for Indiana in his final years. She supervised the artist's end-of-life care team and prescribed the drugs found in his system at the time of his death.

Wayne Flaherty A studio assistant. Flaherty failed to deliver a document to Sean Hillgrove that would have revoked Jamie Thomas's power of attorney, choosing instead to stash the paperwork in his safe and take a trip to Florida. After Indiana died, Flaherty pleaded guilty to Social Security fraud. During the investigation and court proceedings, Flaherty accused Indiana of sexually abusing him in his teens.

John Frumer An attorney representing Jamie Thomas. Frumer began exploring legal options against Morgan Art while Indiana was still alive. After

Indiana's death, Frumer defended his client against allegations of abuse and theft.

Melissa Hamilton A studio assistant for Indiana from 1999 to 2016. She left the Star of Hope in August of that year when Jamie Thomas and Michael McKenzie's influence was expanding. She moved to Connecticut before Indiana died, but remained involved in his life. She learned of the artist's death from island friend Cheryl Warren and informed others, including another studio assistant, Webster Robinson.

Sean Hillgrove A longtime and loyal studio assistant. Hillgrove was one of Indiana's most trusted friends and considered the artist to be a father figure. He was hired as a bodyguard and was with Indiana in New York during the terrorist attacks on September 11, 2001. He was the subject of island scorn and eventually forced out of Indiana's inner circle. He died at age fifty-one in 2020, with feelings of guilt for not having protected Indiana when he was most vulnerable.

Robert Indiana The world-famous artist and self-proclaimed "sign painter" from the Midwest whose art was always more famous than he was. He moved to Manhattan in the 1950s and to the Star of Hope Lodge on Vinalhaven island in Maine two decades later. Best known for his designs of LOVE and HOPE, he created accessible art with Pop sensibilities loaded with biographical meaning and political messages. He lived his life mostly alone and vanished from public view in 2016. He died two years later, at age eighty-nine, leaving an estate valued at as much as $100 million.

Michael Komanecky A curator at the Farnsworth Art Museum. Komanecky worked closely with Indiana on exhibitions and became an expert on the Star of Hope and its contents, as well as an advocate for Indiana and work late in the artist's life. After Indiana died, Komanecky organized a memorial for him at the museum.

Thomas P. MacDonald An FBI Special Agent. MacDonald came to Vinalhaven to investigate art fraud after Indiana's death. He has handled a long list of famous cases, among them the theft of several paintings from the Isabella Stewart Gardner Museum, in Boston. He also pursued the fugitive Whitey Bulger.

Michael McKenzie A New York art publisher. McKenzie had an on-again/off-again history with Indiana. In 2008 he began a concentrated, decade-long association with the artist that lasted until Indiana's death. He paid the artist $10 million during that time, then asked for $3.5 million

back after Indiana died. He was accused of making fraudulent art under Indiana's name, but said he had permission from Indiana. His relationship with the artist prompted Morgan Art's original lawsuit.

Morgan Art Foundation A foundation in name only. Morgan Art signed contracts with Indiana to fabricate his sculptures and reproduce other artwork, including LOVE, in 1999. Relying on Indiana's agent, Simon Salama-Caro, for advice, Morgan Art paid Indiana millions of dollars and brought him the fame he cherished. Morgan Art was accused of underpaying Indiana and misleading him with confusing and incomplete invoices.

Luke Nikas A partner at the law firm Quinn Emanuel Urquhart & Sullivan, in New York City. Nikas is perhaps best known in the art world for keeping disgraced Knoedler gallerist Ann Freedman from going to prison. Nikas took on the Indiana case for Morgan Art in 2017. Mild in manner but relentless in defense of his clients and the protection of his turf, the Harvard Law graduate has been named one of the top litigation lawyers in the country.

Daniel O'Leary The former director of the Portland Museum of Art. O'Leary had a fruitful friendship with Indiana, trading the artist furniture for his Odd Fellows lodge in exchange for art for the museum's collection. He gave Indiana his first answering machine and computer, and in 1999 collaborated with him on the exhibition *LOVE and the American Dream: The Art of Robert Indiana.*

Marius Peladeau A former director of Maine's Farnsworth Art Museum. Peladeau was an early friend to Indiana when the artist came to the state and gave him his first Maine exhibition, *Indiana's Indiana,* in 1982. He brought the sculptor Louise Nevelson to visit Indiana at the Star of Hope.

Rob Potter A former deputy sheriff on Vinalhaven. Potter says he didn't know Indiana had died until after the body had been removed from the island. He was fired for misconduct in 2019, and now works as a caretaker on the island.

Webster Robinson A former studio assistant. Robinson began working for Indiana in 1994 and worked for him off and on until he was fired, in 2018. He handled Indiana's email, as well as other tasks in the Star of Hope and studio, and is one of the few people with firsthand knowledge of Indiana's circumstances still willing to talk. He was kicked out of the Vinalhaven house Indiana purchased for him and was homeless for a time on the mainland.

Kathleen Rogers Indiana's former publicist. Rogers remains one of Indi-

ana's most loyal advocates. She met him in 1999 and they remained friends until 2015, when she was forced out of his life. Rogers grew concerned that he was being abused and filed complaints with the Maine Department of Health and Human Services.

Susan Ryan Indiana's biographer and longtime friend. Ryan interviewed Indiana many times throughout the 1980s and 1990s. Her book, *Robert Indiana: Figures of Speech*, was published in 2000, and she continued to write about his art for many years.

Marc Salama-Caro Son of the art dealer Simon Salama-Caro. Marc became a trusted confidant and a frequent visitor to Vinalhaven until the circle around Indiana become smaller and the Salama-Caros, father and son, were forced out.

Simon Salama-Caro An art dealer central in Indiana's life and career. Salama-Caro began working with Indiana in the 1990s and connected him with the Morgan Art Foundation, representing Indiana as his agent and Morgan Art as its consultant. He was accused of being a double agent and taking advantage of Indiana, but is also said to be responsible for helping Indiana achieve his greatest artistic heights.

Earle G. Shettleworth Jr. The longtime State Historian for Maine. Shettleworth advised Indiana about his early work on the Star of Hope and helped him get the building listed on the National Register of Historic Places. He also worked with Indiana and Maine Arts Commission director Alden Chandler (né Wilson) on the First State painting project.

Ronald Spencer Indiana's former attorney. In 2016, Spencer was fired by someone using Indiana's email account. The lawyer also represented Morgan Art. He was a strong advocate for Indiana, badgering the Maine attorney general to investigate whether Indiana signed his final will under undue influence.

Star of Hope The Victorian-era structure on Vinalhaven's Main Street. The building was the historic home of the local order of the Odd Fellows fraternal organization. Indiana began renting the upper floors of the building as a studio in 1973 and later purchased the lodge for $10,000. The Star of Hope embodied Indiana and his life: he filled it with his art and artifacts and took great pride in showing it off.

Larry Sterrs The chairman of the Star of Hope Foundation. Sterrs emerged as a key player in the hard-won legal settlement and the future of

Indiana's artistic legacy. The SoH Foundation, which owns Indiana's home and other property on the island, benefited from the artist's assets and is charged with managing his legacy.

Jamie Thomas Indiana's final personal assistant. Admired by the Vinalhaven community for bringing order to Indiana's affairs, Thomas was reviled by others, who accused him of isolating Indiana from his friends and art-world associates. He worked for Indiana in the 1990s and rejoined the Star of Hope crew in 2013. A caretaker, fisherman, artist, and actor, Thomas performed all manner of tasks for Indiana, including cooking and book-keeping, and formed an alliance with Michael McKenzie.

Vinalhaven An island roughly fourteen miles off the coast of Maine. With just shy of twenty-four square miles of landmass, Vinalhaven is larger than its sister island, North Haven; accessible only by ferry, they are known collectively as the Fox Islands. Famous for its thriving lobster fishery, rich history of granite quarries, and prosperous summer colony, Vinalhaven had a year-round population of 1,165 at the 2010 census.

John Wilmerding A retired Princeton art scholar. Wilmerding is a leading authority on Indiana's art, and was a longtime friend of his. He was outspoken in his belief that McKenzie was making work in Indiana's name, with or without Indiana's approval, and that Thomas was abetting him by keeping Indiana's friends at bay. A regular summer visitor to Vinalhaven, Wilmerding last saw Indiana in 2015.

TIMELINE

Early Years

1928	Robert Indiana is born (September 13) Robert Earl Clark in New Castle, Indiana. Adopted by Earl Clark and Carmen Watters Clark, of Indianapolis.
1938	Earl Clark and Carmen Watters Clark divorce.
1946	Graduates as valedictorian from Arsenal Technical High School, Indianapolis. He receives a Scholastic Art and Writing Award to attend the John Herron Art Institute, but chooses instead to enlist in the U.S. Army Air Corps.
1949	Enters the School of the Art Institute of Chicago on the G.I. Bill.
1953	Visits Maine for the first time, to study at the Skowhegan School of Painting and Sculpture.
1954	Receives BFA from the School of the Art Institute of Chicago. Moves to New York City.
1956	Befriends Ellsworth Kelly and moves into a loft studio in Coenties Slip.
1958	Changes last name to Indiana.
1963	Museum of Modern Art and Whitney Museum of American Art, both in New York City, exhibit Indiana's work, as does the Walker Art Center, in Minneapolis.
1964	Exhibits electric sign sculpture *EAT* in the New York State Pavilion at the New York World's Fair, alongside Pop art luminaries such as Roy Lichtenstein, Robert Rauschenberg, and Andy Warhol.
1965	Moves studio from Coenties Slip to Spring Street and the Bowery. Commissioned by the Museum of Modern

Art to design a Christmas card, Indiana submits *LOVE*.
Stable Gallery opens third solo Indiana exhibition.
LOVE is shown in different mediums, colors, and
configurations; a small edition of aluminum *LOVE*
sculptures is produced.

1968 The Institute of Contemporary Art, at the University of
Pennsylvania, in Philadelphia, hosts Indiana's first solo
museum exhibition.

1969 Visits the photographer Eliot Elisofon on Vinalhaven
island, off the coast of Maine.

1971 A *LOVE* sculpture is installed at the Fifth Avenue and
60th Street entrance to New York City's Central Park,
and is then returned to the Indianapolis Museum of Art
for permanent display.

1973 U.S. Postal Service issues 330 million eight-cent *LOVE*
stamps. Indiana begins renting the Star of Hope Lodge as
a seasonal studio.

1976 A *LOVE* sculpture is installed on the John F. Kennedy
Plaza, Philadelphia, as part of the city's bicentennial
celebration; the park eventually becomes known as
"Love Park." Indiana buys the Star of Hope from
Elisofon's estate for $10,000.

Vinalhaven Years

1978 Moves permanently to the Star of Hope Lodge.

1979 Shelley Lieberman, Indiana's former lover, visits
Vinalhaven and is later found dead.

1981 Rents sail loft to use as a sculpture studio.

1982 Farnsworth Art Museum, in Rockland, Maine, hosts first
Indiana exhibition in the state, *Indiana's Indiana*. The Star of
Hope is listed on the National Register of Historic Places.

1988	Sean Hillgrove begins working for Indiana as his bodyguard and studio assistant, and stays with him thirty years.
1989	Jamie Thomas begins working for Indiana; he says he worked with Indiana for about ten years, although others say he was fired within a year of being hired.
1990	Charged with solicitation of prostitution from minors on Vinalhaven.
1991	Exhibits with Salama-Caro Gallery, in London, for the first time.
1992	Acquitted of prostitution charges.
1994	Partners with Michael McKenzie on ABSOLUT INDIANA ad and *LOVE* poetry project. Webster Robinson begins working for Indiana.
1997–98	State and federal liens are placed on the Star of Hope.
1998	Musée d'Art Moderne et d'Art Contemporain, in Nice, hosts Indiana's first museum retrospective in Europe.
1998–2002	Liens on the Star of Hope are lifted.
1999	Signs contracts with Morgan Art Foundation Limited for rights to *LOVE*, as well as other two-dimensional works, and the right to produce sculptures in the artist's name. Portland Museum of Art, Maine, exhibits retrospective of Indiana's art. Melissa Hamilton begins working for the artist.
2000	Susan Elizabeth Ryan publishes *Robert Indiana: Figures of Speech* (Yale University Press).
2001	Experiences September 11 terrorist attacks on New York City with studio assistant and bodyguard Sean Hillgrove. Returns home and affixes American flags atop his home and paints flags on panels covering windows onto the street.
2002	Indiana Governor Frank O'Bannon declares April 9 "Robert Indiana Day."

2007	After much wrangling, Indiana donates the painting *First State* to the State of Maine.
2008	Celebrates eightieth birthday on Vinalhaven. Signs five-year *HOPE* contract with Michael McKenzie's company, American Image Art. A six-foot-high, stainless-steel *HOPE* sculpture is displayed during the Democratic National Convention in Denver.
2009	The Farnsworth Art Museum opens a survey of Indiana's work. A twelve-foot-high steel *LOVE Wall* is put on display and *EAT* is installed on the museum's roof and illuminated for the first time since 1964.
2010	Declines a meeting with Barack Obama at the White House at the last minute, upset that he did not receive a written invitation.
2011	Indiana and American Image Art modify *HOPE* contract to renew annually contingent on continued annual payment of $1 million royalty.
2013	*Beyond Love* retrospective opens at the Whitney Museum of American Art, New York City; *HOPE* is not included in the exhibition. Michael McKenzie buys a home on Vinalhaven. Jamie Thomas is rehired as an assistant.
2013–14	*LOVE* license-plate project for Maine falls through when Morgan Art demands a licensing fee for use of the image. Indiana leaves fans disappointed when he fails to appear for International HOPE Day outside the Star of Hope on his birthday.
2015–16	Disappears from public view.
2016	Fires longtime attorney Ronald Spencer; assigns power of attorney to Jamie Thomas. Attorney James Brannan rewrites Indiana's will, naming himself the artist's personal representative and Thomas the future executive director of the Star of Hope Foundation. McKenzie organizes the traveling exhibition *Robert Indiana: Now and Then*, which includes work that raises alarms about its validity among Indiana scholars when they see it at Bates College Museum of Art, in Lewiston, Maine.

2017	Morgan Art pays Indiana a little more than $1 million, its final payment to him as a living artist. Luke Nikas represents Morgan Art and prepares to sue Robert Indiana for breach of contract.
2018	Morgan Art files lawsuit against Robert Indiana. Indiana dies in the Star of Hope at the age of eighty-nine. *Wine Enthusiast* magazine's cover features *WINE* sculpture attributed to Indiana. *BRAT*, another sculpture attributed to Indiana, is installed in Wisconsin; the sale is his last big payday as a living artist, earning him $320,000.
2018–21	Estate of Robert Indiana is embroiled in legal troubles.
2020	Sean Hillgrove dies, age fifty-one.
2021	Studio assistant Wayne Flaherty pleads guilty to Social Security fraud and accuses Indiana of sexually abusing him in his teens. The Star of Hope Foundation opens its first exhibition, featuring the artwork of student-artists from Vinalhaven hung in the windows of Indiana's former home.

NOTES

14 *Before a frustrated museum director presented him with the answering machine*: Interview with the author.

15 *Some said he had lived his final months in squalor*: "Robert Indiana lived last years in squalor, neglected by caretaker, estate says." *Portland Press Herald*. August 14, 2019.

 1 to 3 percent of autopsies result in a finding of "undetermined": Statistics from the Office of Maine's Medical Examiner.

17 *Some works on paper were water damaged*: Interviews by the author with sources who accessed the Star of Hope after Indiana's death.

21 *He looked disgusted and disengaged*: Observations of the author, who was present for the meeting and conducted the interview.

 "Michael has reached the conclusion": "A Legacy of Love and Hope." *Portland Press Herald*. September 28, 2008.

23 *Indiana told Salama-Caro they were McKenzie's work*: Allegation contained in initial complaint filed by Morgan Art on May 18, 2018, in Southern District of New York.

24 *"His legacy is enormous. He is truly a giant American artist"*: "A Legacy of Love and Hope." *Portland Press Herald*. September 28, 2008.

25 *After a tense few hours*: "Indiana Cleared on Sex Charges." *Courier-Gazette*. September 23, 1992.

 "We were lucky": "Indiana Innocent in Sex Case." *Bangor Daily News*. May 23, 1992.

 Those allegations resurfaced three years after his death: Sentencing memorandum filed in U.S. District Court in Portland, Maine in May 2021 in U.S. Justice Department action against Wayne Flaherty by Jeanne D. Semivan, Special Assistant U.S. Attorney.

26 *Prosecutors working with the Social Security Administration*: Sentencing memorandum filed in U.S. District Court in Portland, Maine in May 2021 in U.S. Justice Department action against Wayne Flaherty by David Beneman, attorney for Flaherty.

27 *By 2002, all the liens against Indiana were released*: Knox County records.

28 *With McKenzie paying him $1 million a year to work on* HOPE: Court documents and interviews with the author.

As early as 2014, he told Indiana he should sue to reclaim his rights: According to an email reviewed the author by someone who received a copy of it.

"It's part of his psyche": Interview with Simon Salama-Caro conducted by Joe Lin-Hill for Albright-Knox Art Gallery, in Buffalo, New York. "Robert Indiana: A Sculpture Retrospective," 2018.

35 *Marc Salama-Caro received an email*: "Lawsuit paints sad image of exploitation in Robert Indiana's final years on Maine island." *Portland Press Herald*. May 23, 2018. These allegations are part of Morgan Art's original lawsuit; Thomas denied sending the email.

38 *Marc Salama-Caro eventually mended things*: Testimony in Knox County Probate Court, September 12, 2018.

he wrote to a Portland attorney: Email shown to the author by its recipient.

39 *on May 13, 2014, McKenzie emailed Indiana*: Email shown to the author by its recipient.

44 *Soon after, he was plotting*: Minutes from a Star of Hope Foundation meeting on December 22, 2017, included in court documents filed by Morgan Art on March 18, 2020, in Southern District of New York.

In a June 2017 meeting: From notes of the meeting taken by Marc Salama-Caro and later included in court documents filed by Morgan Art on March 18, 2020, in Southern District of New York.

His attitude had changed by year's end: Included in court documents filed by Morgan Art on March 18, 2020, in Southern District of New York.

47 *He received an email from Melissa Hamilton*: Robinson showed the email to the author; Hamilton declined several requests to discuss it.

50 *But they made another employee call the ambulance*: Webster Robinson recounted this story to the author.

51 *In the days and weeks afterward*: Desmond in an interview with the author; through an FBI spokesperson, MacDonald declined to be interviewed for this book.

53 *"The metabolism and distribution"*: The medical examiner's office responded by emails to a series of questions posed by the author over the course of several months.

56 *He slept in a bed that was barely more than a cot*: This description of
Indiana's sleeping quarters was provided by several regular visitors
to the Star of Hope.

58 *"How did you find out?"*: Author interviews with two sources
familiar with Bowley's phone call.

 Nikas felt the need to act with urgency: Both Potter and Nikas spoke
of concern about art being removed from the Star of Hope in the
aftermath of Indiana's death.

60 *Before long, Potter was fired*: "In trove of officer misconduct
records, Maine sheriffs hide the worst offenses." *Bangor Daily
News*. December 2, 2020. According to the article, the Knox
County Sheriff's Office gave no written description of
Potter's misconduct, but noted that the discipline levied was
"termination." In an interview with the author, Potter said he was
fired for "missing a mandatory meeting."

64 *It was a pivotal moment*: Indiana biographer Susan Ryan in an
interview with the author.

65 *Indiana purchased the Star of Hope from the photographer's estate for
$10,000*: According to the deed on file in Knox County, Maine.

76 *One curator recalls a mid-1980s visit*: This story was shared in
confidence by a mutual friend of the curator and the author
and recounted here with the curator's blessing but insistence on
anonymity.

79 *"It is a beautiful painting about Maine"*: "Governor accepts Indiana
painting for State House." *Portland Press Herald*. May 27, 2007.

84 *He told people LOVE was supposed to be FUCK*: *Robert Indiana:
Figures of Speech*, by Susan E. Ryan. Yale University Press, 2000.

91 *He called them his "huskies"*: Multiple sources interviewed by the
author said Indiana used the word *huskies* to describe the men
working around his home and studios.

92 *"I found him really bright and really feisty"*: Disclosure: the author
received a Rabkin Prize in 2017 from the Dorothea and Leo
Rabkin Foundation.

94 *He chose the name Indiana*: *Robert Indiana: Figures of Speech*, by
Susan E. Ryan. Yale University Press, 2000.

95 *but for Indiana it was especially true*: Author interview with Michael
Komanecky.

99 *"I'll tell you one thing about this guy"*: This quote was told to the author by a friend of the lawyer.

who once snagged a half-empty bottle of scotch: Biographer Susan Ryan recounted this episode in an interview with the author. "He saw it and picked it up and said, 'Wait a minute,' and went back in the lodge. He said, 'It should not go to waste,' she told the author.

"He just felt it would be sexier for it to be a million dollars": Testimony in Knox County Probate Court. September 12, 2018

101 *"Bob's not up for a conversation right now"*: The *Portland Press Herald* reporter is the author of this book.

102 *"It ain't fucking happening," Thomas told the crowd*: "How Robert Indiana's Caretaker Came to Control His Artistic Legacy." *New York Times*. August 1, 2018.

103 *But the behind-the-scenes drama at the Star of Hope*: As Indiana's former publicist and longtime advocate, Kathleen Rogers had unusual access to the artist because she exchanged emails freely among all his inner circle over many years. She saved and shared many of those emails, which provided insights into what was happening inside the Star of Hope in the years leading up to the lawsuit and Indiana's death.

111 *drawing a $10,000 weekly salary beginning in 2017*: Interview with Hillgrove's daughter, Alexandria Aiken.

114 *Vinalhaven made national news*: "'Group of Local Vigilantes' Try to Forcibly Quarantine Out-of-Towners, Officials Say." *New York Times*. March 29, 2020.

115 *who complained about shoddy police work*: "Residents say police protection on Vinalhaven is ineffective." *Bangor Daily News*. July 3, 2020.

118 *"My problem with the passport office might have saved my life"*: "Bearing Witness: Artist Robert Indiana's Experiences on Sept. 11 have given rise to a new, controversial work." *Portland Press Herald*. September 8, 2002.

Hillgrove told Indiana they should go back inside: Based on interviews with Webster Robinson and Hillgrove's daughter, Alexandria Aiken.

"What would I do without you, Hillgrove?": Hillgrove told this story to his father, according to his daughter, Alexandria Aiken.

"*This is the one thing I did the town probably approved of*": "Bearing Witness: Artist Robert Indiana's Experiences on Sept. 11 have given rise to a new, controversial work." *Portland Press Herald*. September 8, 2002.

121 *After Indiana died, Wulp defended Thomas publicly*: "How Robert Indiana's Caretaker Came to Control His Artistic Legacy." *New York Times*. August 1, 2018.

122 "*Bob is looking for somebody that can run the studio that isn't a jackass*": Testimony in Knox County Probate Court. September 12, 2018.

123 *There's a video posted to YouTube*: Posted by BlouinArtInfo.com.

124 *During the final two years of Indiana's life*: Testimony by Thomas in Knox County Probate Court. September 12, 2018.

 The art handlers and assessor hired to move Indiana's art: "Robert Indiana lived last years in squalor, neglected by caretaker, estate says." *Portland Press Herald*. August 14, 2019.

125 *Thomas never explained why*: Based on Thomas's testimony in Knox County Probate Court.

 When allegations of abuse, neglect, and fraud: "Robert Indiana's caretaker rejects accusations of neglect." *Portland Press Herald*. August 16, 2019.

 The gifts of artwork: Hearing before U.S. Magistrate Judge Barbara C. Moses. March 6, 2019.

126 *In the final year of Indiana's life*: Based on interviews with Webster Robinson and Sean Hillgrove's daughter, Alexandria Aiken; and on testimony by Jamie Thomas during probate proceedings in Maine.

129 *Hillgrove was offered the money but refused it and wouldn't sign the NDA*: According to his journal, shared with the author by his daughter, Alexandria Aiken.

 After severing his alliance with Thomas: Author interview with Hillgrove's mother and daughter.

130 *Hillgrove remembered MacDonald*: "Robert Indiana's death is a messy portrait, and Vinalhaven's the canvas." *Portland Press Herald*. May 27, 2018.

132 *Even though Hillgrove had refused Brannan's offers of money*: Author interview with Hillgrove's mother and daughter.

133 *She fills the page with photos of Hillgrove and Indiana going back decades*: Posts on Facebook page "Justice for Sean Hillgrove."

134 *When Roberts gaveled open*: "Rockland lawyer gets seat in the impeachment trial." *VillageSoup*. January 23, 2020.

136 *But Indiana was intent on keeping a low profile*: "In wake of famed artist Robert Indiana's death, a tangle of allegations." *Boston Globe*. February 16, 2019.

139 *For a $25 million estate*: Based on author interviews with national estate experts and estimates from estateexec.com.

140 *In addition to her legal career*: Decision and order of State of Maine Board of Dental Practice dated October 11, 2019.

 The closure of her dental practice was attributed to an "unforeseen illness": "Midcoast dentist shutters business, leaves 3,500 without dental care." *Bangor Daily News*. July 25, 2017.

141 *Soon, the others showed up*: The account of this meeting is based on author interviews with James Brannan, Jennifer Desmond, and Catherine Bunin-Stevenson.

142 *The four-page will is surprisingly standard*: "The Last Will and Testament of Robert Indiana." Stevens & Day, Attorneys at Law. Blog post.

143 *On May 20, 2016, less than two weeks*: Sarasota County, Florida, property-deed records.

149 *When Flaherty came back that winter*: Author interviews with Webster Robinson and Sean Hillgrove's daughter, Alexandria Aiken.

 Flaherty admitted to receiving $1,500 monthly: "Waldoboro Man Pleads Guilty to Social Security Fraud." Department of Justice press release. January 27, 2021.

 "Waldoboro man admits to Social Security fraud." *VillageSoup*. March 25, 2021.

 In May 2021, Flaherty was sentenced: United States District Court District of Maine, Criminal No. 2:20-cr-00101-JDL, amended judgment issued May 25, 2021.

 As the lawsuit filed by the Morgan Art Foundation: Motions filed by Maine attorney general in Knox County Probate Court in May 2021.

150 *He billed the estate close to $294,000 for his evaluation:* Accounting
was included in documents presented in Knox County Probate
Court detailing expenses incurred by the estate.

155 *They're not happy with me:* As of the time this book went to
press, Brannan hadn't been removed from the case—but in early
2021 the Maine attorney general sought the return of nearly
$3.75 million in legal expenses Brannan had billed to the estate,
according to a filing by the Maine Attorney General's office to
the Knox County probate court on April 20, 2021.

 Brannan assured the attorney general: "Star of Hope Foundation
seeks final say over sale of Robert Indiana's artwork and assets."
Portland Press Herald. September 25, 2020.

 "Indiana estate representative offers valuable paintings as collateral
for $5 million loan." *Portland Press Herald.* December 17, 2020.

157 *Later, on the advice of the Maine attorney general:* "Former lawyer
for Robert Indiana wants to see artwork under new ownership."
Portland Press Herald. February 16, 2021.

 "If the estate is ever going to be preserved or studied or visited": "Robert
Indiana: the artist, the caretaker, the lawsuit and the $4M auction."
The *Guardian,* November 14, 2018.

160 *Through a mutual friend at the fair:* The entire anecdote of Simon
Salama-Caro meeting and courting Robert Indiana is based on
an interview with Joe Lin-Hill, deputy director, Albright-Knox
Art Gallery, in Buffalo, New York, and recounted in "Robert
Indiana: A Sculpture Retrospective," 2018.

162 *Salama-Caro was beguiled by both the art and the artist:* From an
interview with Joe Lin-Hill, deputy director, Albright-Knox Art
Gallery, in Buffalo, New York, and recounted in "Robert Indiana:
A Sculpture Retrospective," 2018.

167 *In their first agreement, signed in April 1999:* Counterclaims filed by
James Brannan and the Indiana estate against Morgan Art in the
Southern District of New York, March 2020.

170 *Through his attorneys, Brannan accused Salama-Caro:* Counterclaims
filed by James Brannan and the Indiana estate against Morgan Art
in the Southern District of New York, March 2020.

171 *In one exchange:* Telephone conference on August 20, 2020, among
attorneys for Morgan Art, Michael McKenzie, and the Indiana estate.

According to the estate's allegations: Counterclaims filed by James Brannan and the Indiana estate against Morgan Art in the Southern District of New York, March 2020.

172 *During the first decade of the arrangement*: Counterclaims filed by James Brannan and the Indiana estate against Morgan Art in the Southern District of New York, March 2020.

In 2009—the year after Michael McKenzie began working: Counterclaims filed by James Brannan and the Indiana estate against Morgan Art in the Southern District of New York, March 2020.

173 *Morgan Art sent more-frequent summary statements*: Counterclaims filed by James Brannan and the Indiana estate against Morgan Art in the Southern District of New York, March 2020.

According to Nikas, Morgan Art made its final payment to Indiana: Interview with the author.

174 *In 2017—when eighty-eight-year-old Robert Indiana*: Counterclaims filed by James Brannan and the Indiana estate against Morgan Art in the Southern District of New York, March 2020.

177 *"…a little slimy, but I don't mean that in a bad way"*: As this book was going to press, Ryan asked if she'd said "anything negative" about Salama-Caro during her interviews with the author. She asked to retract this quote, saying it was accurate when she said it but in hindsight worried it was "a little harsh" and "now I think unjustified."

181 *The issue's cover featured a photograph of the sculpture* WINE: "One on One with Robert Indiana." *Wine Enthusiast*. May 2020.

To many who knew Indiana: Multiple sources told the author they never believed Indiana did the interview.

182 *"He's a bit of a recluse"*: "80 years of iconic art by famed Pop artist Robert Indiana on view at Allentown Art Museum." *The Morning Call*. October 4, 2014.

183 *"I showed some of that to Bob"*: Interview with the author.

185 *Michael Komanecky, the curator from the Farnsworth*: The notes were part of a filing by Morgan Art in March 2020 seeking sanctions against Jamie Thomas and James Brannan regarding what Morgan Art claimed was willful destruction of emails. Morgan Art's request for sanctions as later denied.

186 *"I thought he should be bigger"*: Testimony in Knox County Probate Court. September 12, 2018.

187 *Then it stopped*: From a petition to the Supreme Court of New York by the Indiana estate against Michael McKenzie and American Image Art.

Meanwhile, he continued to peddle HOPE: As personal representative of the Indiana estate, Brannan petitioned the Supreme Court of New York for a preliminary injunction to prevent Michael McKenzie and American Image Art from continuing to produce artwork under its contract with Indiana.

When McKenzie was cut out: "Major parties in Robert Indiana lawsuit reach settlement." *Portland Press Herald*. March 4, 2021.

188 *McKenzie boldly told the* New York Times *in 2019*: "His Art, Their Ideas: Did Robert Indiana Lose Control of His Work?" *New York Times*. January 18, 2019.

191 *"But it felt to me like kind of a funhouse"*: Interview with the author.

193 *His contact replied*: Webster Robinson shared a screenshot of his text exchange with the author.

McKenzie has defended the authenticity of BRAT: Interview with the author.

194 *He said Indiana endorsed the idea*: "How Robert Indiana's Caretaker Came to Control His Artistic Legacy." *New York Times*. August 1, 2018

"I told him that I had seen this thing before": Testimony in Knox County Probate Court. September 12, 2018.

196 *"Hey Michael I am going to send you a pic"*: Copies of these text messages were included in Morgan Art's court filings.

207 *However, the Maine attorney general*: Motions filed by Maine attorney general in Knox County Probate Court in May 2021.

210 *Why did he withdraw:* Based on Thomas's testimony in Knox County Probate Court.

Why did his wife turn over a bag of cash: Based on Thomas's testimony in Knox County Probate Court.

And who hid $95,800 in cash: "Robert Indiana lived last years in squalor, neglected by caretaker, estate says." *Portland Press Herald*. August 14, 2019.

211 *During its investigation of Flaherty*: Sentencing memorandum filed in U.S. District Court in Portland, Maine in May 2021 in U.S. Justice Department action against Wayne Flaherty by David Beneman, attorney for Flaherty.

213 *Whatever the truth*: United States District Court District of Maine, Criminal No. 2:20-cr-00101-JDL, amended judgment issued May 25, 2021.

ACKNOWLEDGMENTS

MY THANKS BEGIN with Robert Indiana, who invited me to Vinalhaven in late-summer 2002, soon after I began writing about the arts for the *Portland Press Herald*. We met first by phone to discuss an exhibition he was participating in that summer, and the interview went well enough that he followed up by suggesting I come to the island to see new work he had made in response to 9/11.

Indiana was standing off to the side at the boat landing when I got off the ferry, away from other islanders greeting their guests. There was no mistaking him, a robust figure with white hair flowing from underneath a large hat and a cigar planted in his mouth. He didn't say much. He removed his cigar and pointed to his Subaru. We must have shaken hands, though I have no memory of it.

We drove in silence. Moments later we parked outside his Sail Loft studio, across from the Star of Hope, and I realized I had mistaken his social awkwardness for rudeness. Robert Indiana was not comfortable or patient with small talk, but he was eager to talk about his art. I was eager to listen.

Photographer John Ewing and I spent the day with him— we got the full tour of the Star of Hope and lunch in his kitchen. He was a good soul, and I remember the thrill of watching him open his flat files, remove drawings, and tell stories. He was energetic and engaged, and passionate.

After that day, I would remain in contact with Indiana over the next fifteen years. I interviewed him about his pleasure and pride in seeing the resurrection of *EAT* atop a Maine museum. He spoke with ambivalence when *First State*, a painting about Maine, was accepted as part of the official

state-owned art collection, and I was there for his eigh-teenth-birthday party on Vinalhaven, in his friend's kitchen, taking notes as Indiana, Simon Salama-Caro, and Michael McKenzie rattled on about *HOPE*.

I had no idea at the time, of course, about what was un-folding behind the scenes of the party, but I felt sorry for Indiana because I thought he looked sad, alone, and scared. When I left the party, I remember thinking of the John Prine song "Hello in There" and its haunting refrain: "Old people just grow lonesome."

My last contact with Indiana came in 2016 when Michael McKenzie asked if I would consider writing a story for the *Press Herald* about an Indiana exhibition at Bates College featuring artwork inspired by the lyrics of Bob Dylan. I have huge respect for Dylan—I've seen him perform eighty times—so this exhibition was of enormous interest. When McKenzie pitched the idea by saying that Indiana used to turn up the volume to "Like a Rolling Stone" and "Highway 61 Revisited" in his New York studio, I couldn't say "Yes!" fast enough to scheduling an interview with Indiana.

I was intrigued by the idea of these two artists from the Midwest both ending up in New York with new names and new identities, and each forging a unique personal expres-sion centered on the explosive use of words—and at the same cultural moment. One was a true orphan. The other created an orphan/everyman persona. During the time the exhibition was up at Bates, Dylan had a tour stop scheduled in Portland. It was a perfect story, and I desperately wanted to tell it.

But McKenzie refused to make Indiana available for even a phone interview. At first, he said Indiana wasn't feeling well. When I pressed and said I could wait until he felt well

enough to talk, McKenzie said Indiana was physically fine, he just didn't want to talk. He was old and tired. He needed to save his energy for his art, not for the media.

McKenzie was lying and I knew it. Indiana turned me down for interviews when I asked to talk about his estate and other touchy subjects, but he always wanted to talk about his art. If this work was as personal to Indiana as McKenzie led me to believe, there was no way Indiana would not want to talk about it. I had Indiana's number in my Rolodex, so I called him directly. I let it ring once, hung up, called again and let it ring twice, etc. Sometimes it just rang. Other times, someone answered and hung up without saying anything.

After a while, you take the hint and stop trying. A cranky old artist, who spent years avoiding people and making enemies, had dug a deeper moat. That's hardly news, especially in Maine.

But it's still a tragic, heartbreaking story, and that's why I wrote this book—to explain his silence and disappearance, to make sense of the mystery, and to create context for a complicated and consequential truth. My history with Indiana, the good and bad, informs this story. Difficult though he was, Robert Indiana deserves the truth.

In addition to the artist, I owe thanks to the two most important women in my life, my mother and my wife.

My mother, Edna Keyes, because she always envisioned me becoming a writer and always encouraged me. My mother was the librarian at Portland School of Art, which later became Maine College of Art, when the Indiana biographer Susan Ryan worked there and began the research for her book *Robert Indiana: Figures of Speech*. I was living in South Dakota at the time, and my mother conveyed both her friend's progress on the Indiana biography during our weekly phone calls

and her ardent hope that someday, perhaps, I would write a book about an artist as famous as Robert Indiana.

And to my wife, Victoria—my beloved Vicki—who understood and never questioned the importance of this project, despite the turmoil and disruption it caused during a stressful time, as this project coincided with the pandemic, when both of us were suddenly at home. Early in my research, I told Vicki I wanted to move my office from a spare room to our bedroom, because the bedroom was larger, more private and would enable me to work more intensively and more efficiently. She said yes, and we rearranged our home to accommodate this book. She supported me and always listened to my Robert Indiana stories. She was the first to read the earliest drafts and offered the most important feedback.

Thanks to my eighth-grade English teacher and world-class bibliophile, Brainerd Phillipson, for introducing me to Kurt Vonnegut, William Shakespeare, and Sir Arthur Conan Doyle, all of whom made me want to read and write.

I owe gratitude to all the sources named in these pages, who indulged my questions, shared private emails, and directed me to documents. Kathleen Rogers, Webster Robinson, and Alexandria Aiken were patient and accommodating. Thanks to all the lawyers who returned my calls—until they stopped doing so: Jim Brannan, Ed Boyle, Luke Nikas, Sig Schutz, John Markham, Nat Putnam, Ron Spencer, and others. Curators and scholars were invaluable: John Wilmerding, Susan Ryan, Dan O'Leary, Michael Komanecky, Chris Crosman, Marius Peladeau, Cindy Buckley Koren, Susan Larsen, Mark Bessire, and Wes LaFountain. And thanks to dozens of other sources named and not named in these pages, whose stories, anecdotes, and opinions are reflected in my understanding of this story.

I am in debt to my editors, Joshua Bodwell, Celia Johnson,

and Doris Troy at Godine; and the trio of Cliff Schecht-man, Steve Greenlee, and Leslie Bridgers at the *Portland Press Herald*.

Josh, the editorial director at Godine, contacted me early in 2020 to ask if I had considered writing a book about Robert Indiana. In fact, I had. I had pitched a book elsewhere the year before and been turned down. Josh told me to take another crack at it. As a former reporter, he knew there was more to the story than I had time or space to tell in the newspaper. He advised me to think like a movie director: choose the characters and scenes I wanted to include and set the tempo and tone with my writing. That freedom felt scary and liberating—and intoxicating.

Josh's editing was precise and penetrating. He challenged, pushed, and prodded, and set a high bar in regard to both the quality of the information and the tenor of the narrative. Celia read the manuscript from the proverbial 20,000-foot view and her input gave me the ability to focus on the reporting and storytelling while she sorted out the mess and helped stitch it together. Doris, on the other hand, paid attention to every detail in the manuscript—and in doing so reminded me that copy editors have been saving me from embarrassment for a very long time. Thanks also to designer Tammy Ackerman and cover designer Alex Camlin. It's humbling to work on a team whose members care as much about the book as its author.

As a daily-newspaper reporter, I appreciate editors who have faith in my work and encourage me to keep digging. We might have dropped this story early on or relied on the wire services or our editorial colleagues in Maine to tell it. But from the first few hours when we got word that Indiana had died, the editors at the *Press Herald* recognized the

importance of the story, assigned me to it, and kept me on it for three years—and counting. That's the embodiment of responsible community journalism. In that same spirit, I humbly thank all my colleagues at the *Press Herald* and in the newsrooms of my past at the *Argus Leader* in Sioux Falls, the *Greenwich Time* in Connecticut, the *Morning Sentinel* in Waterville, Maine, and the *Red & Black* in Athens, Georgia.

Finally, I want to thank newspaper subscribers, book readers, and art lovers everywhere.

ABOUT THE AUTHOR

Bob Keyes has worked as a journalist for four decades. He is an award-winning, nationally recognized arts writer and storyteller with specialties in American visual arts and the contemporary culture of New England. Keyes has written about arts and culture for the *Portland Press Herald* and *Maine Sunday Telegram* since 2002.

Prior to reporting in Maine, Keyes covered arts and culture for the *Argus Leader* in Sioux Falls, South Dakota, with a personal interest in indigenous issues. He's also written for newspapers in Connecticut and Georgia. He grew up in Massachusetts and graduated from the University of Georgia.

Keyes has received numerous awards for his writing, including the Maine Writers & Publishers Alliance's Distinguished Achievement Award for exceptional and steadfast contributions to the Maine literary community, and the Rabkin Prize for Visual Arts Journalism in recognition of his contributions to the national arts dialogue.

Keyes lives with his family in Maine.

A NOTE ON THE TYPE

The Isolation Artist has been set in Bembo with Clarendon—the *LOVE* typeface—for display. Bembo was designed by the Monotype Corporation's British division in the late 1920s but draws its inspiration from a typeface by Francesco Griffo for the Venetian printer Aldus Manutius in 1495. Clarendon, released in 1845 by Thorowgood and Co. of London, is a handsome, clear display face often associated with WANTED posters from the American Old West.

Design & Composition by Tammy Ackerman